# The Art of Tantra

# The Art of Tantra

Philip Rawson

*176 illustrations, 25 in colour*

New York Graphic Society Ltd, Greenwich, Connecticut

I gratefully acknowledge the assistance of the Arts Council, and wish to point out that this work was only made possible by the exhibition they supported in the Hayward Gallery in the autumn of 1971. Thanks are also due to Nik Douglas for the work he has done for the identification of a large number of the objects; to Jeff Teasdale for his skill and long patience; to Jean Claude Ciancimino for his great kindness and readiness to help at all stages in the project; and to Ann Stevens of Thames and Hudson for the sustained care and thought she has devoted to the planning of this book.

P.S.R.

International Standard Book Number 0–8212–0518–8 (Cloth)
International Standard Book Number 0–8212–0523–4 (Paper)

Library of Congress Catalog Card Number 72–93940

First published in Great Britain by
Thames and Hudson Ltd, London

First published in the United States of America
by New York Graphic Society Ltd, Greenwich, Connecticut

© 1973 Thames and Hudson Ltd, London

# Contents

The art of Tantra has only come to light during the last ten years; small exhibitions have been held in London, Paris, Rome, San Francisco, New York, Montreal and elsewhere. In 1971 the largest exhibition was held in London, under the auspices of the Arts Council of Great Britain. But so sudden was its discovery that even people professionally concerned with India had known nothing about it. Western museums contain many examples as yet unrecognized. Art-critics have been at a loss how to cope with it; it was so different from anything they had seen before, even of Indian art. And the galleries which have recently put on shows have had difficulty in giving coherent and intelligible explanations. But to artists, art-students and younger people in general it has come as a revelation. All over the world it has caught their imagination; and even though most of them had not known much, if anything, about Tantra, the qualities of the art offered them something positive and special.

Tantra itself has been known to a handful of interested people in the West for about seventy years, mainly through Sanskrit texts and English translations. A few pieces of visual art were published here and there as oddities, or as accessories to the study of Indian religion. No-one had recognized in them an art worthy of serious attention though a few had been bought as curiosities. We owe their discovery very largely to one man, Ajit Mookerjee, from whom a knowledge of the art has been emanating since about 1955. He comes from Bengal, one of the great strongholds of Tantra from at least AD 600, probably earlier. He is the author and designer of the first, most important books on Tantrik art, which are based on his private collection. In fact, what now passes current as Tantra art is in one sense the product of Ajit's intelligence working through the channels of modern publication.

Tantra art may seem to have no clear limits; one cannot easily say such and such is Tantrik, and such and such is not. But this does not mean that the unity is unreal. In practice Tantra has adopted and adapted imagery from different sources, remodelling its significance and weaving the strands of tradition together into a complex pattern of symbolism. Ajit is the man who has been able, through the resources of the modern world, to recognize the pattern and give it an identity. He is by profession a Museum Curator: he is thus concerned every day with collecting, rationalizing, conserving and explaining. He has

long had opportunities for study and purchase which no layman would have had. But by themselves these would not have been enough. He has, too, an interest in and an eye for modern art, and has written about it. Furthermore, his museum is the National Crafts Museum, which has given him a special interest in what are usually called Folk arts – nowadays an unfortunate title: we should perhaps call them 'Root arts'. For India still (but only just!) preserves live art whose function and symbolism are as old as humanity. Ajit has thus been aware for many years of the common substratum of archetypal significance between primitive and modern arts. He has seen living Indian tribal peoples producing age-old images, and recognized that they embody intuitions not unlike those towards which modern artists are groping their way through the labyrinths of modern conceptual clutter. He has said as much in print many times over.

Tantra is a special manifestation of Indian feeling, art and religion. It may really be understood, in the last resort, by people who are prepared to undertake inner meditative action. There can be no quick and easy definitions. They have been tried; but they either turn out to be so broad and general if they are expressed in Indian words that they scarcely mean anything to the Westerner, or so narrow that they are only true for a part of the enormous and diffuse reality. There are many variations of practice and belief. However, there is one thread which can guide us through the labyrinth; all the different manifestations of Tantra can be strung on it. This thread is the idea that Tantra is a cult of ecstasy, focused on a vision of cosmic sexuality. Life-styles, ritual, magic, myth, philosophy and a complex of signs and emotive symbols converge upon that vision. The basic texts in which these are conveyed are also called Tantras.

Tantra has a particular wisdom of its own. This sets it apart from all other religious and psychological systems, especially those traditional to the orthodox Brahmins. The other systems agree in asserting that our real world is a meaningless illusion, that the mental play of forms which we call our experience of life and the world is utterly without value. They show that all those experiences which ordinarily we cherish most, such as love for our lovers and children, food, the intense emotional joy nature, music and art can produce, even the adoration we may feel for a personal God, are merely traps, whose grip on us has to be prized loose. We must learn to reject totally any fondness for worldly experience of any kind, so as to allow our whole attention to be flooded with a consuming abstract vision of the Brahman, i.e. 'The Truth', 'The undivided whole', which is the ultimate Ground of Being. According to the Brahmin systems, when we manage to stay permanently in this state of attention, with our entire mind stilled and absorbed in the Ultimate, we may achieve Release. Our nature may cease to be human, so that we are converted into an all embracing Consciousness which is at once Being and Bliss. Obviously it needs a special kind of heroism to detach oneself utterly from experience in the world, and it takes a long, long time – many successive lives according to Indian thinking. But this has been the constant obsession of Indian orthodoxies.

To achieve such insight one may dwell on the urgent misery of the human condition. Hundreds of Indian religious texts (notably Buddhist) contain

somewhere in their first few paragraphs the phrase 'Sarvam Dukham' – 'Everything is misery'. To help one along the way of detachment when one is meditating, one may pick out for special attention the agonies, despair and crimes of which one knows: there are plenty. One may also focus one's mind on the 'disgusting' aspects of one's own body and the bodies of others, thinking of them as mere transient bags of phlegm, shit and putrefying offal. One can then discover how easy it is to say 'No!' to the world enjoyed by such bodies, to deny the claims of all apparent but vanishing possessions. The horrors of suffering will thus fade into insignificant dreams. By the same token the most beautiful lover will dissolve into a temporary illusion, the airy fantasy of a desiring mind. When all this is quite clearly seen one's libido is freed from its idle imagining, its motions may be stopped, and one can fix it on the eternal, changeless light. By oppressing the body and the mind with fasting, asceticism and vigorous discipline, one can obliterate from one's consciousness every last shred of the interest that knots the self to any piece, part, fragment, image, movement or memory of the world of illusion; one's own mind may thus be swallowed into the Brahman like a drop of water into the surface of a lake. Then even though other people may see the body walking, there will be no man in it. It will be a husk, an empty pupa-shell when the butterfly has gone. It will continue to exist merely so as to finish up the last remnants of impulse from its immemorial past.

Tantra does not dispute the fundamental truth of this position. But it believes that the methods used are absurd. It declares that there is no need for such a desperate upstream struggle to reach the shore, that such an ideal of life produces a dreadful world for those as yet unreleased. In fact distinguished nineteenth-century Tantrikas stated emphatically that they believed many of the miseries of their poor India to be caused by the world-hatred which traditional Brahmin philosophies had instilled into the majority of the population. No one nowadays can doubt that they were right. In addition, as Dr S. S. Barlingay has pointed out, there is a logical and phenomenological fallacy involved in any assertion of the nature of Being which fails to take account first of all of that which is and its relation to man.

In complete contrast to the strenuous 'No!' that official Brahmin tradition said to the world, Tantra says an emphatic, if qualified, 'Yes!' It asserts that, instead of suppressing pleasure, vision and ecstasy, they should be cultivated and used. There are, in fact, plenty of references to this even in the most sacred orthodox Upaniṣads. Because sensation and emotion are the most powerful human motive forces, they should not be crushed out, but harnessed to the ultimate goal. Properly channelled they can provide an unparalleled source of energy, bringing benefits to society as well as continually increasing ecstasy for the individual. To help in this the physical body needs to be carefully cultivated. Tantrikas suspect the officially-approved 'No-sayers', who hate and

deny the world, at worst of a hidden and dangerous self-indulgence which we should now call sadistic, at best of neglecting their fellow-creatures. Tantra deals in love, and love needs objects. One cannot love nothing. Love means care; and care carried to the limit is probably the ultimate social virtue. At the same time, different forms of Tantra cultivated elaborate frameworks of qualification and ritual procedure, to make quite sure that its followers did not fall into complacent ways of self-indulgence. It is fatally easy – millions do it! – to seek pleasure, even ecstasy, and make nothing of them, leaving them lying as dead and sterile experiences in one's own past. Writers on Tantra have pointed out, though, that in the total oneness occasionally experienced in everyday love the goal can be glimpsed. Tantra, however, distinguishes very sharply indeed between the beast-like man in bondage to appetites, who seeks pleasure only for the sake of experiencing the ecstasies it may offer, and the committed Tantrika who treats his senses and emotions as assets to be turned to a special kind of account. It never denies that our fragmented experience of the world is intrinsically valueless. But it does accept that life contains positive experiences which can be put to use. They may be made into a ladder of ascent, or built into something like a linear-accelerator to propel a person into ecstatic release, drawing behind him a wake of love and benefit.

Hindu Tantra proclaims everything, the crimes and miseries as well as the joys, to be the active play of a female creative principle, the Goddess of many forms, sexually penetrated by an invisible, indescribable, seminal male. In ultimate fact He has generated Her for his own enjoyment. And the play, because it is analogous to the activity of sexual intercourse, is pleasurable to Her. The Tantrika must learn to identify himself with that cosmic pleasure-in-play, and to recognize that what may seem to others to be misery is an inevitable and necessary part of its creative web, whereas the pleasure is a true reflection of the cosmic delight. This point is made even in the titles of Tantrik texts: Kāmakalāvilāsa (p. 198), for example, means 'erotic joy in the movements of love'; Śaktisaṁgama Tantra means 'the Tantra about Śakti intercourse'. By the exertions of their coupling the two divinities generate around themselves, in various kinds of patterned halo in stages less and less subtle, more particularized figures, called devatās, among whom their energy is shared. The patterns are described in the maṇḍala designs and yantras with which the texts and art are very much concerned. Buddhist Tantra in practice shares with Hindu the use and valuation of figurative symbols, even though it may seem to differ over their ultimate significance.

2, 65

The devatās are all human in shape, female or male, and have different colours to show their qualities, perhaps many arms to show their special functions, heads, expressions, garments, gestures and postures all with specific meanings. Personalization in the bodily shape of beautiful people has important implications of its own. At the superficial level it engages the human libido in

1

98

9

135

92

5

8

sensuous and erotically attractive imagery. But at a deeper level it reflects a principle which has ramifications throughout the whole of Indian thought, including medicine and astronomy. According to this principle Tantra equates the human body with the cosmos. The two are, so to speak, the same functional system seen from different points of view, and each is inconceivable without the other. 'I' and 'That over there' are functions of each other. The cosmos which man's mind knows is a structure of the energy-currents in his bodily system. Only by the activity of man's mind does a cosmos come into any kind of meaningful existence. MIND (cosmic) and mind (human) are not essentially different; nor are BODY (cosmic) and body (human). The trick is to knit together the two aspects, by getting rid of obstacles and limitations. So the devatā-bodies to which Tantra constantly refers are invitations to each human being to identify himself with them, first at lower then at higher levels.

Tantra has mapped the mechanism of currents of energy through which the creative impulse is distributed at once through man's body and the world's. The universe of phenomena which results has, therefore, for the Tantrika a kind of subtle four-dimensional skeleton of channels, the knots and crossings of which are occupied by devatā-figures. The Tantra texts and art contain maps of the system, together with detailed instructions for working the mechanism. The Tantrika does this by sādhana, i.e. psychosomatic effort, assimilating his own body to higher and higher levels of cosmic body-pattern. In the end he may become identical with the original double-sexed deity, which is involved, without beginning or end, in blissful intercourse with itself. The incentive to his continual effort is an occasional vision, as if one were to glimpse the fire of a raging furnace through a crack in its wall, of the cosmic bliss which is an all-embracing love, sexual, maternal, filial, social and destructive, all at once.

Sādhana consists, fundamentally, of repeated rituals and carefully designed meditative activities, some of which will be described later on. The Tantrika has to lead a controlled life. For he knows that only wholehearted and continuous repetition of *real acts*, both physical and mental, can change his body and consciousness. Mere reading and thinking is no good at all. Tantra is not a belief or faith, but a way of living and acting. Indians have anyway enjoyed ritual since very ancient times. To repeat prescribed ceremonies gives them great satisfaction, and a powerful assurance of their identity in their universe. Regular ritual is not for them the weary chore it can so easily become for the city-bred Westerner. Tantra, like most other Indian cults, focuses all its interest on prescribed schemes of behaviour and imagery. Its texts are full of imperatives, which again some Westerners may find distasteful. 'The Sādhaka must do so and so; then he must do so and so', or 'Before doing this he must do this, this and this.' He has to stick to rigid laws and observances, avoiding certain things like the plague. In practice Tantra has never shown any interest in valuing and contemplating the continuously different forms produced by

the creative play. Although there could be plenty of room for them in the system, Tantra has never discovered anything similar to the *hexeity* (haecceitas) of Duns Scotus or the deeply individualized *inscapes* of Gerard Manley Hopkins. Tantra accepts the structure of the world as defined by an abstract universal pattern, semantically conditioned by abstract nouns. The prescribed methods are felt to be precious discoveries, related certainly to the limitations of Indian culture, which only a fool would question. If they are properly used a sādhaka can reach bliss and release in a single lifetime. Among them are meditation, the cult of extreme feeling, aesthetic experience, sex, drugs, magic and social action.

One story famous among Tantrikas is given in two slightly differing versions in the Rudrayāmala and the Brahmayāmala. It summarizes many of the chief ideas behind the Tantra. Among them are: that Tantra is a 'way' superior to but not inconsistent with traditional ways; that it combines the virtues of different religious sects; that it seems scandalous to the conventional; and that it deals in a special kind of ecstasy.

The chief figure in the story is an Indian culture-hero called Vaśiṣṭha, who is the prototype of the Brahmin sage, and is said to have been son of the God Brahmā and teacher of the incarnate god Rāma. He was highly skilled in orthodox Hindu religion and philosophies. He is thus a very good symbol for all those in need of Tantra's lesson. The story describes how Vaśiṣṭha performed his orthodox meditations, with terrible asceticisms, for six thousand years, trying to compel the great Goddess to show Herself to him. He failed, and in a fury wanted to curse Her. His father told him not to, explaining that he had an altogether wrong idea of the Goddess. In reality, he told Vaśiṣṭha, She is the boundless material, brilliant as ten thousand suns, out of which everything in the cosmos is made; She was Herself the substance of the Buddha's enlightenment, kindly, loving and beautiful. Vaśiṣṭha tried again in a different spirit, and in the end She appeared to him, in the bodily form of Sarasvatī, the holiest Goddess of ancient Brahmin Vedic wisdom – an appropriate iconic shape for a Brahmin like him. She told him he was still way off the proper track, and that he ought to learn the 'Kula' method of religion, that is, the Tantrik tradition. She said he could not hope to get anywhere by mere yoga and asceticism, not even to glimpse Her proper feet. 'My worship', She said, 'is without austerity and pain!' He must go to Mahāćīna (probably somewhere in the Himālaya) and learn the proper forms. Then She dissolved herself back into space and time.

Vaśiṣṭha did as She said. But when he reached Mahāćīna he was horrified to recognize there the great Hindu god Viṣṇu, incarnate as the Buddha, sitting among colleagues naked and red-eyed, fuddled with drink. They were surrounded by beautiful women wearing jewelled belts and tinkling bells on their broad hips, with whom they continually had sexual intercourse, giving

and taking great pleasure. Vaṣiṣṭha made a great fuss and protested that this all went against every sacred teaching. But the Buddha pointed out to him that he was making a vulgar mistake and being deceived by outward appearances. The men and women involved were doing things that had been prepared for by prolonged ritual and meditation. In reality their outer actions were merely instruments to an intense inward vision; the women were images of the great Goddess Herself, and there was no self-indulgence involved. He then taught Vaśiṣṭha the special Kula yoga and ritual, and the sage understood. He achieved his goal.

No one knows how old Tantra is. There are hints of it in India's oldest literature. The earliest surviving complete texts are Buddhist, and date to about AD 600. But there are many elements of what became Tantra in older Hindu and Buddhist scripture; and later texts even refer to Tantra as 'Atharva Veda', thus identifying it as an aspect of the most ancient sacred and orthodox literature of Hinduism. There is Tantra which is Hindu, Buddhist and even, by stretching a point, Jaina. Since the Middle Ages it has flourished in many strata of Hindu society, notably in Bengal, Assam, Kaṣmir and parts of the South. It assimilated and occasionally combined with Muslim ideas, and travelled to many other countries of the East. It reached China during the eighth century, when there were two major Tantrik Buddhist temples in the T'ang capital. From these it was transported to Japan. It is likely that sexual rites, also familiar in Chinese Taoism, were used by these T'ang Tantrik Buddhists. They certainly were by the Japanese Tachikawa sect which was founded in the twelfth century. But in both China and Japan puritan Confucianism has expunged the memory and literature of sexual Tantra, leaving only a schematic psychological version. On the other hand, in Tibet Tantrik Buddhism flourished exceedingly from the seventh century into recent years; and Tibetan Tantra made its way into Mongolia, with occasional excursions into China. In Nepal Buddhist Tantra has flourished from early times, mingling with Hindu Tantra. In Southeast Asia Hindu Tantra was adopted in Cambodia and Java c. AD 900, while Buddhist Tantra was probably known elsewhere in Southeast Asia.

4

Tantra contains many archaic elements. Some are as ancient as the palaeolithic caves of Europe, and can be precisely matched with them. The great French cave complex of Pech-merle, for example, contains a chapel-chamber with female emblems which can be duplicated very closely at Indian shrines. Other parallels will be pointed out later on. It is therefore more than probable that what we know as Tantra is an adaptation into later Indian life-patterns of very ancient and powerful images, practices and thought. Indeed India is famous for the way it has preserved unbroken traditions of immemorial antiquity. There is not much profit, therefore, in arguing about the priority of one Tantrik sect or text over another; although, of course, historians must do so for their own purposes. The important point is that since the essential ingredients of

Tantra are likely to be older than any of the individual Indian religions, there is nothing surprising in each of them developing a version of it, simply adapting the ingredients to its own world-picture. This also helps to explain why the careful linguistic analysis of terms which Agehānanda Bharati has made[1] was not more profitable. For at bottom Tantra is not a matter of rationalized terminology, but of inner facts of experience to which terms are only pointers: different terms may, and frequently do, indicate similar facts. The important thing for us is that the archetypal elements in the cult may in practice bridge the gap enabling us to discover, and perhaps to try to vitalize in ourselves, the same kinds of experience, learning to use them for similar ends.

As we know it in relatively recent history, Tantra has been transmitted through family groups, down lines of pupil-teacher descent. Frequently the pupil has had to spend many years in search of his own personal and true teacher. It is said that only he who is fit for a teacher is able to find and recognize him. Since they were used either for explanation between teacher and pupil or for individual rites, most works of Tantra art fit into the modest person-to-person context. They are on a small scale, executed in an immediate brushwork that makes no pretension to perfect finish. It is characteristic of this art that the artist always knew what he was going to make before he made it. Even the minor details were standardized and prescribed, and artists had learned what they should be by imitating them exactly from earlier work. The freehand directness of the styles was possible because the artist had himself made the same images with the same touches many times before. Colour was based on a standard repertoire of hues, all with their own definite significance, and three-dimensional forms all used the same set of plastic metaphors.

But though colours were used primarily for their conventional symbolic significance, in practice they also have powerful emotive effects. It is not a simple question of hue, saturation and density. The pigments used were chosen, and adopted as traditional, because their particular colour-inflections evoked the required emotive responses. They were not diluted in intensity or 'killed'; their force was always kept at its maximum. Further, such colours, combined as they often were to meet prescribed symbolisms, were nevertheless also juxtaposed very skilfully in calculated quantities so as to produce definite but indescribable visual and emotive effects.

The figures represented in Tantra art naturally share in the common heritage of Indian traditions. But Tantra was never concerned with imitating an external world; and so its figures are all to some degree stereotypes, puppets stimulating by their visual inadequacy a vigorous reinterpretation in the imagination of the meditator. They may embody almost geometric ideals of beauty; and only in the Rajput paintings which preserve the fading influences of Islam and European sixteenth-century art are the interpersonal dramas acted out between beings who seem to be aware of each other's existence.

10

84

16

1  Tibetan painting meant as a dwelling for the Buddhist Goddess of Supreme Wisdom whom the figure represents. Her lotus connects her with the ancient Goddess of the Creative Waters, Lakṣmī. Tibet, 18th century. Gouache and gold on cloth 16 × 11 in.

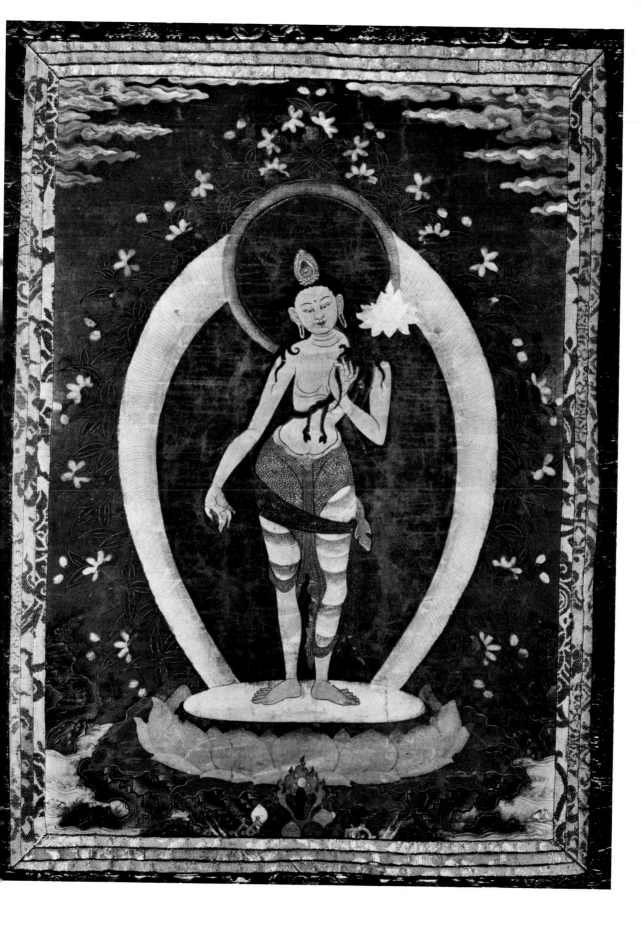

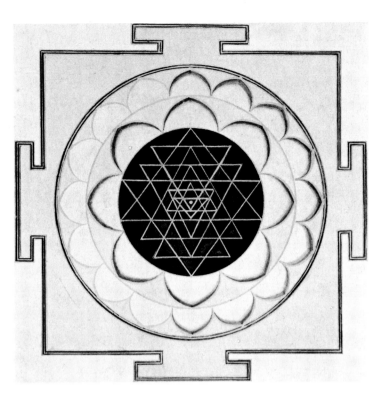

2 Śrī Yantra, a diagrammatic embodiment of the creative sexual activity of the Universe. Rajasthan, 18th century. Gouache on paper 8 × 8 in.

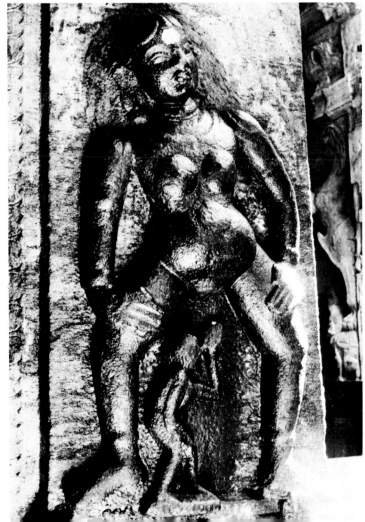

3 A stone pillar-sculpture representing worship of the yoni (vulva) of the Yoginī as Goddess. Madura, South India, 17th century.

4 Manuscript containing prescriptions for ritual and figures for visualization, with maṇḍalas. Nepal, 18th century. Ink and colour on paper 66 × 8 in.

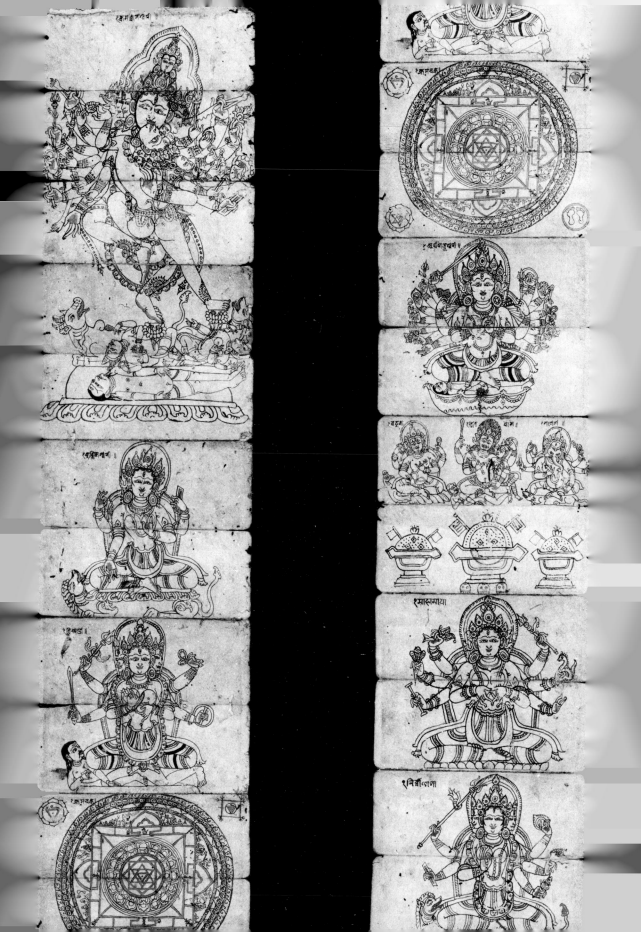

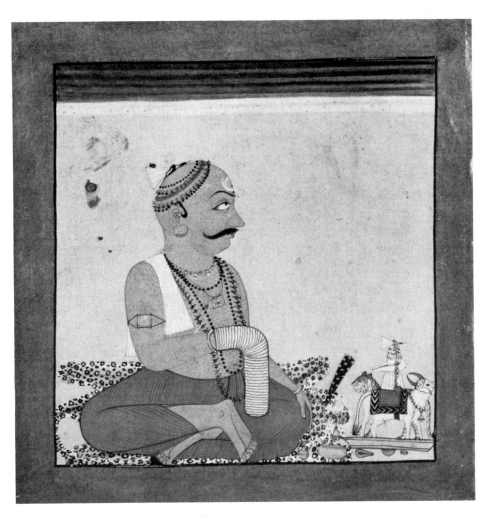

5  Rāja Sidh Sen of Mandi performing pūjā with his hand in a rosary-bag. Mandi, *c.* 1720. Gouache on paper 8 × 8 in.

6  Head of the Goddess for worship. Rajasthan, 18th century. Bronze h. 5 in.

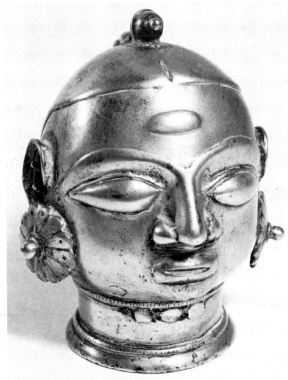

(*Opposite*)
7  The Goddess Parvatī, a form of the consort of Śiva. South India, 16th century. Bronze 27 in.

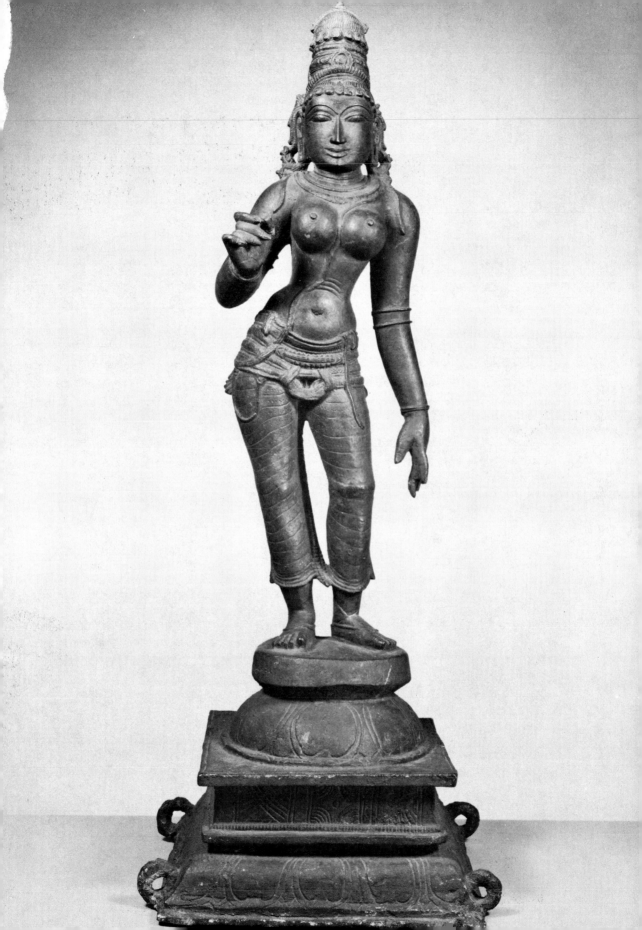

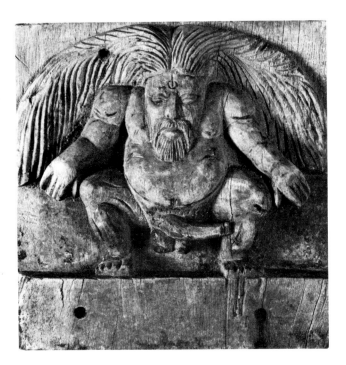

10 Worship of the Trident as emblem of its indwelling deity, Śiva. Rajasthan, 18th century. Gouache on paper 10 × 7 in.

8 Long-haired sage in a condition of sexual arousal. South India, 17th century. Carved wood, probably from a temple car. 7 × 7 in.

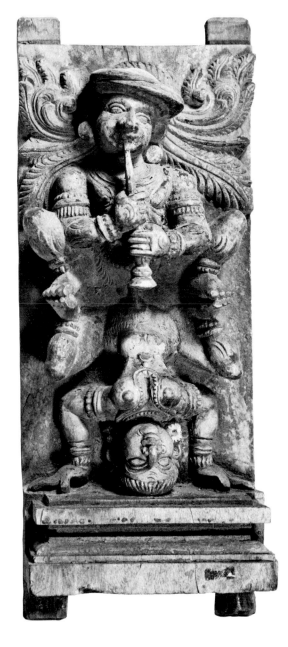

9 Celestial couple in sexual intercourse in an acrobatic posture, the man playing a wind instrument, the whole an image of celestial delight. South India, 18th century. Wood, probably from a temple car, h. 16 in.

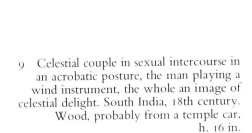

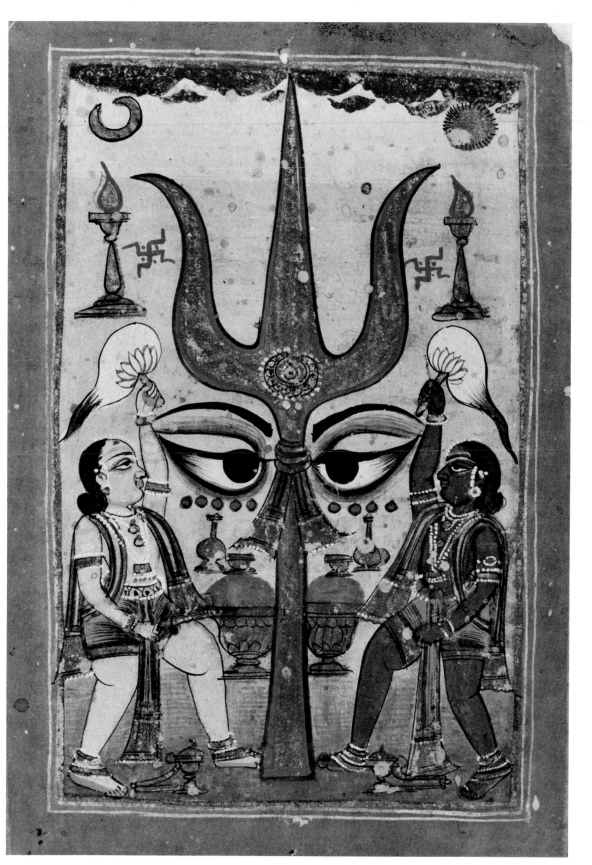

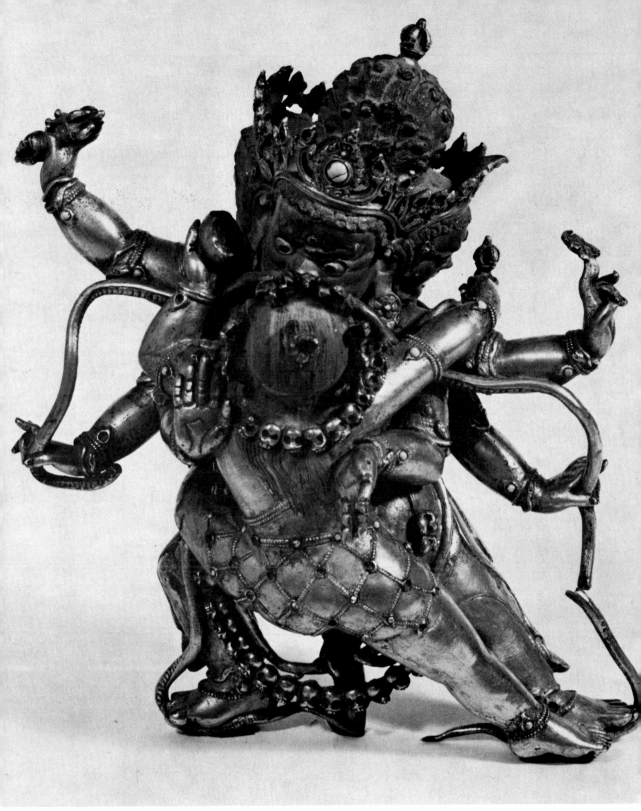

11   Yab-yum image of a terrible form of the Bodhisattva Vajrapāni, in union with his wisdom, the couple being the protectors and embodiment of Tantrik Buddhist doctrines. Tibet, 16th century. Bronze 9 in.

The objective coloured surface was never meant to challenge comparison with any sensuously derived image of external reality. It was meant to stimulate radiant inner icons, whose bodies and features could be quite unrealistic in any ordinary sense of that word. Blue skin or red skin, many heads and arms were commonplace. The density and strength of colours, the vigour of plastic development could lift the imagery, so to speak, off the page or wall, dissolving it, at the same time interposing a barrier between the inner icon and any comparable visual object. This was meant to produce a higher key or grade of objectivity than any transient reflection on the retina of the eye, a consistent world of the imagination against which visual phenomena seem grey and pale.

Tantra still exists as a living cult; and although it is endangered like so many other Indian institutions by the advance of Western mass-conditioning and crudely quantified causal theories of man, Tantra may well be in a better position than most to survive, although it will certainly need adapting. Its vivid world of the creative imagination (using those words in their most serious sense) draws on the fabulous wealth of Indian myth and legend and weaves the elements together into a dense tissue of meaning. This could quite well be programmed to embrace the material science of the industrial world. Indeed one branch of Tantra has always dealt with physics and medicine, as they were traditionally understood; so that it is quite possible to reconcile Tantra with, say, chemistry. What is not possible, however, is to reconcile Tantra with the ironical self-hatred, purely convergent thinking and closed mind common among workaday scientists. To a Tantrika the table of elements or the abstract forms of molecular structures and particle physics amount to revelations of the actions of devatā, and can be welcomed as such.

The Indian Tantrika knows his cult from the inside, as a code of rites and practices along with their explanations. Some he has done from childhood; others he may learn by seeking progressive initiations, according to his ambition. Most of these need not conflict with his carrying on a domestic life; in fact they can dignify and enhance that life by filling it with significance. But there are some men and women who may want to devote their whole lives to Tantrik sādhana; such people can take vows which involve leaving home, perhaps joining an āśram or an order. Then they will start more intensive rituals. And although most Tantrikas have been born into their tradition it has been quite common for converts to gain initiation. Some of the most famous Bengali poets were converts. And the Kaṣmiri Abhinavagupta, one of the greatest philosophers of India, who made what may be the most important individual contribution to the world's aesthetic theory, travelled to Bengal to be initiated into the Kula Tantra.

We know Tantra nowadays from the manuscript texts called Tantras, in Sanskrit or vernacular languages. Only a few of those surviving have been

published; fewer still translated. They seem to have been composed at different times and places in India, more or less as encyclopaedias of Tantrik ritual and philosophy, and to have been copied and added to many times over. The earliest were put together about AD 600, but some of the most important and influential during the later Middle Ages and at the command of Rajput princes. They are never actually given hard dates, so chronology is usually a matter of internal evidence; and that is none too reliable anyway, since the compilers borrowed freely from one another.

Some Tantras carry more authority than others with different groups of Tantrikas. The most generally authoritative among Hindu Tantras are, perhaps, the Śaktisaṁgama, the Kulārṇava, the Mahānirvāna, and the Tantrarāja.[2] Some are more inclined towards philosophy, some to magic, others to the science of sound. Some are more flamboyant and extreme than others. There are also important abbreviations or summaries, often in the form of hymns, like the Karpūrādistotram or the Ānandalaharī. Most of them set out, as we have seen, to be inclusive, combining into their symbolic structure ancient Vedic rituals along with sectarian deities and popular legends. Everything is grist to their mill; for they take it for granted that Truth can be indicated by many different symbolic combinations. From one text to another there is no particular consistency of system or names. Virtually all of them insist that there are parts of the ritual which can never be put down in writing, and that Tantra can never be learned from books, but only from a competent teacher, or guru. A few use code-language for crucial passages. Virtually all use symbolisms which can only be partly understood by an outsider who is prepared to pursue them down to their roots in Indian life and culture. To the Tantrika, however, the whole point of his rites is that the symbolisms of which they are composed open in his own mind vistas of feeling and meaning which change him, obliterating his materialist view of the world. This demands that, as he performs them, he has to contemplate what he is doing with total awareness. It is true that many Indian customs are now carried out in a perfunctory and formal spirit. But a genuine Tantrika knows he will get nowhere if he runs through his ceremonials in an empty and half-hearted way.

How the West has learned about Tantra has its own history. The most important figure in that history is Sir John Woodroffe, a Justice of the High Court of India at Calcutta during the last decade of the nineteenth century. He devoted his personal life to publishing Tantras, speaking and writing extensively about Tantra under the pseudonym Arthur Avalon (a very romantic and mystical pen-name). Tantra owes more to his advocacy than to the work of any other single man. He was writing for a double audience: there were the Europeans deeply infected with Victorian prudery; and then there were the English-speaking Indians who were mostly under the influence of their caste-prejudices, ashamed and violently critical of elements in their

own culture, and hence anxious to seem even more puritan than their Western rulers. Arthur Avalon devoted an enormous amount of effort to explaining and justifying the element of carnal enjoyment in Tantrik practices, wrapping it up in lurid warnings against taking them as mere bestial pleasures. He was driven by a quite genuine fear of being misunderstood by his audience into implying, without perhaps actually stating it in so many words, that no good Tantrika actually *enjoys* the ritual. He included extensive quotations from Tantra warning that only he who has totally conquered passion and desire is entitled to participate in the rites during which cooked hog-flesh, wine (abhorrent to most high-caste Hindus) and sexual intercourse (even more abhorrent) were 'indulged in'. It is, of course, true that the purpose of Tantrik ritual is far from being carnal indulgence, as will be abundantly clear from what follows. But we must also remember: first, that Avalon was standing out against a vocal alliance between an Indian caste élite and Western missionaries who were aiming to get Tantra outlawed (he was, of course, a lawyer); and second that the published Tantras as we know them have already been filtered, often many times, through the minds of high-caste Indian editors who have written something of their own prejudices into the very text of many of the Tantras, often adding long sections specially emphasizing the social and philosophical conformity which so much concerned their caste. Other European scholars have even been guilty of Bowdlerizing their translations, which Avalon, much to his credit, did not.

As with so many other religions we must, for our own purposes, learn to distinguish between what in these texts is conditioned by local, historical and cultural factors, and what has general value. The latter we can assimilate without prejudice into our own outlook. In fact enjoyment (bhoga) is the essence of Tantra, as has been explained; and that kind of enjoyment can only be the direct function of desire of some kind. Tantrik desire and enjoyment, therefore, may be defined as transformations of the raw material. No Tantra rite can work, though, unless the enjoyment and desire are there. It is absurd to pretend that such a rite can be undertaken in the spirit of mere cold duty. To begin with, no man can get the necessary erection for a sexual rite unless both his body can be possessed with normal instinctual response, and he can expect, on the basis of past experience, that the desire will be consummated in some way. True Tantrikas have always known – and declared – that the strength and success of their rituals depends on a vividly intense and directly physiological appeal. This is a fact which many writers on Tantra still attempt to suppress.

A related fact that tends to be forgotten in what scholars have written about Tantra is that many of its practices were deliberately intended to breach the caste system. A number of the elements that Tantrik rites involve were aimed directly at the heart of Hindu social prejudice; and Buddhist Tantra had its

own version of social iconoclasm. [3] The meaning here, of course, is that a pride in social identity and virtue is the most insidious and crippling of all the mental blocks on the road to release. The Tantrika has to commit himself to acts which destroy any vestiges of social status and self-esteem. Older Westerners have been inclined to overlook this aspect of Tantra; members of the Alternative Society may find it especially interesting. And once again, we can discover how the 'official' caste outlook has even been written into many of the texts. For it seems that Brahmin editors may have tried to present the rites as if they were occasional formalities which did not really alter the social *status quo,* instead of as the drastic purges of personal commitment they were meant to be. Anyone who actually carries Tantra to its ultimate degree, as real devotees must, can only end up a scandalous outcast. We catch sufficient glimpses from Indian history to be quite sure of the truth of the matter.

What is known of folk cult and custom among the vast populations of ancient India also corroborates the suggestion that the literary record, which has always been compiled by literate Brahmins, needs a good deal of supplementation, to say the least. There would have been no need for the many dire warnings uttered by puritan apologists for Tantra against the danger in orgies perpetrated by 'low-class' people in the name of religion, unless such orgies did in fact take place. Popular religion in India has always made a special feature of orgiastic behaviour; and there is plenty of evidence that various forms of Tantra contain echoes of the same ancient theories as those on which such behaviour was based.

There are vital differences at the practical, as well as the theoretical, level between Buddhist and Hindu Tantra, which will be brought out later in this survey. It is chiefly the Buddhists who insist upon these differences, for reasons of their own. Indeed Tibetan Buddhists, whose Tantra came from India in the early Middle Ages, now seem to wish to dissociate themselves entirely from what they know of Hindu Tantra, even though their own original Tantra contained many Hindu ingredients. Their special reasons are bound up both with their own racial inheritance and perhaps with Chinese infiltration. So I can make no apology for presenting Tantra as the Indian phenomenon it originally was and still is today.

Its history is tied up with accidents in the survival of manuscripts, with the travels of individual masters, with the extreme secrecy Tantrikas have generally preserved and with the history of India itself. As a consequence the important Hindu Tantra of Bengal and Bihar, where Buddhism was obliterated about AD 1200, retains and makes its own sense of many Buddhist elements. Indeed one Bengali Hindu Tantra is called, after an early medieval Buddhist goddess still known in Tibet, Tārābhaktiśuddhārṇava, 'The pure ocean of adoration of Tārā' – a goddess who also plays a role in the Hindu cosmic system of devatā. It is typical of India that the symbolic figures do not remain distinct,

but overlap and interpenetrate. This is not the place to go into the complexities of Tantrik syncretism; but the point should be made that theological differences between sects are at the relatively superficial level of terminology. Since these are verbal and conceptual, they fascinate modern academics, Indian and American in particular. But genuine Tantra is so much a matter of practice, of intuition and archetypal symbolism that many people in the West, who are not at all interested in scholastic argument, have responded to it directly. It offers them a concrete symbolism with which they can feel affinities through deep human links, despite the cultural differences – which, of course, it would be absurd to minimize. Not by accident has Tantra art demonstrated its power to many people who have never studied Indian philosophy. It is a great pity that we now have with us jealous scholastics who are anxious to protect their study-investment and reserve Tantra for an academic and verbally-oriented élite.

# 3 Sex and logic

Some people are troubled by the way Indian thought goes in for vast and wide-ranging generalization. It is true that Indian art and thought all work on a principle of total conceptual enclosure. From about AD 400 onwards Brahmin culture made a sustained effort to define and organize all the manifestations of reality, life and experience within a single imaginative whole. It attempted to comprehend the history of each individual in relation to the entire cosmos. It therefore constructed a kind of pyramid of generalizations, each higher level being more comprehensive than the one below, to which different aspects of life and philosophy were made to correspond. Mental concepts that embrace the whole landscape of reality are matched in Tantra art by summary diagrams which refer to continents, planetary movements and cosmic genesis. One can easily be deceived by this bandying-about of vastly-embracing ideas into fancying that Tantrikas had an image of a world rather like that which nineteenth-century Christians used to have until astronomy taught them better, as a modest chunk of ground about six thousand years old with a lid of sky. Nothing could be farther from the truth. Indian culture, at least since the third century AD, has held an idea of the cosmos as being vast beyond human imagining, containing worlds numberless as the sand-grains of the Ganges, and developing through incalculable aeons of time. Indian mathematics and metaphysics have long recognized number, both abstract and concrete, of an order of magnitude which only became familiar to educated people in Europe during this century. When Tantra makes statements or paints icons relating the structure of the world to faculties in the minds of men and gods, one has to realize that it is not simply being glib, reducing the content of its concepts to false and easily manageable proportions. Even though its generalizations were made without the benefit of modern scientific knowledge they were never meant to be anything but colossal in scope. Meditation has the job of filling the abstractions with a valid content of reality. In their everyday lives the Indians know what vastness means; they live in a vast country watered by immense rivers, fringed to the north by the world's highest mountain-range. In their imagination they see even the most momentous events in their lives in relation to their stupendous reality as mere ripples on an ocean. At the same time, they do not see that reality either as dead or unconcerned with themselves, but as

12

130, 152

30

intimately identified, through those channels of creative energy, with their own inner natures. The link is sex.

Lying at the root of Indian imagery is an assumption which gives meaning to cherished beliefs and practices in Indian culture.[4] To some extent it has a shadowy existence even in Western Christian culture, though modern sexological theory runs very much against it. The assumption, however, has very ancient roots in the constructive imagination of the human race. It is this: that human sexual libido is in some sense identical with the creative and beneficial energy essence of the Universe. From this assumption various courses of action may follow. The most significant consequence that has been drawn is that for human libidinous energy to be 'spent' in normal sexual relations, or even in erotic dreams, represents a serious spiritual loss to the person concerned, perhaps even to the world. A popular belief widespread in India thus holds, for example, that sex and wet dreams give a hold to disease. Dr Morris Carstairs found that his Brahmin informants, whose special caste-role it was to be vessels of the Brahman, tended to avoid intercourse even with their wives as much as possible, out of dread for the dangerous spiritual waste entailed. When their wives had a 'right' to intercourse, at the end of menstruation, they performed the act hedging it about with ritual precautions. High caste and moral virtue both seem to depend, to some degree at least, on sexual abstinence. This was probably the source of Gandhi's extreme sexual inhibition, of which he made so much and which so troubles his Western admirers. Any ascetic who aims spiritually very high must, according to this assumption, hold in and build up both his sexual libido and the semen which embodies it to the uttermost limit. His body will then become full of a kind of radiant energy (tejas) which enables him to work all kinds of supernatural effects; and folklore has it that the highly-developed ascetic, if cut, bleeds not blood but semen. There are, of course, other outflows through which more generalized libido may escape, and they may be inhibited as well. Sensuous pleasure of all kinds (food and clothing) may be abandoned as far as possible; the head may be shaved; the body may be tortured.

All of these activities represent the cult of what one may call the 'sexual misers' which has gained such a powerful hold in India. According to it every individual develops his psycho-sexual energy for his own spiritual benefit; though it is true that Indians also believe that people well advanced along this road are able, if they feel inclined, to work a power of good to others, as well as harm, by their supernatural energy. In spite of its cult of 'enjoyment' some Tantra still keeps very strictly to this asceticism, especially the Buddhist Tantra of Tibet, which makes a vital issue of treasuring the male 'Thig-le', called Biṇḍu in Sanskrit, whose physical form is the semen. Tantra which has been rigorously vetted by Brahmin prejudice also makes a great point of such energy-hoarding.

13

95

14–16, 72–3

17–23

8

110, 111

There are, however, other courses of action which can follow from the basic assumption, reflecting a cult of sexual generosity. Folk ceremonies, such as the spring-harvest Holi procession, when people spray each other with coloured water or powder and once used to sing extremely erotic songs and participate in promiscuous sex, probably symbolizes a kind of generous spreading abroad and exchange of this energy, when it was at its seasonal height. A connected imagery must have underlain the violently erotic songs and dancing once performed in so many Hindu temples in front of the divine icon, their many superb sculptures of the erotic delights of heaven, as well as the custom of religious prostitution which used to flourish widely in India. In such contexts, as in parallel 'primitive' customs, the more copious the expenditure of pleasure and sexual juice the better.

Hindu Tantra does not go as far as this. But it does cultivate activities aimed especially at arousing the libido, dedicating it, and ensuring that the mind is not indulging in mere fantasy. All the concrete enjoyments and imagery are supposed to awaken dormant energies, especially the energy which normally finds its outlet in sexual intercourse. The energy, once aroused, is harnessed to rituals, meditation and yoga, turned back up (parāvṛitta) within the human energy-mechanism, and used to propel the consciousness toward blissful enlightenment. Orgasm is in a sense an irrelevance, lost in the sustained and vastly enhanced inward condition of nervous vibration in which the union of the energies of man and world are felt to be consummated, their infinite possibilities realized virtually on the astronomical scale of time and space.

In spite of the protests of some authors, much Hindu Tantra in fact welcomes orgasm, provided it is recognized as being the analogue to ancient traditional Hindu sacrifice. This sacrifice consisted essentially of pouring oil, fat or butter on to an altar fire, in which other things may also be consumed. Tantra equates the male ejaculation with the oil poured out; the friction of the sexual organs with the rubbing of sticks to light the fire; the vagina of the female companion, who should, for extreme 'left hand' ritual, be menstruating so that her own vital energies are at what is believed to be their dangerous peak, with the altar on to which the offering is poured; the fire with the enjoyment; and the woman with the Great Goddess. The 'White' and the 'Red' were thus combined – a profoundly important symbolic conjunction throughout Tantra.

Here is a quotation from the Karpūrādistotram, which sums up the joint image and act, translated from the code language in which it is expressed in Sanskrit: 'O Goddess Kālī, he who on a Tuesday midnight having uttered your mantra, makes an offering to you in the cremation ground just once of a [pubic] hair from his female partner [śakti] pulled out by the root, wet with semen poured from his penis into her menstruating vagina, becomes a great poet, a Lord of the World, and [like a rāja] always travels on elephant-back.' There may be scholars who, for reasons suggested above, would repudiate any

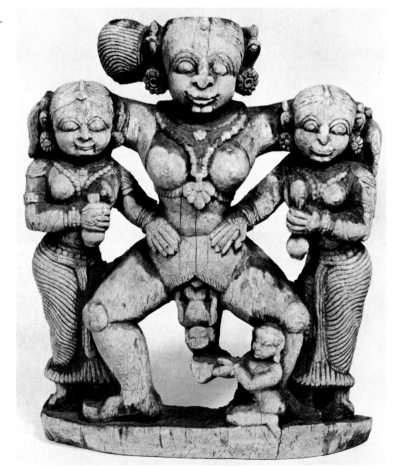

12   Reductive diagram of the con-
stellations, a page from a manuscript of
the Samāraṅganasūtradhāra. Rajasthan,
dated 1712. Ink and colour on paper
5 × 10 in.

13   Image of birth, analogue
of the creative function of the
Goddess. South India, 18th
century Carved wood h. 13 in.

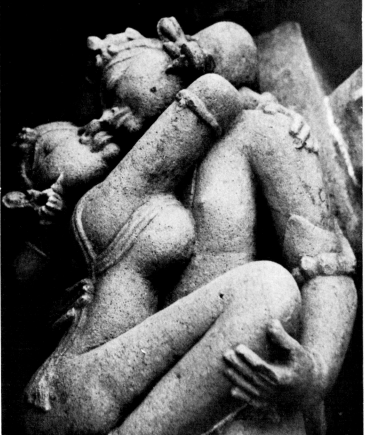

16 Couple from the 'heaven bands' of
temple at Puri, Orissa, *c.* 12th century

14 Relief sculpture of couple in sexual
intercourse, from the 'heaven bands' of
the Devī Jagadambū temple at
Khajurāho, *c.* AD 1000.

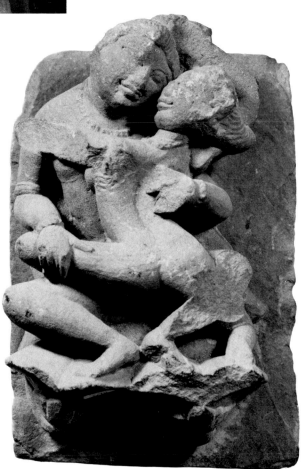

15 Couple from the 'heaven bands' of
a temple, Rajasthan, 13th century.
Sandstone h. 11 in.

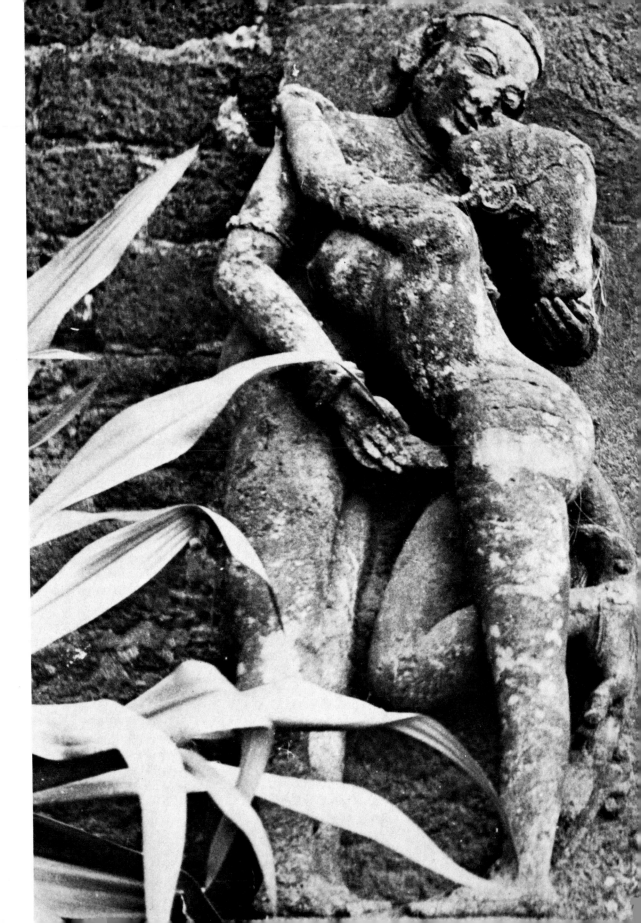

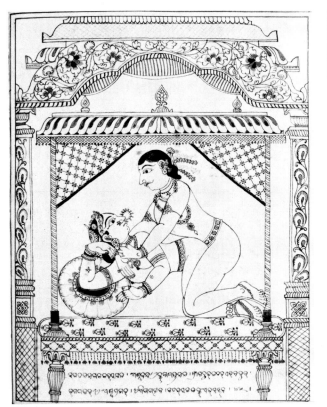

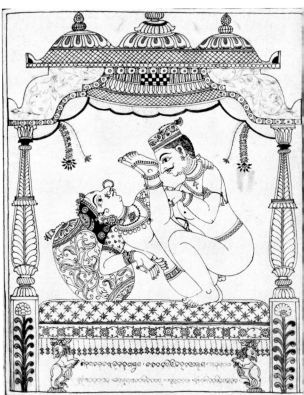

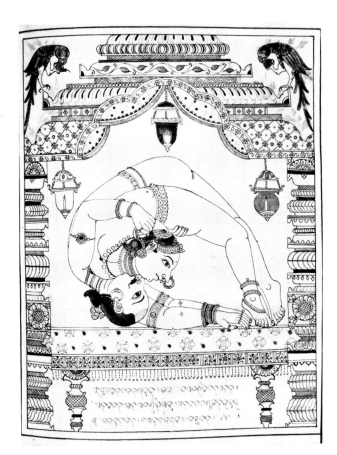

17–23 Drawings illustrating the postures which enhance the act of love, from a manuscript in ink on paper, from Orissa, 19th century.

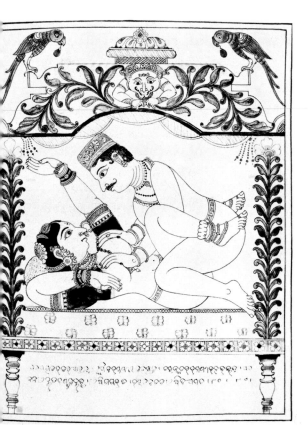

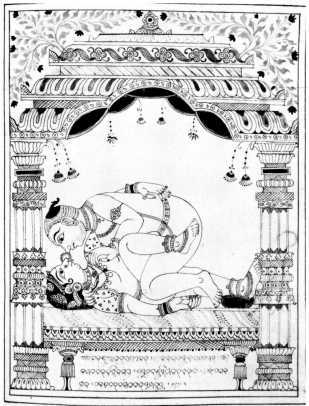

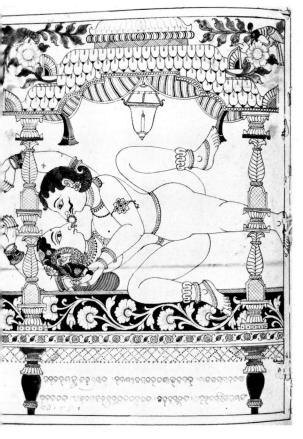

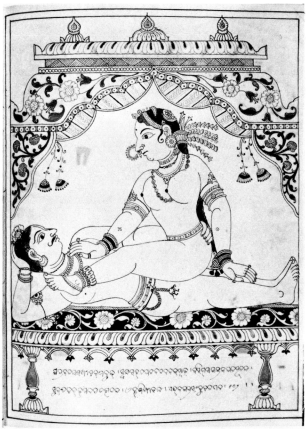

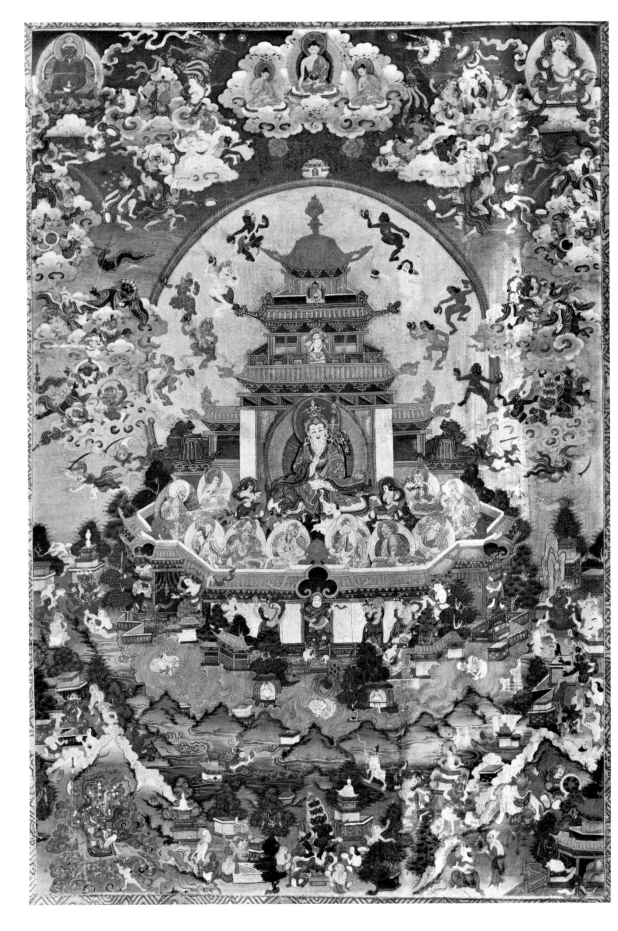

24   Tibetan Tanka painting representing the saint-magician Padmasambhava in a magical palace surrounded by celestials and siddhas who demonstrate their supernatural powers. Tibet, 18th century. Gouache on cloth 32 × 23 in.

25   Astrolabe, for the calculation of celestial relationships. Western India, 18th century. Brass dia. 9 in.

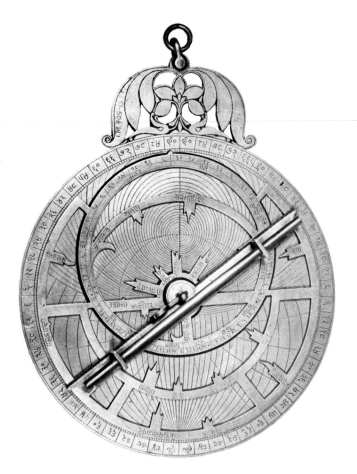

26   Globe, illustrating the projection of the original world into existence from the unfolding lotus of transformation. Orissa, 19th century. Papier mâché, lacquered, dia. 7 in.

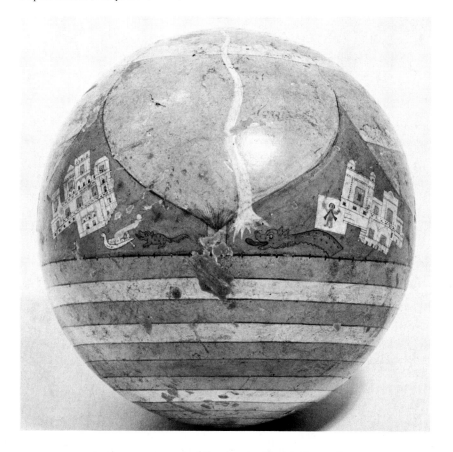

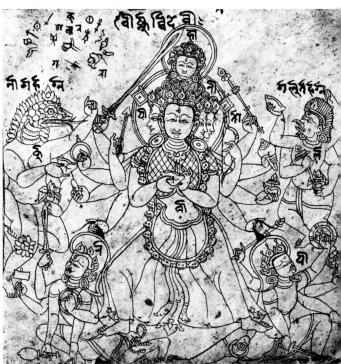

27 Drawing of devatā combining elements of symbolism from several deities into the image. Nepal, *c.* 1500. Ink and colour on paper, whole manuscript 106×11 in.

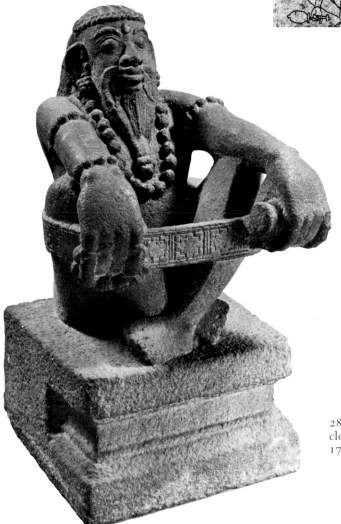

28 Sage seated in his meditation band, a cloth strap to support the body. South India, 17th century. Stone 19 in.

suggestion that this passage, and many others like it, had any factual basis; they may prefer to believe that all such expressions are only figurative, and never referred to any but purely internal processes. Tantra, however, has always had its feet on the ground of real practice; things done come first, interpretations later. No Tantrika would expect to be able to move straight from ordinary life to the most exalted stage of internal symbolism by mere thought. Tantra was always hard-headed, and not at all interested in fantasy. For each sādhaka its symbolism was given solid roots in a bed of ceremonial fact.

Only at the most advanced stages of Tantrik practice, when his assimilation of his own to the cosmic body was far advanced, could the sādhaka learn to internalize what had originally been 'external' realities. A man then had no need for 'outer' women or for all the other 'outer' paraphernalia which were essential to rituals performed at earlier stages in his development. It was recognized that the ability to perform totally realized but purely inward rituals was achieved only by a few of the most gifted sādhakas in any generation.

One can thus say, quite correctly, that Tantra represents a thoroughgoing practical system for manipulating and focusing human libido, enhancing it, and then withdrawing it completely from the passing and valueless phenomena of the world and directing it instead to a transcendent object – in other words for ecstasy; but an ecstasy in which a concern with infinite multiplicity, individuality and unrepeatable change like that which plays such an important part in Chinese and European theology and metaphysics, has no place. Like all Indian metaphysics Tantra assumes that there is never anything new under any sun; since the cosmos is unutterably vast, everything which happens must have happened before many times over; what matters therefore is always the pattern rather than the instance, the general rather than the particular. The standardized patterns of ritual and art are the ones which work. Whatever variations there may be among them are incidental, not essential. The value of the patterns depends entirely on the fact that they are, in some fundamental and immutable sense, true.

Scientists now recognize that their own discoveries, the planning of their experiments along with their hypotheses, are functions of their own psychic situation. Quite a small rapprochement or inversion is needed for modern man to re-establish a true idea of the link between man's psyche and his world, though it may be one which may be particularly difficult for people with hypertrophied conscious ego-functions to make. However theoretically 'communal' or 'inductively established' any 'world' may be, it can never be other than psychic. For that total 'thing in itself' which we might like the Universe to be could never be identical with man's world-image, however many scientists – who are also men – agree about it. It is inner, of the mental order, not outer, of a 'dead' order.

26

Tantra thus begins its investigations with the human psyche – which word is the most convenient portmanteau term for all the instinctual, archaic and individual subconscious and conscious structures which are arranged in perceptual experience, communication and introspection to present a man with his world. No one need expect that physiology, zoology and animal ecology will infringe on or conflict with Tantra. For Tantra has millennia of direct observation and analysis of the human psyche behind it. One may grant that a Tantra meant for the modern Western city-dweller may not be identical with that intended for a seventeenth-century Bengal villager. But there will be far more common ground than might be expected at first sight. Modern thinking, like Indian, has concentrated on creating static images of the world, in which change is represented as change of state, following the demands of our systems of calculation. All our most important problems concerning reality and the psyche have been relegated to a kind of limbo, where the issues raised by time, change, and individual history are kept so to speak around the corner, out of philosophical sight. But psychic truth demands that such aspects of the world be treated as realities *in their own terms,* not merely transcribed into a system of general notions derived ultimately from Aristotelian taxonomy.

The logically 'convergent' world of concepts which each man fabricates for himself during the first two decades of his life with the aid of language is, of course, essential for everyday activity. It provides him with the mental and behavioural map of the world he needs to act rationally and succeed in his profession. Society must have its maps of 'real events' if it is to function properly. But however truthful it may be, however accurately it may meet utilitarian needs and guide courses of action over the terrain, a map *is* not an actual landscape. As the key to a conglomeration of concepts, it is not the reality it indicates; which latter is always infinitely richer in possible forms than any conceptual reduction of it that can be made. And when one's customary map comes to impose its own conceptual limitations on the landscape, preventing one from even experiencing any aspects or forms of the reality which are beyond its scope, then it becomes an insidiously comfortable prison. The ordinary, non-artistic usages of language help every day in forging that prison's bars by reinforcing the conventional patterns of perception and experience. The reaction so common today, of resentment against one's circumstances, only reinforces yet further the illusory existence of the bars.

Worse still, our ordinary linguistically conditioned concept-structures are based overwhelmingly on the noun. We come to identify the processes of our experience with a 'self', around which the apparently stationary structure of our world of concepts crystallizes. The prospect of death thus confronts us with the prospect of personal disintegration, with the negation of all that we have been at such pains to fabricate over decades. The mature personality has to face out this prospect. How he does it is always his own problem. But only the

immature remain immersed in their illusory consolations. They may refuse to face disintegration, stupefying themselves with the constant flow of 'happy endings' offered by popular enterainment; or they may stake their identities on ideal images of activity to which they attach an absolute value, such as 'science' with its refined conceptual maps, or 'motherhood' with its patterns of feeling. Tantra, however, reduces each man's original convergent structure to its true status, as a merely provisional invention which belongs to the mental kind of reality, and as such is part of cosmic process. It describes how each idea of separate self emerges from the general storehouse of intelligible forms into a consciousness, which is yet another realization in the mental order of the possibilities of creation. Tantra demands disintegration of the often comfortable prison of conceptual habit and illusion as an absolute necessity before its processes and images can even begin to work. This will be described in Chapter 8.

Perhaps the most difficult elements of this prison to dissolve are tied up with immature beliefs in causality, will and conventional morality. For the West these have already been finally demolished (or should have been) by Friedrich Nietzsche in *Twilight of the Idols*. We must therefore beware of interpreting the practical magic which looms so large in Tantra as involving, in any sense, the subordination of a 'dead external nature' to a 'human will'. The inner state which Tantra inculcates is beyond integration or disintegration in any normal terms. For it proposes an enjoyment of the infinite relations of the Great Whole which conceptual maps can only hinder.

24

It seems likely that much of the fantastic elaboration of imagery found in later Tantra, both Hindu and Buddhist, represents an effort to overcome the semantic mode based on the noun, without stepping outside it. All Indian languages favour the noun, with its variations and compounds, to an extreme degree. One of the goals of Indian (and other) mysticism can be described as, in one sense, the 'unselving' of objects, dissolving the individual man and his world of separate things by a vision of the endlessly mobile tissue of change borne by currents of energy and kinetic principles of shape related to each other through time in different ways. This tissue cannot be seen past the barrier of 'selved' and separate objects with beginnings and ends, linked by crude causality, which each man's libido isolates and with which he fills his utilitarian universe. To think and speak of this vision should demand that the noun, which is a semantic parallel to the 'selved' object, should be overcome somehow. But Tantra, because of its Indian linguistic heritage, was obliged to refine 'selved' concepts, to push continually further its refinement of supernatural noun-objects, deities, principles, definite shapes and sounds in an endless pursuit of the 'unselved' and hence non-objective 'absolute' which will never, in fact, submit to noun-shaped thoughts. This is a point at which the *I Ching* (the famous ancient Chinese oracle-book treated in both East and

West as a fundamental text of metaphysics), with its images of change in time which are not limited to specific things, may be useful as a counterpoise.

As Mircea Eliade has pointed out[5] it has now been well established by generations of workers engaged in collection and analysis that the great traditional mystical symbolisms are spontaneously rediscovered by modern men in dreams, hallucinations and pathological ecstasies, including those chemically induced. The community of pattern crosses boundaries of race and time which we might have thought were impassable. In view of what has just been said, this means that they should be taken seriously. For it is among them that we are likely to discover the originating formulae which make us men-in-a-world. Tantra presents perhaps the most fully comprehensive knotting together of all those traditional symbolisms which elsewhere are known relatively fragmented and dispersed. In comparison with its insights even the work of Cassirer, Hüsserl or Whitehead seem fragile indeed.

140, 141

Tantra's maps of the subtle body are not meant to be maps of a body which is conceived as pure organism with its 'origins' in an unexplained astronomical and chemical 'dead-nature'. The associated medicine is not a pragmatic allopathy. The kinds of yoga used by Tantrikas do not work as a system of athletics, 'physical cause' producing 'physical effect'. The subtle physiology they define reflects a developing discovery, authenticated by generations of investigators whose devotion goes far beyond anything we know among ourselves, about the interrelationship of body, mind and world. Without the psychic performances the physical acts are meaningless, and can never produce any result that matters. Taken together, and carried through to the limit, they provide the unifying perspective against which every phenomenal question falls into an intelligible position.

The Tantrarāja describes the character of the worshippers of this Great Wisdom. They are not uncertain about the future life, and are contented, for they have nothing more to attain; they are completed (per-fect) in space and time, and so they are full of bliss, depending on nothing and nobody. They do not covet or hoard, are free from crookedness, meanness or busybodying. They are merciful, care nothing for profit or loss, and help everyone. They love all creatures, being free from anger. They stay where they want, have no fear of kings, thieves or enemies, and enjoy life. Women adore them. They are particularly fond of music, as it is the clearest manifestation of the body of their Goddess as Sound. They envy no-one, for they spend their time united with the goal of all their desires.

There remains one defect which can appear to vitiate the whole of Tantra, which it may well be the responsibility of a contemporary generation of Tantrikas to remedy. Though it is more apparent than real, it involves a serious question of value.

As it is recorded in many texts and explained by recent Indian writers,

Indian Tantra could be understood to share that common Indian habit of devaluing entirely the contingent world, personality, and the individual experience of passing sensuous reality. Everywhere it seems to be saying, 'Withdraw your interest entirely from these things; they are of no significance and value at all. They are *as nothing* beside the vision of the ultimate whole.' It may also seem to be suggesting that Tantrik success somehow depends on withdrawing from the world into a realm of generalized ideas and images. Indian tradition often answers the question 'why is there something rather than nothing?' by offering the concept of 'līlā', 'play'. This suggests that the world is the result of the 'play' or 'sport' of the Deity, or in the case of Tantra, of sexual play between the Originating Couple. This explanation again appears to drain all value out of the results of that play.

Earlier (p. 10) it was suggested that true Tantrikas recognized this attitude as the fatal 'Indian disease' of their society, giving rise to an apathy towards the 'real world', an indifference to suffering and a refusal to initiate any change. The truth is that this disease has even infected Tantra itself and can be found implicit in passages from many Tantrik texts. There are plenty of Tantrikas who still feel their prime object is to negate the world and eliminate it from their field of interest. It is perhaps inevitable that a cult which concentrates so intensively on a radiant inner vision of the Whole should run the risk of seeming to devalue the component parts of that whole. But a moment's careful thought should make it quite clear that, actually, Tantra calls for exactly the opposite.

Creation, in Tantra, is described as sexual self-realization through the activity of the Goddess. As the venerable Bṛihadāraṇyaka Upaniṣad says: the One alone 'knew no delight' and so he desired and generated for himself 'a second', the female partner, whose function it was to present to him a discursive reflection of his own splendour, laid out in time and space. This is to both an infinite bliss, which implies infinite value. And it can only mean that what the Goddess generates, down to the humblest minutiae of creation, the twining of each twig, the crunch of a mouse's spine, the gestures of a gnat's foot, the rising of a bubble, are essential to that bliss. All of them *are* (in the sense of identity) the cosmic sexual joy; and creation means to make that which is concrete, individual, and transient. Tantra thus means realizing that the concreteness, particularity, narrowness and seeming horror of individual existence and change, the web of cruelty which binds life to life, are essential to creation, essential to bliss, the whole purpose of the cosmic sexual act. In all of these minutest phenomena lies the purpose of the Great Whole. The successful sādhaka is thus not someone who has eliminated appreciation and value of phenomena from his life, but one who is totally aware of them and has elevated their meaning to the highest degree possible. He does not see 'God in everything' as base pantheism might claim; but he should know that every smallest

170

phenomenon, with all its infinite network of causal and structural relations to every other – including those which human faculties cannot read – is essential to the existence of the Great Whole, and therefore of infinite value. The suffering of animal existence is integral to the showing of the Lord to Himself in the discursive Mirror of His energies, which is realized when the diffracted consciousnesses of separate selves can be induced to become aware of what they are. Saṃsāra equals Nirvāna. There is thus nothing which cannot be grist to the Tantrika's mill. All this is implicit in the true value-system of Tantra; but it is still particularly hard for Indian Tantrikas to realize; all their natural modes of thought, feeling and expression obscure it. Here is where a modern and enlightened syncretism might help.

Tantra is esoteric and much of it was always kept secret. In addition its functions and imagery are, so to speak, simultaneous and totally interdependent.

It can be approached from two distinct points of view: as a ladder of Genesis, leading down from an ultimate unknowable origin; or as a ladder to be climbed in the opposite direction, from the created world towards an ultimate goal. Goal and origin are identical. This book will take the path the Tantrika himself takes, by ascent towards origin through sādhana, the psychological and bodily effort and mechanism which are the Tantrika's constant concern.

In fact, all visions of a Genesis amount to the presentation in reverse of what was initially an intuitive insight towards ultimate origin. And since any such intuitive view was discovered first by visionaries who ascended the ladder of their own conceptual and imaginative categories to the limit of possible meaning, it is perhaps more reasonable to take the approach of 'ascent'. In this way the high abstractions near the goal will retain their full wealth of content, and there will not be so much risk of them seeming 'empty'. Hinduism recognizes anyway that Genesis is a permanent condition necessary for the continuing existence of the world, not just a once-for-ever making. Whenever Tantra uses words denoting succession in time, such as 'first', 'last' and so on, it is referring to a relationship in the order of continuous existential hierarchy, which have no real temporal implications.

Pūjā is the root activity in all Indian ceremonial. It is done at specified times each day, and on special occasions. It means in a general sense 'worship', but there is far more to it than that. Pūjā is active. It involves the making of offerings which are far more than a mere giving. The basic idea is that of sacrifice; only things in some way valuable can serve as offerings, and the recipient of the offering is normally made visible in some symbolic form such as an icon. In India the usual things offered are flowers, incense, perfumes, lights, bells and music, choice food, valuable cloths and ornaments. The ritual actions of pūjā involve seating the image, welcoming the devatā into it with appropriate gestures, washing its feet symbolically, as if the devatā had come a journey, making the offerings, sipping and offering water, anointing the image with honey, liquid butter, milk or curd, smearing it with red powder, bathing the image, and perhaps adorning it with cloths and jewels, as if it were

6, 7, 33–4

31

47

35

a supremely honoured visitor. Flowers in the form of garlands may be used in the welcoming.

A simple sacred object or icon may be distinguished by being painted red, either all over, or with stripes and dots; it may be sprinkled with water, and, most important, it may have melted butter or oil poured on to it. The implements used in pūjā are often elaborated artistically. At public shrines and temples the pūjā is usually done thrice daily by official pūjārīs, on behalf of visitors, with special ceremonial on the occasion of some festival. Pūjā can also be seen as a modified descendant of ancient animal sacrifice, called in the Veda 'Yajña'. In some Tantrik temples animals are still sacrificed (e.g. at the Kālīghat, Calcutta), and there are references here and there to human sacrifice, which was certainly performed even during the twentieth century. In the pūjā which forms the basis of sādhana, however, animal sacrifice may sometimes be symbolized only by the offering of small copper plaques which are shaped in repoussé with forms suggesting butchered animals.

32

The most important point in Tantrik pūjā is that the symbolism of the whole ceremony is taken over and applied by the pūjārī to himself, through an intense meditation on the significance of each act as he performs it. It thus becomes the central occasion for and element in the whole of Tantrik meditation, and is especially effective if it is done at some significant time, such as an eclipse. Before he begins he should have gone through the yogic processes described later in the book. The 'honorific' aspects of garlanding and anointing, which again he may do to himself, are imbued with a sense of their archaic significance. Both indicate that the pūjārī, in performing his act, is proclaiming his recognition that the divine power resides in the symbolic recipient, which may also be himself. The garland signifies the power of blossoming continuity, an unbroken stem filled with plant-juice;[6] the anointing is an externalization of the oil of divinity, a widespread image in humanity's ritual customs. Because of the equation of body and cosmos discussed earlier, Tantra sees both of these as outward acts realizing inner attributes of the pūjārī; and in practice all icons which present themselves face to face with the worshipper invite him to identify himself with them.

33

This self-identification is taken further. One group of the offerings is intended to represent the five senses whereby a man differentiates, constructs and explores his world. When these are offered to the divine principle residing in a recipient icon it amounts to a complete symbolic abdication of the pūjārī's sensuous nature, by dedicating it utterly to the trans-human. His nature becomes thereby transmuted. The commonest group of symbols representing the senses of sight, hearing, touch, smell and taste used in pūjā are, respectively, flowers, bells, cloths, incense and food. At the bottom of Tibetan Buddhist paintings, however, one often finds depicted a cruder emblem of the sacrifice of the senses in a little heap of chopped-off human eyes, ears and hands, nose

1

29 Incense-burner shaped as
a tree of life composed of
serpents. Rajasthan,
18th century. Bronze, h. 21 in.

30 Ceremonial water-pot.
Rajasthan, 19th century.
Brass h. 11 in.

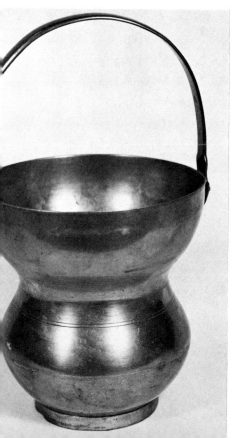

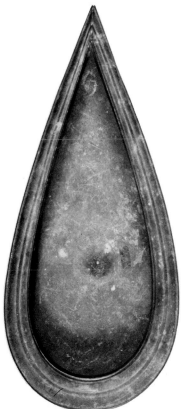

31 Holy-water container in
the shape of the yoni.
Bengal, 18th century.
Copper l. 12 in.

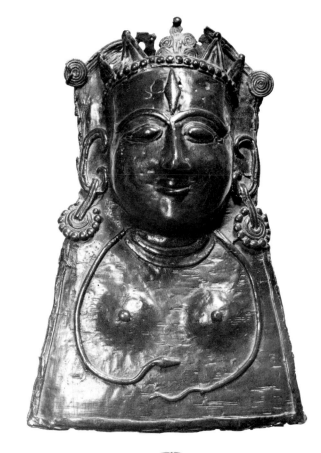

32   Symbolic offering with flayed bull
motif. Nepal, 18th–19th century.
Beaten copper 7 × 5 in.

33   Mask of Kālī to receive worship.
Kulu, 16th century. Bronze
h. 11 in.

34   The Goddess Jagadambā, an image meant
to be dressed and adorned with jewellery.
The name means 'Mother of the World'. Bengal,
18th century. Eight metals h. 15 in.

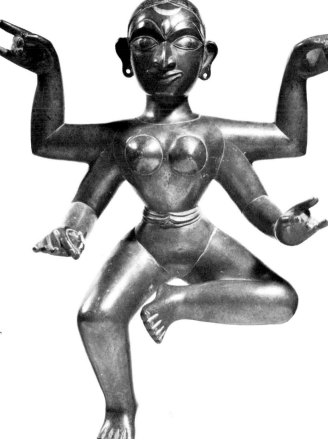

35 Icon of the liṅgaṁ (phallus) set in the yoni, the standard emblem of the double-sexed deity as used in shrines as principal icon; pūjā offerings are laid on it, and the honorific umbrella is broken. Kangra, Himachal Pradesh, 18th century. Gouache on paper 5 × 4 in.

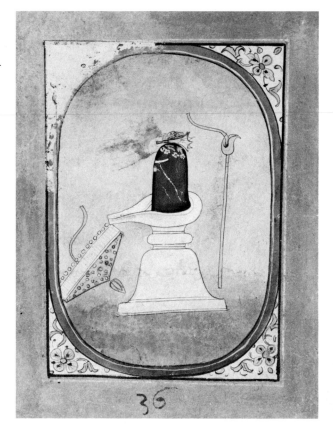

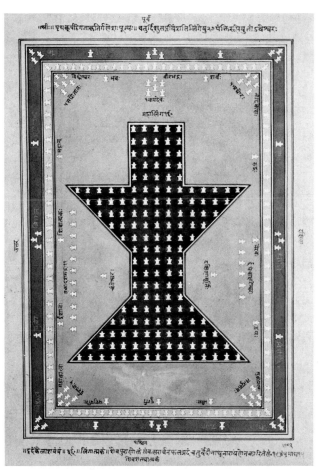

36 Painting illustrating the relationship of all lesser liṅgaṁs to the Great Liṅgaṁ. Rajasthan, 18th century. Gouache and silver on paper, 14 × 10 in.

37  Relief yoni emblem, stained
with coloured pūjā powder. South India,
19th century. Carved wood 8 × 7 in.

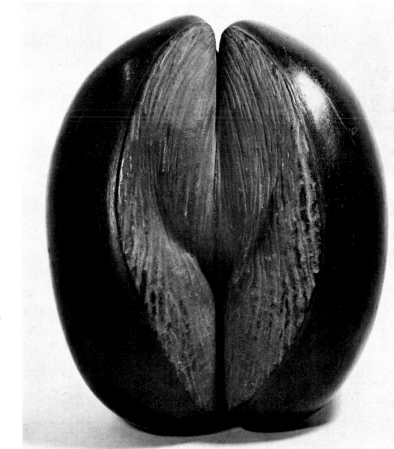

38  Coco-de-mer, serving as emblem of
the yoni of the Goddess. South India,
19th century. Coconut shell, h. 17 in.

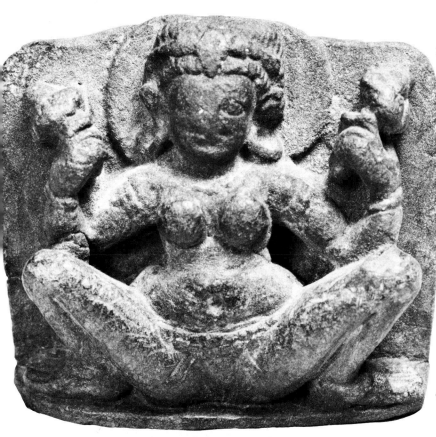

39 Image of the Goddess as genetrix of all things, displaying her yoni. Northern eastern India, *c*. 600. Provenance unknown. Stone h. 4 in.

40 Icon of the Goddess as genetrix of all things displaying her yoni for pūjā. Hyderabad, 11th century. Stone, from a temple.

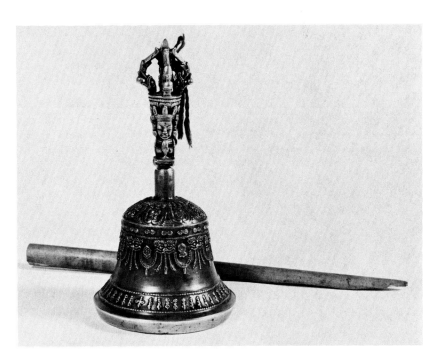

41  Meditation bell, handle worked
with vajra motif and face of the
Bodhisattva Avalokiteśvara, whose r
rubbed with the stick produces a
continuous hum. Tibet, *c.* 1800.
Silver with bronze h. 7 in.

42  Brocade fabric woven w
invocations to Durgā. Banaras, 1
century. Silk and gold 85 × 92

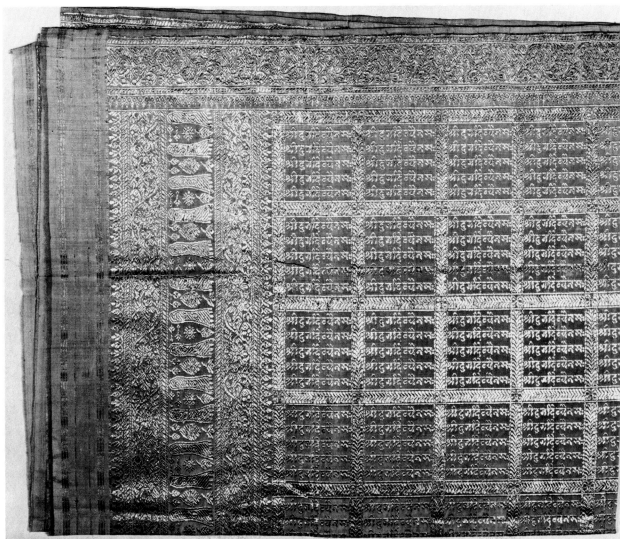

43   Garland of letters, as a yoni-shaped rosary. Rajasthan, 18th century. Gouache on paper 11 × 8 in.

44   The letters of the Sanskrit alphabet, for meditation and worship, as the sound-root of all divine knowledge. Rajasthan, 19th century. Ink and gouache on paper 11 × 9 in.

45   Image of Śiva and the Goddess Annapūrnā, drawn entirely with mantras. Bengal, 19th century. Ink on paper 16 × 12 in.

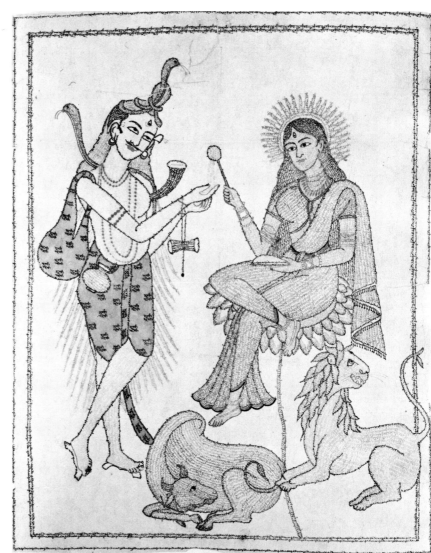

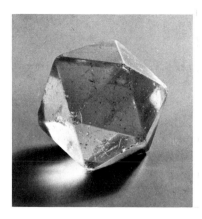

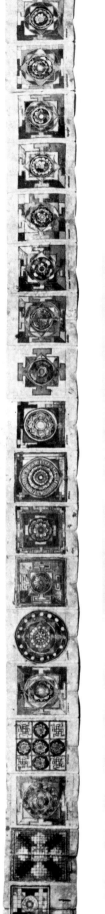

46 Tetrahedron of rock crystal, whose triangular facets condense the significance of the Śrī Yantra, used for meditation. Tibet, 18th century.

47 Manuscript illustrated with a long series of maṇḍala yantras, designed to be used in sequence. Nepal, 17th century. Ink and gouache on paper 220 × 9 in.

48 Hindu-Buddhist yantra, combining the symbolism of the Hindu devatā yantra with Buddhist stupa symbolism. Nepal, 18th century. Bronze 6 in.

49 Śrī Yantra. South India, c. 1700. Copper plate 6 × 6 in.

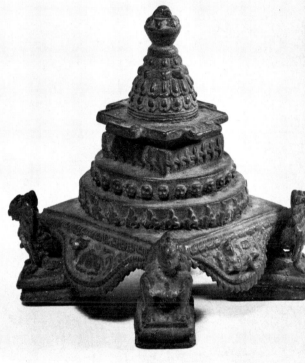

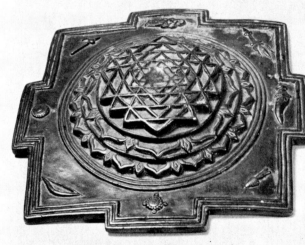

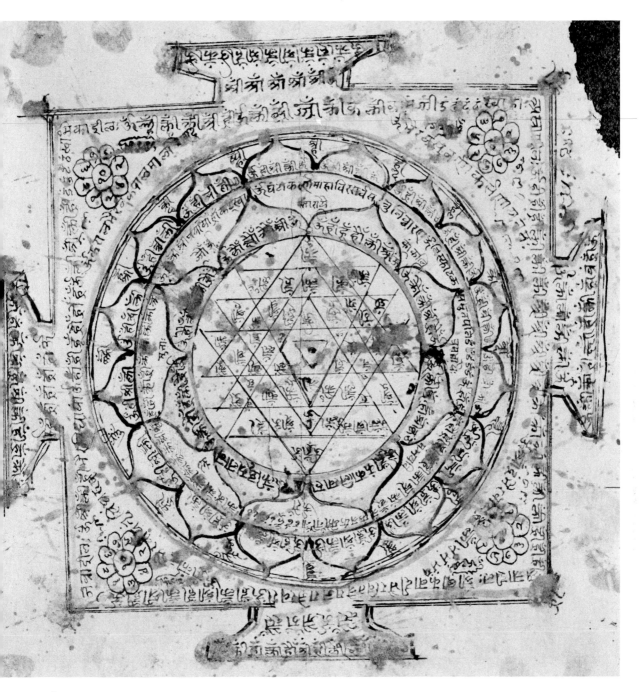

50 Śrī Yantra, with mantras, bearing thumb impressions in red of gurus, by which the yantra was re-activated. Rajasthan, *c.* 1800. Ink and colour on paper 9 × 8 in.

53  Kālī yantra. Rajasthan, 18th century. Gouache on paper 7 × 7 in. >

54  Yantra. Nepal, 17th century. Gouache on paper 8 × 8 in. >

51  Meditation-cards, painted with symbolic yantras. Rajasthan, 18th century. Gouache on paper each 4 × 2 in.

52  One of a set of fifteen diagrams of planetary time. Rajasthan, 19th century. Ink and colour on paper each 11 × 7 in.

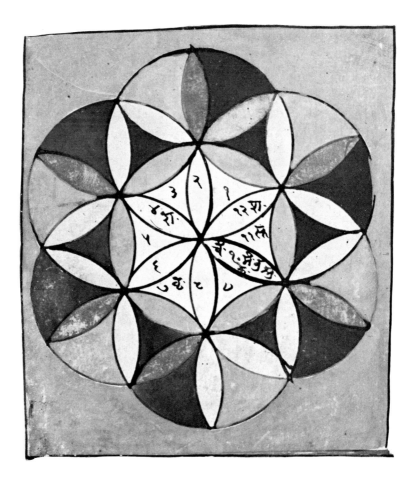

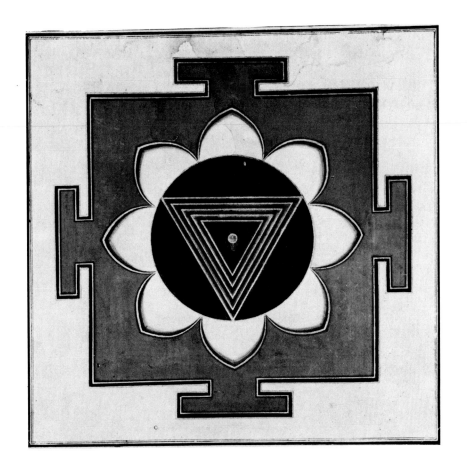

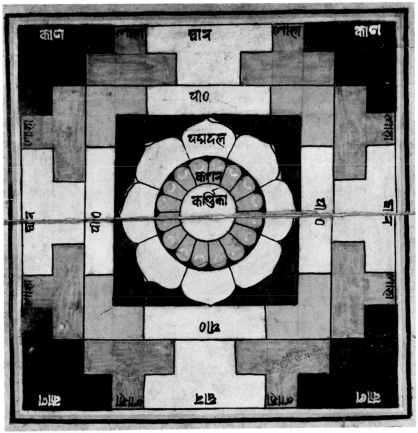

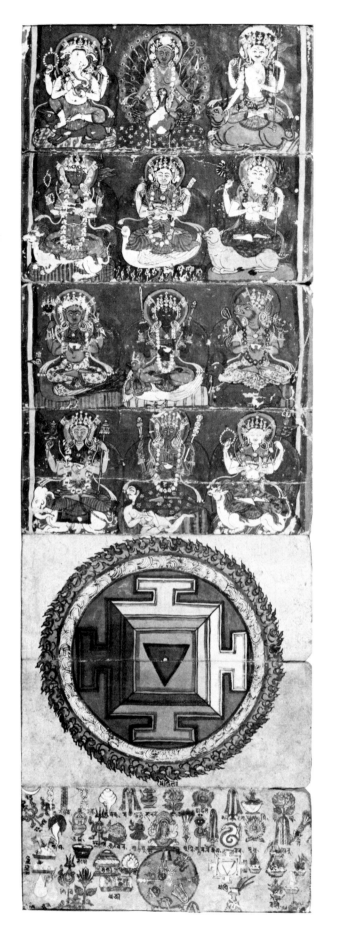

55 Yantras, from a Hindu painted book, with figures of devatās. Nepal, c. 1600. Gouache on paper 22 × 8 in.

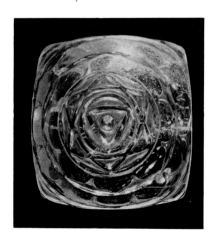

56 Śrī Yantra incised on rock-crystal, for meditation. Nepal, 18th century. 2 × 2 in.

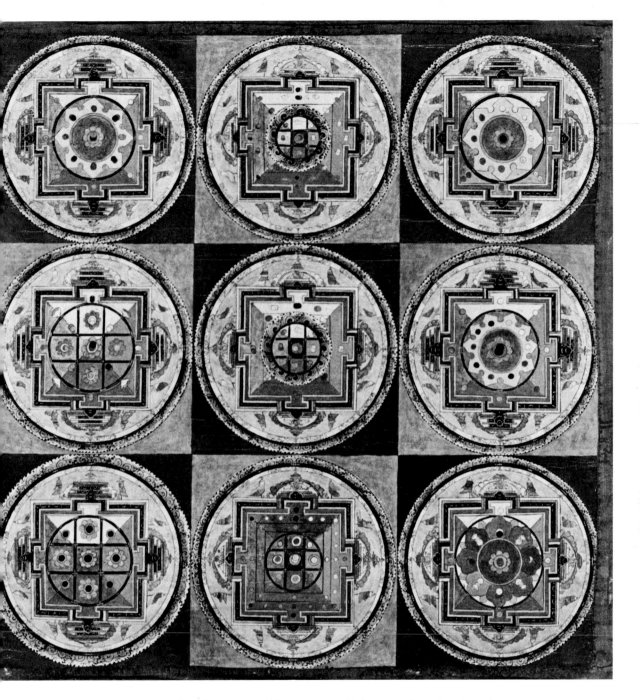

57  Tanka painted with nine maṇḍala-yantras, which are meditated on in series to produce a special condition of consciousness. Nepal, *c.* 19th century. Ink and colour on paper 22 × 22 in.

*(Overleaf)*
58  One of a set of seven maṇḍala tankas, part of a meditational series (see also *Ill.* 66). Tibet, *c.* 1800. Gouache on cloth, 28 × 19 in.

59  Tanka with five maṇḍalas. Tibet, 18th century. Gouache on cloth, 57 × 38 in.

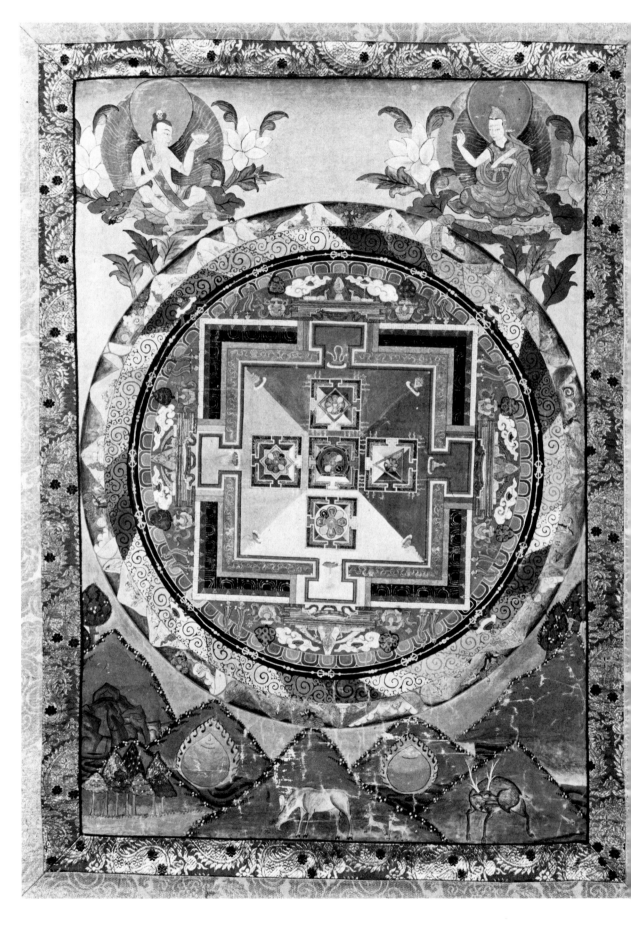

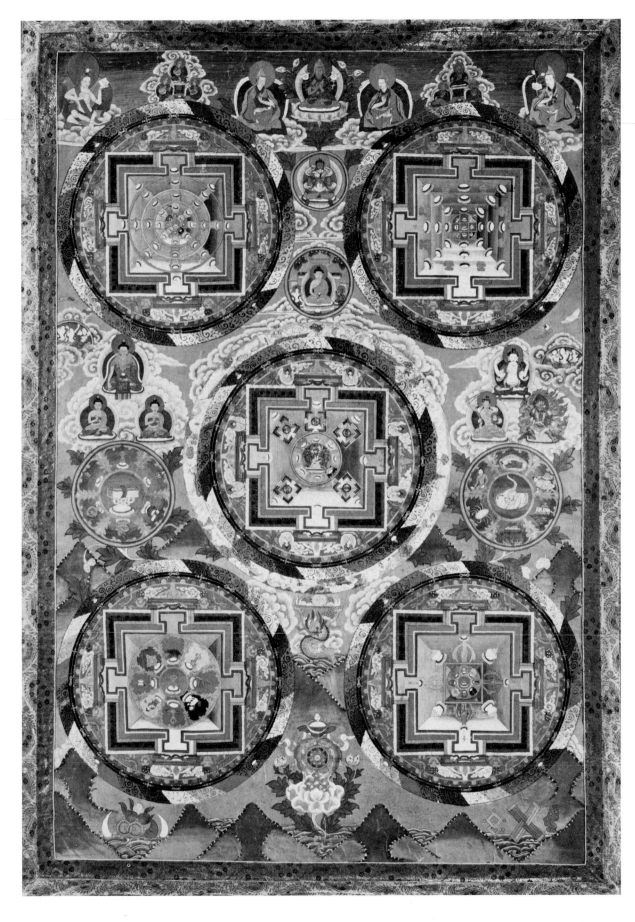

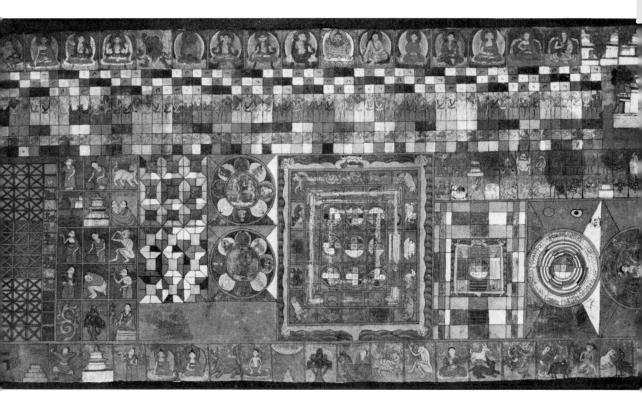

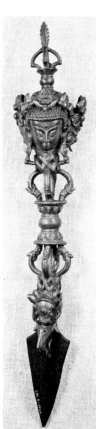

60 Buddhist yantra, incorporating a computatio board. Nepal, c. 1700. Gou on cloth 14 × 29 in.

61 Vajras, symbols of Tantrik Buddhist Truth. India, Tibet, Nepal, China various dates. Metal, varyi sizes (3–9 in).

62 Phur-bu, or spiritual dagger incorporating the power of the mantra Hūṁ Tibet, 18th century. Bronze h. 19 in.

63 Buddhist initiation car with Hūṁ at the centre. T 19th century. Paint on clot 4 × 4 in.

and tongue laid in a skull-cup full of blood. These, needless to say, refer not to an actual but to an imaginative act of self-butchery. Innumerable works of Tantrik art contain references to basic pūjā, from the garlands used as picture frames to the colours associated with the senses. The list of these varies somewhat, but one common group is (following the order of the senses given above) blue, white, yellow, red and green.

The vessels and implements used by Tantrik pūjārīs are often themselves worshipped as devatā, emblematic of the activities of the transmuted self. Certain paintings make the point very clearly, by giving these objects eyes, and even rudimentary hands. The water pot is probably the commonest devatā substitute. In pūjā it is covered with mango leaves and a green coconut, whose stem is painted vermilion, and set behind a diagrammatic representation of the devatā who is intended to take up residence in it.

10, 30

In fact there are many symbolic objects and substances used for special pūjā rites listed in the many Tantra texts. They differ according to the devatā worshipped and the reasons behind the rite. And during prolonged meditative rituals, when many different devatās are invoked, each one may require its own act of pūjā, either external or internal.

The way outer worship is converted to inner is described in the Gautamīya Tantra. After evoking the image of the Goddess in the heart-lotus, you should 'dedicate your heart as the [devatā's] lotus-seat; give divine nectar from the Sahasrāra lotus [in the crown of the head; see p. 167] as water to wash Her feet. Give aether as Her clothing, the principle of smell as perfume, the mind as flower, the body's vital energies as incense, the principle of light as lamp. Give Her the ocean of nectar as food, the inaudible heart-sound as bell, the principle of air as fan and whisk; give the activity of sense and the agitations of the mind as dancing. To realize divine thought, give these ten different flowers [of the spirit]: freedoms from delusion, selfishness, attachment, insensitivity, pride, arrogance, hostility, perturbation, envy and greed. The supreme flower of non-injury, the flowers of control of the senses, of pity, forgiveness and Knowledge.' All these comprise the fifteen inner sentiments that should be offered in pūjā.

Tantrik ritual is developed from pūjā, and pūjā is addressed to a recipient. All Hinduism uses images or icons of one kind or another to receive pūjā. Indians have always been ready to recognize the holy everywhere about them. Their named gods can appear at any time, anywhere; and their whole countryside is scattered with objects in which the divine shows itself in ways and for reasons which local tradition alone can explain. These hallows receive pūjā, in the form of simple, maybe even casual offerings. At the humblest level the hallows may be a little cluster of red-painted stones in the corner of a field, or a big boulder on a hillside, one of whose faces is painted red; village men and women may deposit before them a few handfuls of flowers or squeezed balls

of rice. As well as the general sacred spots in the countryside, a village may have its own special hallows in the form, say, of a gnarled and desiccated sacred tree, an old anthill, or even an ancient broken sculpture dug up from the fields. The art-made images in temples of all types and sizes fulfil the same function, forming a focal point where the world of everyday spread-out reality and the world of concentrated truth meet.

Hindu Tantra does much the same, save that its images are overwhelmingly based upon the germinal idea of the two-sexed divinity described in Chapter 1. This is the place where Tantrik ideology strikes root into genuine popular and ancient custom. It is impossible here to draw a hard and fast line between general Hinduism and Tantra. For the commonest icon in Indian temples is the liṅgaṁ, a phallic emblem that displays the male sexual energy for which it is a symbol as the analogue of cosmic divinity. It occupies the 'womb cell' in the temple, while the outer structure of the temple displays the feminine creative function. At the same time there are also innumerable temples and festivals focused around images of the Goddess. Tantra takes these public images as the most outward manifestations of its cult, adapting and transforming them for more personal use. And since the feminine aspect of the deity is responsible, in the eyes of the Tantrika, for the activity of creation, it is the feminine, the cosmic Śakti or power-energy, which offers him the best approach to his goal and origin by sādhana. The masculine partner in the deity is felt to be more remote, buried within the feminine, attainable only as a final achievement. Hence the images upon which Hindu Tantra concentrates are images of the female. The masculine element plays its part, as we shall see. But Hindu Tantrik pūjā is usually addressed primarily to one form or another of the Goddess.

Such forms are felt to be powerful channels through which love can operate. If one begins by loving a living creature one can end only in love for a living creature. But if one addresses one's love to an image, which is merely modified material signifying devatā, one can end in love for the Devatā. And since the activity of pūjā is only a preliminary to, not a substitute for, genuine meditation, an image which is beautifully and correctly conceived can supply a visual pattern for meditation. By concentrating on the actual icon one can awaken its inner image in the mind for inward meditation and worship. Since, as we have seen, all Tantra art has about it something of yantra, the formal attributes of a good image are all metaphors for attributes of the Devatā itself, who is the intermediary between the worlds of reality-extended-in-time and the Formless Truth. No physical image can thus be any more than a reflection of the true transcendent image whose sphere of existence is the MIND-mind. What one worships, that one becomes. Most Tantras contain brief schematic descriptions of the attributes of the principal devatās, including the high Goddess herself and the figures which symbolize Her many distinct functions.

35, 36

The descriptions are meant to help both those who wish to make and use outward images as well as those who need only to be reminded of the formal attributes of images which they will inwardly realize in their own meditation. Among many Tantrikas it is customary to make temporary images which can be disposed of at home or thrown away into water, so as to prevent what the physical eyes have seen impeding the transformation of the visual image into an inner presence.

The author of the Tantratattva describes the ideal condition: 'whenever or wherever I look', he says, 'within or without, I always see the Goddess, whose substance is desire, as Bhagavān [male] or Bhagavatī [female] [Bhaga means both vulva and wealth] in whatever form she is pleased to appear. I see my mother, the crazy girl [beautiful as a sixteen-year-old], dancing with gentle movements of her body, taking up in turn the flute and the sword, mingling her laughter with her dancing, binding up and unbinding her hair [symbolic of creation and dissolution] . . . Who in the three worlds has the power to break this image to which my heart is fastened with so deep a love?' The outer image with which you are concerned is nothing but a reflection of the real one. So long as the real image remains unbroken, what does breaking its reflection matter?[7]

Buddhist Tantra may seem to take a different attitude. Certainly it has no precise equivalent to the outer image to which pūjā is addressed by Hindus, and the idea of Śakti as power is displaced. Buddhist Tantra, although it has produced an immense volume of superb art, always makes the proviso that its devatās are purely 'mind-originated'. The fundamental difference between Buddhist and Hindu doctrines is here brought out into the open. Hinduism says that behind every image or reality there is 'something' which can be called by the names of devatā, each appearance sliding easily into others up the scale from grossest fact to unimaginable Brahman. Buddhism, on the other hand, uses assertions that where we think we see something we see in truth 'nothing'. It refuses any positive statement, cancelling every provisional expression as ultimately empty of meaning. It aims at a state of mind devoid of any normal existential content whatever. A Hindu image is thus a pointer, however crude, to an ultimate positive truth; a Buddhist image is a device for emptying the mind on its way to the void fullness of Nirvāna, which is empty of any existential thought.

Indian Tantra, however, does recognize a fundamental community of aim between the two cults which Tibetan Tantra denies. Recent Buddhism, despite the way it uses images, tends to make the same mistake about Hindu images as Western missionaries made, confusing Hinduism's positive attitude to them with the 'worship of idols' – something which has probably never existed anyway. Monastic Buddhism has always tended towards puritanism and what has been called in Chapter 3 sexual miserliness. The female is

certainly there as an important element in Buddhist Tantra, as will be seen in Chapter 10. But because of its interest in positive imagery it is Hindu Tantra which shows the female complex most clearly and completely.

There has been much argument among scholars as to the genuineness of the ancient conception of a 'Mother Goddess'. The outcome of the case[8] is now pretty well accepted. The idea of a generically female creative womb, mother of beasts, plants and men, which is a complex analogy between the earth, its caves and the human community of women, seems to have taken root in the mind of man probably by about 30,000 BC. This whole womb-complex was often symbolized by signs referring to the outer appearance of the human vulva, as in numerous emblems and objects from the European palaeolithic caves. Indian Tantra preserves this symbolism, alongside its own anthromorphic images of the Goddess. The Tantrika who makes pūjā to one of the many small icons of the female vulva (called yoni) is making it to that all-embracing creative energy for which the yoni is the symbol. Ritual objects may also be made in the shape of the vulva, or decorated with surface designs of the same shape. Objects which combine striking visual or tactile effects with a vulva shape are used in the same way. The coco-de-mer, from the Seychelles islands, which is sometimes washed ashore on the coast of India and regarded as sacred, is a most beautiful example. Spiral shells too are widely recognized as a symbol of femininity, creation and growth, and are adopted in Buddhist Tantra as symbols for the root-mantra 'Oṁ'.

The association between the vulva as icon and the anthromorphic female is stressed by a sculpture which illustrates Indian practice. It represents a pūjā altar in the form of a female figure with her legs spread apart to display the vulva. This will connect at once in most people's minds with the figures called 'Sheila-na-gig' from Irish and Welsh churches, which represent the survival of a similar idea, much degraded in Western culture. (So, too, does the horse-shoe over the door, for 'luck'.) Other sculptures in Indian shrines illustrate devotees literally worshipping the vulva of the Goddess.

37

31

38

176

40

3

'Mantra' is one of the most important elements in all Tantrik ritual. The nearest parallels in English to the meaning of the word are 'spell' or 'charm'. But these words, which are anyway degraded in our own speech, have many deficiencies and unwanted extra meanings. So here the word 'mantra' will be used un-translated.

A basic mantra is a single syllable, commonly ending in a nasal ṁ, sometimes k or ṭ. A complex mantra is made up of a series of these syllables, perhaps forming the abstract of a phrase with a known prose sense. Some are pure sounds in their own right; the best known is the ancient Vedic 'Oṁ'. Others are the first syllables of the names of devatā, perhaps slightly modified and given the ṁ or other ending. Four chief types are generally recognized.

174

A mantra is felt to be a sort of nucleus or gathering point for energy, a concentrated form of cosmic power. To utter one correctly (which needs patient study and effort) evokes from the interfused structure of man and cosmos the specific force to which it is related. Agehānanda Bharati has pointed out[9] that the ordinary Indian, faced with a demand on his strength, will utter a mantra under his breath; as when, say, he picks up the shafts of a heavily loaded cart. The mantras which concern us here, however, are those with a ritual purpose. They may be recited either voiced or voicelessly, thousands of times over in what is called 'japa', so as to produce a cumulative stream of energy. On cloths mantras may be woven or printed many times over, as a visual equivalent to japa. A single mantra may focus more intensely energy which has been previously crystallized into a grosser or more bodily representation. Raṁ, for example, is the 'Fire' mantra, Hṛīṁ, a heart mantra, based on the Sanskrit word 'Hṛidaya' for heart, used when the heart-energy of a devatā is to be evoked. 'Klīṁ' condenses the energy of sexual union.

42

Mantras are supposed to work by each creating its own special kind of resonance in space, in the realm of subtle sound or vibration, called Nāda, discussed in Chapter 12. And, since a most important aspect of Tantra is its interest in patterns of vibration, there are Tantras which are devoted almost entirely to mantra and the science of sound. Just as all devatās are held to be relatively gross modifications of an original hidden double-sexed principle, so all mantras are held to be modifications of an original, underlying vibration

41

which sustains the whole energy-pattern of the world, and which is another form in which the principle can be recognized. The mantra nearest to the root-vibration is 'Oṁ'; meditation bells are made which produce a sound of equivalent value when their rims are continuously rubbed with a wooden stick. Devatās and cosmic forces may be evoked by uttering their mantras, inducing them, for example, to take up residence in sculptured or painted images. Every ritual has its set of appropriate mantras, which must be spoken in the right tone of voice in the right order at the right time. Some are especially sacred, and kept secret. But all Tantras include instructions for using them. So pieces of Tantrik ritual equipment are often marked with one or more of the mantras which are to be uttered when they are being used. The energies concentrated by mantras can be directed to specific magical purposes, including healing, obstructing enemies, causing the crops to grow or attracting a necessary woman.

44

One important reflex of the whole idea of mantra is a Tantrik theory about the Sanskrit alphabet itself. Since cosmic energies are reflected in the world of sound through syllabic mantras, an extension of the reasoning suggests that the root-syllables out of which the *words* for all things, qualities and functions of the world are made up, i.e. the alphabet, are a root-form of the named cosmos. And, since virtually all the letters have a mantra–deity anyway, the Tantrika looks on the whole alphabet of his sacred Sanskrit language with a special reverence. He calls it 'the necklace of letters' which the Great Goddess wears, symbolizing her creative activity as sound, the gross form of her subtle vibration (see Chapter 12). This conception is often illustrated in art, the necklace itself being shaped like the female vulva (yoni), emblem of the creative source of reality, whose significance is amplified later on. Furthermore, the individual letters of the alphabet are characterized according to their emotive and operative effects: mantras themselves may be cruel, benevolent or indifferent according to their components. Mantras with an excess of 'aetherial', 'fiery' or 'airy' letters are cruel. Mantras with more 'earthy' or 'watery' letters are benevolent. But Tantra never suggests that it is possible to use mantras in a merely mechanical way, as crude magic. It repeatedly points out that: 'The sounds which are uttered are not by themselves mantras. The proud gods and celestials were deluded by this false idea.'[10] For 'the immortal Śakti is seen to be the life of mantras. Devoid of Her they are as fruitless as an autumn cloud.'[11] And 'a mantra without Śakti cannot exist. Both flow from knowledge, and cannot exist separately.'[12]

43

Related to mantra is 'yantra', a word for which there is not even the remotest parallel in English. The function of yantra in the sphere of the visible is analogous to that of mantra in the sphere of sound. As mantra is a nucleus of sound by means of which cosmic and bodily forces are concentrated into ritual, so yantra is a nucleus of the visible and knowable, a linked diagram of lines by

means of which visualized energies are concentrated. Mantra and yantra complement each other, and are used in conjunction. A yantra may look at first sight like an abstract design. But what we may call its 'abstraction' is the effect not of its indicating an abstract concept for a mental class-relationship, but of its concentrating concrete, formulated energy. Its 'patternness', like the stylized syllable of mantra, is the essential element of its force; its spareness is not the result of generality, but of condensation of energy and content. It provides the focal framework for acts of meditative visualization. All Tantra art thus has in it a special element of yantra. It provides the relatively 'gross' forms which point forwards and evoke the 'subtle' forms of mental imagery, and cannot be mistaken for anything but what they are. The wide-ranging meaning which is compressed to a high degree of density in the purest yantra is at first synthesized and fed into the sādhaka's mind through the more expansive art and diagrams, with their elaborated symbolism, which will be illustrated later. To use yantra thus involves a continuous meditative dialectic in which content and concentration drive each other to a higher pitch of intensity. This is one of the ways in which the psycho-cosmic mechanism is worked. And it is also one of the aspects of Tantra art which appeals most to people who have become disillusioned with the vapid conceptualism of much modern art. Tantra knows, and has long used, reductive methods and optical effects. But it has used them synthetically, to concentrate an emotive and psychic content, not analytically, to refine abstractions whose only meaning is their relation to other abstractions.

Yantras may be made of many different materials. The human body itself is often called 'the best of yantras', for reasons which will become clear in Chapter 10. But artistic yantras may be made with coloured pastes or powders on the floor in front of the seated sādhaka; they may be drawn or painted on paper either to be kept permanently and re-used, or remade for each occasion. They may be made in permanent form of many substances; the most important is rock-crystal, which has a symbolism of its own. Its clear colourless substance, which can be shaped so as to focus light at its apex, is a very good emblem for the all-inclusive substance of fundamental reality; just as colourless light includes all the possible colours of light, so crystal can serve as analogy for the substance which includes all substances. In Tantrik Buddhism the terms 'maṇi' (jewel) or 'vajra' (diamond) have a related significance. Red copper is also used especially for yantras with a female significance. It must also never be forgotten that the ground-plans of most Hindu, Jaina and Buddhist temples are also yantras (see illustration p. 73).

Diagrammatic yantras are usually centred on a single point, the point upon which meditative concentration can gradually gather and fix itself. 'One pointedness' of concentration is a necessary achievement for any sādhaka before he can even begin to make any progress. But the yantras illustrated here

51

are also icons, subtle bodies of devatās, bodies from which the gross physical resemblances have been eliminated in favour of the higher, more inclusive imagery of linked energies. When the mantra-utterances of power inscribed on it are correctly recited the yantra itself becomes infused with the actual presence of devatā; its own physical nature is lost; the devatā, so to speak, floats up off the surface of the physical object and expands within the mind and body of the sādhaka as a dense complex identity, the presence of which alters his whole nature. Such yantras may be used alone on single occasions or in series during prolonged meditative rites. They may be used to invoke the subtle bodies of devatās to receive pūjā, as an intermediate step between using the gross representational images of male and female and using purely internal images. In practice, only extremely advanced sādhakas can grasp the true forms implicit in yantra and mantra. For this reason most ordinary Westerners will not be able to grasp them intellectually; even in India the true nature of yantra is normally kept as a secret which can only be indicated verbally between sādhakas, and is never written down. Perhaps the most subtle yantras of all are those which provide only a blank space on to which the meditator has to project his own familiar inner yantra.

There are, however, certain things which can be explained. First is the obvious fact that it takes a great deal of time and effort to build up the content of the imagery stored in any yantra-mantra complex. The realities referred to in condensed patterns of sight and sound can become readily available to the mind only after long practice. To simplify, it is, in a way, like learning an extraordinarily complicated alphabet and vocabulary at once. Then again when a yantra is to be used on any given occasion it takes extreme concentration over a long period of time to build up the presence of the devatā by means of the mantra-schemes which are its subtle anatomy. The subtle devatā present in the sādhaka's body may be persuaded by a long yogic process to emerge in subtle form from his nostril, and take up residence in the yantra.

Second, the general pattern followed by most, if not all, yantras tends to be constant. Around the perimeter is a square pattern of re-entrant 'gates'. This represents the 'enclosure' within which the meditating self is shut (what Jung called the 'temenos'); the successive circuits inside that represent successive 'sheaths' or stages of inwardness, the multiple outer petals or triangles being occupied by 'grosser' forms of energy, which are absorbed and further concentrated in the less multiplied inner circuits. The centre is the point where all the original radiating energies are finally focused, usually in a single mantra such as 'Oṁ' or 'Klīṁ'. The mantra-identities in all the basic circuits may also be represented in anthropomorphic shape, as devatās. In the great Śrī Yantra, the most important of all Tantrik yantras, each of the outer triangles is occupied by the devatās which represent the subdivided energy-self of the Goddess.

65

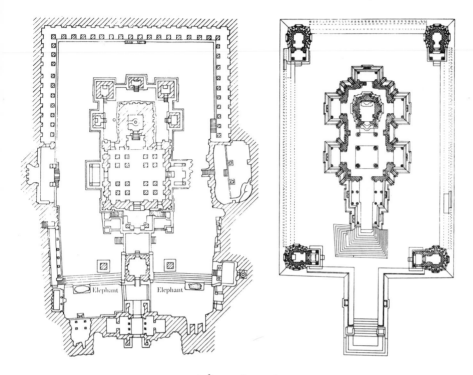

*Ground plans of Indian temples, which are themselves yantras*

These Nityās ('eternal ones') or Mahāvidyās ('greater wisdoms') may actually be presented in human form. They are listed in Chapter 8. Each of these lesser goddesses may have her own yantras as well: which fact will give some idea of how important and difficult the whole matter of yantra is. Some of the lesser yantras are obviously segments out of the all-embracing Śrī Yantra.

Although, of course, yantra has the typical Tantrik double aspect, the Śrī Yantra is best explained from the point of view of Genesis. In meditation it is used in the *reverse* direction, serving to focus from the outer rim into the final 'point' or dot all the sādhaka's realizations of cosmic energy. But since this great yantra is the very image of the process of creation, metaphysically sexual, to penetrate it is to intuit the whole underlying Tantrik metaphysical idea. The description which follows is based on that given in the Kāmakalāvilāsa, translated as an appendix (p. 198). Taken in conjunction with the Sāṅkhya diagram (p. 182) these add up to a 'definition' of the Goddess.

The dot, or biṇḍu, at the centre indicates the invisible first principle, the self-originated seed of Being and consciousness which, strictly speaking, can never be visible or imaginable. From the side of man it is the point of final dissolution. From the side of creation its first act of projection consists in splitting itself into male and female; these are the visible dot and the smallest

50, 56

enclosing downward pointing triangle. As the ancient and most sacred Bṛihadāraṇyaka Upaniṣad (*c.* 1000 BC) says: 'He was alone: he did not enjoy: one alone does not enjoy: he desired a second, and became like a man and woman in close embrace. He made this self of his into two. Therefrom came husband and wife.' Then later: 'He desired, let my wife be: may I be born as many: may I possess things: may I perform acts: this was his desire.' The past tense here signifies not priority in time, but ontological or existential priority. To the Tantrika creation is continuous act. So the form the desire (Kāma) takes is the shape of his female moving identity, making the world for him to enjoy as Bliss, Consciousness and, of course, Being. The dot as its first act of motion traces the triangle which is the original form of the generative yoni (vulva) of the Goddess, the first expansion of space and time in act, a trinity which can be seen in another guise in the icon of Chinnamastā.

86

There is thus 'in existence' at the first stage of creative evolution a dot inside a downward-pointing triangle. The next stages consist in the generation by this couple of four pairs of triangles, each pair having one pointing up, the male, the other down, the female. The innermost pair themselves appear sometimes with an encircled dot inside as the yantra of Bhuvaneśvari, the second of the Hindu Mahāvidyās. All represent the 'going forth' or expansion of the nuclear light-energy from within the first triangle, the 'flash' and its 'developed reflection' (in Sanskrit called Prakāśa and Vimarṣa). The interlacing of the five original female and four male triangles generates the circuits of other triangles in which the range of varied forms of consciousness and creation jointly emerge to shape the whole of the moving world and its history in time. The dance of luminous energy is represented in icons at certain shrines whose essential features can be visually paralleled by modern photographs of particles in cloud chambers. It is characteristic of Indian artistic thinking, though, to express time-patterns by a closed system of stylized enclosures in flat colours. Chinese tradition, for example, expressing its own concept of creative motion in time and space, the Tao, emphasized an endlessly unrolling, never repeating, continuous change as the fabric of the world. In the Tantrik context, however, one must not forget that the motive force underlying the whole process is a transcendental Desire, which justifies the sexual undertone. Desire creates its object as cosmic desire created the world. Desire multiplied creates many objects. Withdrawn and focused on the Void of Ultimate Reality it becomes a special inner radiance known only to the Tantrika.

102

57–60

Buddhism uses yantras, on the whole, in a less developed way than Hinduism. All of the maṇḍalas of devatās discussed under the heading of the subtle body (Chapter 10) are, in effect, yantras, and the devatās may be represented in meditation only by their mantras. The use of mantras in various patterns is one of the few Tantrik techniques to have survived in the Buddhism of China and Japan, being cultivated by the Hua-Yen (Kegon, in Japanese) and especially

the Chen-yen (Shingon) sects. The mantras in Chinese and Japanese diagrams, based on archaic and misunderstood forms of the Sanskrit letters, called Siddha letters, are usually rationalized according to the strict canons of Buddhist philosophy. Since Buddhism's main requirement is the total extinction of desire – one of the basic Four Holy Truths in fact – meditation across the board of these diagrams cannot be called truly Tantrik. Recent Tibetan Buddhism, however, and especially Nepalese Buddhism influenced by Hindu ideas, do both still retain definite means for controlling the functions of the libidinous urge towards separation, union and bliss in their yantra techniques. The forms expressing this union are based upon the germinal mantra 'Oṁ maṇi padme Hūṁ'.

This mantra appears in many forms, and its elements are distributed among a variety of different devatā-principles for combination. Its basic components are: 'Oṁ', the root syllable of origination and dissolution, the ancient Brahmin vibratory syllable in which the presence of the Brahman, i.e. total reality, was condensed (Oṁ also appears as the nucleus of many Hindu and Jaina yantras); 'maṇi' meaning jewel, synonym for vajra, the word which means 'diamond', 'thunderbolt' and 'male organ'; 'padme' meaning 'in (locative case of padma) the lotus', a synonym for the openly displayed manifest world and the female organ; and 'Hūṁ' the nuclear mantra in which resides the highest force of enlightenment, an alternative image of the supreme Buddha of any sect. The sexuality here may be remote and metaphorical, but it is not unreal. The union referred to is certainly meant to propagate a spiritually beneficial energy. The commonest Buddhist pure yantra distributes the six syllables around the six petals of an open lotus, with a reinforced 'Hūṁ' at the centre.

The shape of the strange implement used by Tibetan Vajrayāna (Vajra-method) Buddhists, called vajra (rDor-je in Tibetan), has a metaphorical relationship with the forces implied in this mantra. The stylized shape probably comes from a combination of first: an archaic Indian symbol of power, found even in the crowns of vegetation-deities on seals of the Indus Valley Civilization (c. 2800–1200 BC) as well as on the gates of Sāñchi Buddhist stupa (c. AD 10) and, second: the late Hellenistic three-pronged double-ended 'thunderbolt' carried by second-third century AD images of Zeus or Jupiter. A combination of all these underlying meanings probably fills out the developed symbol of the vajra with its double-end and its prongs, now multiplied to four or more, which curve in to enclose the central protuberance. It thus probably conveys the sense not of 'vajra' alone, but of 'vajra padme'. It is certainly looked on as the mystical bearer of the force of 'Hūṁ'. As such it appears carried in one hand by the highest principles in Tibetan iconography. And bronze vajras are the treasured possessions of monks and magicians.

61

Both these groups of people also use the 'phur-bu', or mystical dagger, an object which has a vajra-hilt, often with terrible faces added to incorporate into the object their own spiritual power. In this it resembles the wands used by shamans (e.g. among the Sumatran Batak). The other end is a triangular blade. The phur-bu is used in rituals by which demonic forces are coerced, driven away or destroyed. The magician wields it with stabbing gestures, thus concentrating the power of the Vajra-Hūṁ. Monasteries used to contain huge 'mother phur-bus', probably standing in the main shrines as the repositories of all the power distributed into individual phur-bus owned by particular monk-magicians.

In a sense, therefore, vajra and phur-bu both belong in the category of yantra.

Since the inner sexual energy of humanity is identified in India with the cosmic energy, images which represent the outward appearance of sexual energy are worshipped as its emblems. The most obvious example is the erect male penis, called liṅgaṁ. Stylized liṅgaṁ-icons are, of course, the commonest icons in Indian Śiva-temples, and they will be discussed in a later chapter. Many anthropomorphic figures of Śiva show him with penis erect. But at the human level, since sexual excitement is felt to indicate the presence of the divine energy, some orders of yogīs worship their own erect penises, performing full pūjā to them; and numerous icons represent sādhakas inflamed with desire for union with the Yoni. One constant emblem for this inner libido, sexual and cosmic, is the snake, whose symbolism is known all over the world in many modifications.[13] In India the image of a magical, many-headed snake has long been used in different contexts. Tantra has developed the idea, and uses it to map ways for manipulating the inner channels of energy which are so important in sādhana. Other images will be discussed in Chapter 10.

Sexual intercourse is the principal form of 'enjoyment' which Tantra harnesses to its spiritual ends, treating it as a paradigm of divine ecstasy. As has also been explained, modern writers on Tantra, for reasons of their own, tend to discuss its sexual rituals in an abstract way, as if they were either purely imaginary or merely mechanical functions of yoga. In fact, real intercourse with complete enjoyment can be treated as an icon of what it signifies, just as the art-made anthromorphic icon for outer worship can be treated as a reflection of the permanent and true inner image. The true inner image behind sexual intercourse is the transcendent enjoyment in energetic love-play of the two-sexed creative divinity in Hinduism, or Buddha-nature in Buddhism. The joy of actual sexual intercourse, undertaken in the same spirit as worship of an outer image, can help to awaken in the mind of the sādhaka that permanent inner blissful image, of which each human intercourse is another reflection.

It is possible for the Hindu Tantrika to treat sexual intercourse of any kind in this way, including that between husband and wife, and that between a male visitor to a temple and a female 'wife of the god', otherwise known as a devadāsi or dancing-girl. There are many ritual aspects to sexual intercourse in India which date back to a very early stage in the evolution of human

35, 36

8

7–9

10

symbolic thought.[14] Among them are the complementary notions, first: that the heaven which awaits heroes and pious sages is full of celestial girls, whose love is their reward; and second: that the male deity resident in the icon of a temple, which latter is itself a reflection of heaven on earth, should be attended by a corps of female dancers. These women are symbolically married to him, so that when male visitors couple with them they rehearse one of the elements in celestial bliss. Most of the superb erotic sculptures on medieval Hindu temples illustrate this combined function.

72, 73

Devadāsīs are also very suitable partners for the sādhaka's sexual rites. Royal or family prostitutes, provided they have undergone correct initiations, may share something of the special symbolic sanctity of the devadāsīs. Traditional music and dancing were part of this system of pleasure. Hindu Tantra uses this imagery of pleasure as a mechanism for enhancing enjoyment in the direction of ecstasy.

It must be obvious that the Tantrika – and indeed the Indian – does not conceive of sexual intercourse as a quick scurry to orgasm. This is an absolutely fundamental factor, which distinguishes Oriental attitudes to all manifestations of sexuality. Western attitudes, reflected in the Kinsey reports and in tens of thousands of banal novels, look on sexual intercourse as a matter of tension, appetite and relief, quick relief being the 'natural' goal of male and female, according to the simplistic biological conception which is still current. It suggests that all that can be done with the sexual act to make it better for both partners is to add to their pleasure by raising the key of the tension, and/or increasing the frequency of relief. It is well known that the man who, in the Kinsey Report on the Human Male, recorded a frequency above thirty times a day for many years became a kind of folk-hero in America. Sexual love, in such a context, becomes at best a matter of frequent happily shared orgasms.

To the traditional Indian mind this attitude is grotesque and pathetic. Even the ordinary man recognized that such banality was absurd, and lacked any real point. Eighteenth-century Indian harlots mocked European men for their miserable sexual performance, calling them 'dunghill cocks' for whom the act was over in a few seconds. Despite recent advances in sexological knowledge, the West's chosen external explanations of sex, attached as they are to a provisional and impoverished rationalization of the infinite complex of human experience, still tend to regard sex as the pursuit of orgasm, maybe decorated and multiple versions of essential biological act. Traditional India did not.

Even at the hedonistic, secular level Indian eroticism always focused on the inner state of erotic possession. Those long sequences of caresses and postures recommended in the Kāmasūtra, Anaṅgaraṅga and other handbooks aimed at creating a condition of extended savouring or enjoyment; in neither text is orgasm treated as necessary relief, nor even as the chief goal. It is simply taken for granted. In the higher reaches of Indian erotics orgasm becomes merely a

17–23

punctuation in, and incentive for, the state of continuous intense physical and emotional radiance which lovers can evoke in each other. Sex is not regarded as sensation, but as feeling; attraction is not appetite, but the 'meeting of eyes'; love is not a reaction, but a carefully nurtured creation. Its meaning is a protracted ecstasy of mind and body, whose fires are continually blown by prolonged engagement and stimulation of the sexual organs, not mutual relief. It is difficult to know how many Westerners or modern men and women experience this condition; certainly very, very few works of literary or pictorial art even suggest it. And the self-abnegation it demands of both partners in prolonging intercourse and studying each other's needs has no place in European cultural attitudes. Laboratory-based conceptual explanations (which 'leave the reality behind') do not embrace it.

96

The postures and inward contractions performed in the course of Tantrik union work on this Indian basis of sexual love. The special inwardly radiant condition they promote only appears, however, when the erotic focus is shifted from the outer sensory personification of desire to the inner Goddess of whom all outer women are paradigms. Actual man and actual woman become keys to each other's bliss. This does not mean that one loses value in the other's eyes; the opposite is true. For each is God in the other. In addition, the rites and mantras accompanying intercourse themselves carry charges of accreted energy from past practice, study and custom; these enhance the activity with their own force.

81, 82

We have therefore to remember that sexual sādhana, for its own methods to be effective, *must* produce no less a delight through the same kind of skills, as well as through extra techniques. Only in this way can the sādhaka reach what is called Rasa (juice-joy) or Mahārāga (the great emotion). Mere mechanical performance is no less absurd than mere undirected indulgence. For certain rituals it is also important that the woman's own vital energies should be at their peak, and that she should be menstruating. Indian tradition has it that on different days of the month a woman's sexual sensitivity, which is related to cosmic movements by her own periods, needs to be triggered by special attention to different parts of her body. Diagrams illustrate these trigger points, and relate them to the phases of the moon. As well, ritual intercourse is preceded by the anointing of different parts of the woman's body with differently perfumed symbolic oils.

71

80

The most significant rituals of Tantrik sādhana are performed with women who have been specially initiated. What this initiation consists of has usually been kept secret and its reasoning hidden. There seems to be a variety of methods, perhaps used together.

74

All seem to be based on the idea of converting the male participant into an image of the male deity (e.g. Mahākāla or Śiva), the female into an image of the Goddess (e.g. Devī, or Kālī). Potions containing the semen of an already

enlightened master may be drunk. Nyāsa is another important method. This consists of touching the component parts of each participant's body, while reciting the mantras which will identify it with, and transubstantiate it into, the same part of the devatā's body. A more complex nyāsa, for solitary, interior meditative ritual, may combine the subtle body of both sexes within the sādhaka's single body. Mantras and continuous japa may also be used during the ceremonial intercourse. And the bodies of man and woman may be marked with symbolic designs that have the force of yantra. These may be done freehand or with stamps dipped in coloured paste.

More important still is the idea that sexual 'divinization' can be performed by a member of the opposite sex who is himself or herself already raised to a high spiritual level, and thus has the capacity to 'initiate'. A specially endowed woman, who has been herself converted into a vessel of the divine energy by sexual intercourse and ritual with one or more divinized Tantrik men, can pass on the initiation by intercourse with male would-be initiates. This was especially important in the Indian Buddhist Tantra on which Tibetan Tantra was originally based, and survives in modern Bengali Tantra. There are plenty of textual references to this particular aspect of the cult. The women were called Dākinīs by Buddhism. In more recent Tibetan literature they have been converted into fantasy-figures (Kha-do-mas – sky-goers); in Hindu Tantra they may be called Dūtīs, Yoginīs or simply Śaktis. The older sources show quite clearly that it was both difficult and essential for a true Tantrika to obtain initiation from such a woman. Tibetan texts describe the Indian founder of the Red Hat sect, Padmasambhava, raping the Dākinī in her 'palace' in a cremation ground, which he had devastated by his magic power, to gain his ultimate initiation. He then meditated in eight further cremation grounds. And it may well be, although there is only indirect evidence to prove it, that here lies the most archaic nucleus of the whole of Tantra.

It is probable that in ancient times the special potency of Tantra was transmitted along a female line of power-holders; by ritual intercourse with them the initiation was diffused. Some scholars have identified them with the women of a mysterious old sect called the Vrātyas. This connects up very well with what can be learned about archaic cult-practices among early palaeolithic peoples. It also accounts for the way in which a female energy-symbolism has survived in later religions, such as Tibetan Buddhism and Brahmanical monistic Tantra, which were male-oriented and not at all likely to have discovered the female principle for themselves. Any such female transmission was bound to be entirely outside the caste system, which depended upon strict rule and custom for its existence. Such female transmitters would be outcaste and, as sexual partners, defiling. To seek an initiation with them would have placed any sādhaka beyond the pale of normal society. An important part of the appeal of such a cult lay precisely in the breaking of all those rigid ties of

75–7

24

64   The kind of lamp used in temple pūjā, as an emblem of the presence of the divine and of the worshipper's adoration. Basohli-Kaśmir, 18th century. Gouache on paper 6 × 4 in.

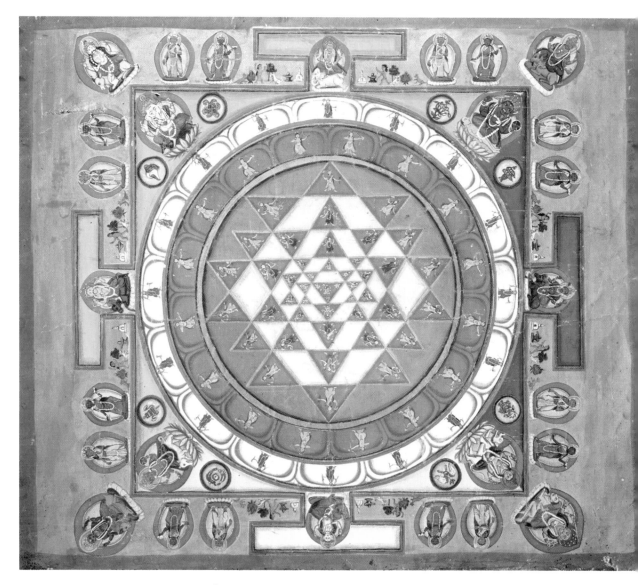

65 Śrī Yantra, a diagram of the continuous process of Creative Generation, with indwelling Mahāvidyā Devatās in all the triangles and stupa and liṅgaṁ motifs combining Buddhist and Hindu symbolism. Nepal, c. 1700. Gouache on cloth 20 × 24 in.

66 One of a set of seven painted maṇḍalas, each of which, when meditated on, > generates a special condition of consciousness (see also *Ill.* 58). Tibet, c. 1800. Gouache on cloth 28 × 19 in.

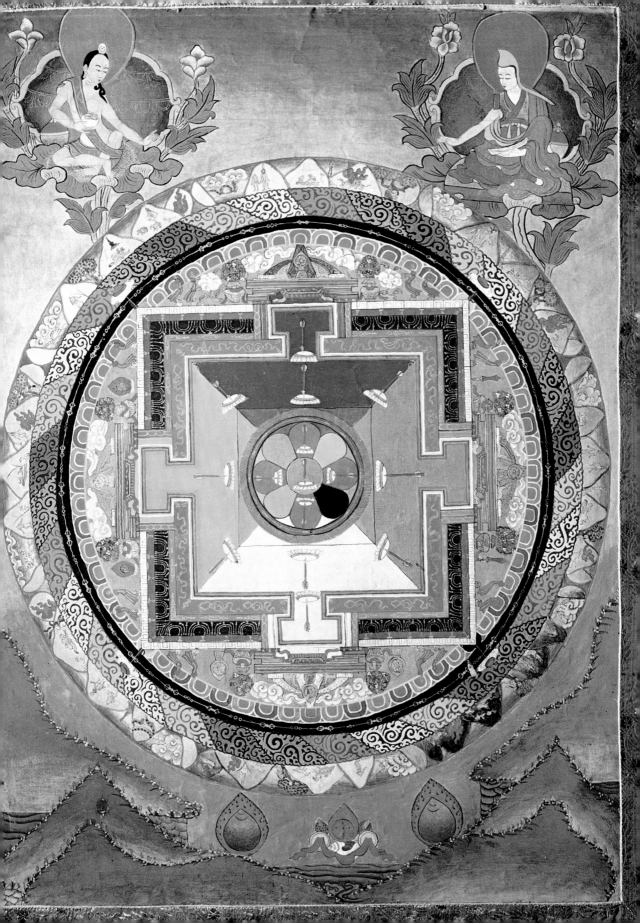

॥ नमोलृग्यां ॥

67 A pair of snakes, symbolic of
cosmic energy, coiled about an invisible
liṅgaṁ. Basohli, *c.* 1700. Gouache on
paper 6 × 4 in.

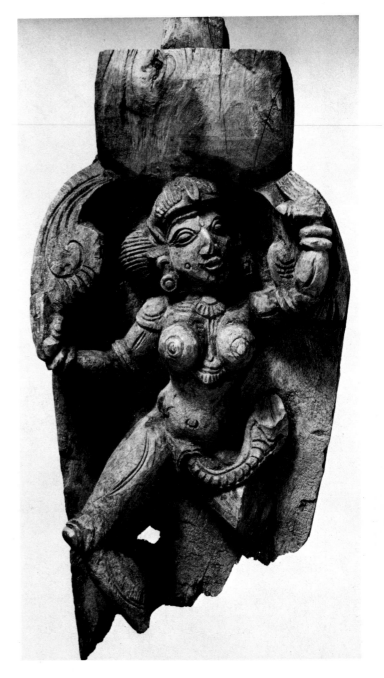

69 Five-hooded serpent-power
enclosing a stone emblem of the
original egg-liṅgaṁ. South India,
19th century. Brass and stone h. 6 in.

68 Yoginī with serpentine energy
manifesting from her yoni.
South India, *c.* 1800. Wood h. 12 in.

70  Painting of erotic sculpture, probably from a temple at Khajurāho *c.* 1000, representing celestial girl. Rajasthan, 18th century. Gouache on paper 9 × 6 in.

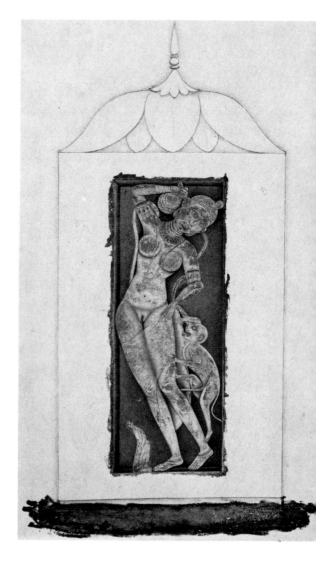

71  Painting illustrating the varying points of sensibility on a woman's body throughout the lunar month. Himachal Pradesh, 17th century. Ink and gouache on paper 6 × 4 in.

72 Couple from the heaven 'bands' of the Devī
Jagadambā temple at Khajurāho. *c.* 1000.

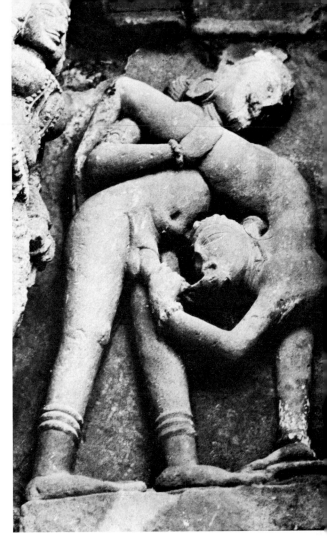

73 Naked ascetic coupling with a Yoginī,
from the Lakṣmaṇa temple at Khajurāho.

74 An initiation. Rajasthan, 18th century. Gouache on paper 7 × 6 in.

75 Red Dākinī, symbolic of the initiatory power of the female.
Tibet, 18th century. Gouache on cloth 10 × 8 in.

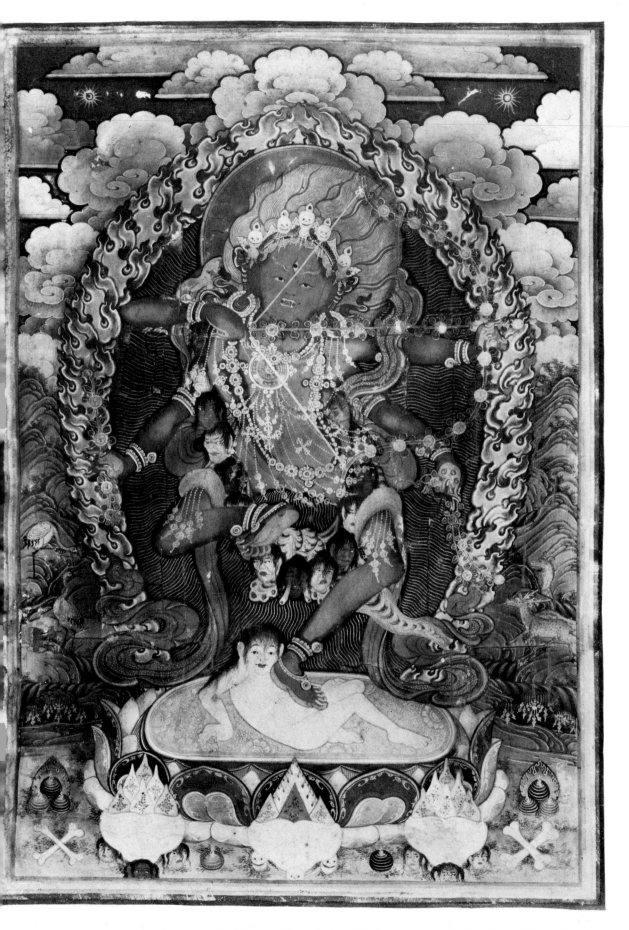

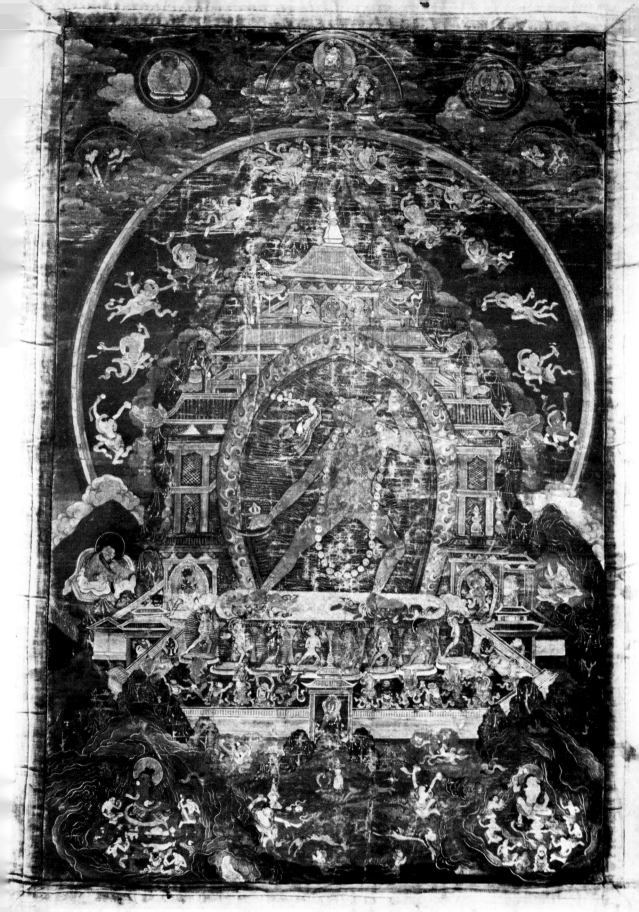

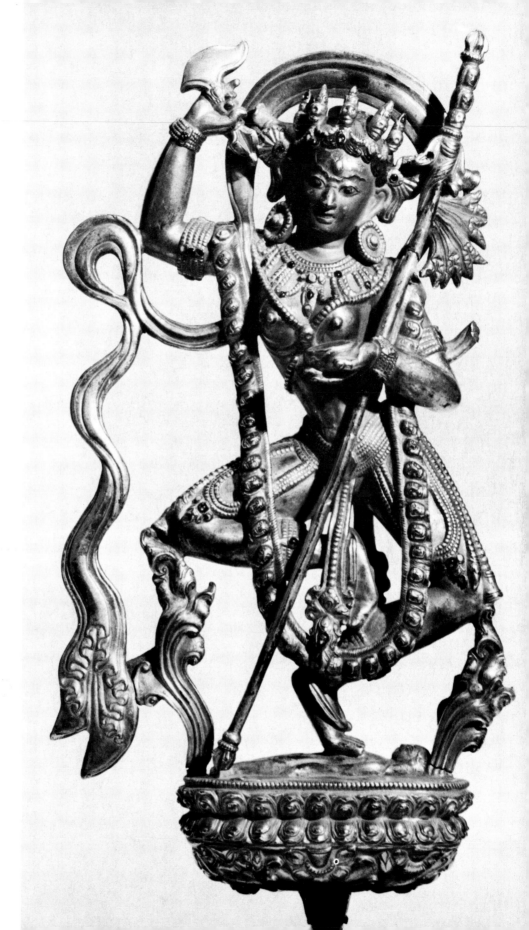

The red Dākinī
ithin her palace,
rrounded by flying
ḍhas; she is the
al of the Buddhist
ḍhaka's transcendent
ire. Tibet, 18th
tury. Gouache on
th 30 × 20 in.

77 Vajravarāhī,
a Dākinī, female
artner of Herūka, a
personification of
intense passion.
Tibet, 17th century.
Bronze h. 13 in.

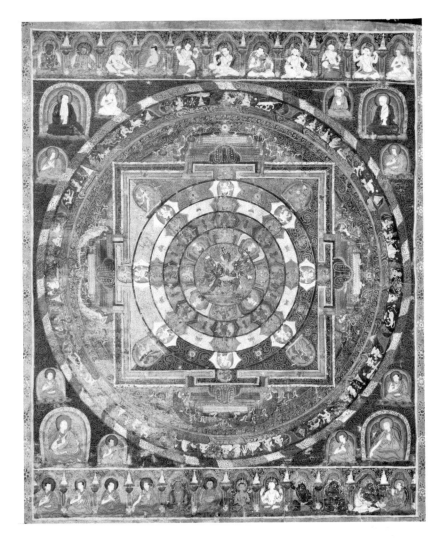

78 Painted maṇḍala of a form of the Bodhisattva Cakrasambhara with red Dākinī. Nepal, 16th century. Gouache on cloth 20 × 17 in.

79 Painting illustrating the five powerful enjoyments (Pañchamakara) ranged round a figure of the Guru. Rajasthan, 19th century. Gouache on cloth 35 × 33 in.

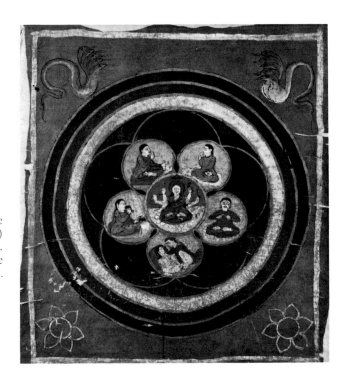

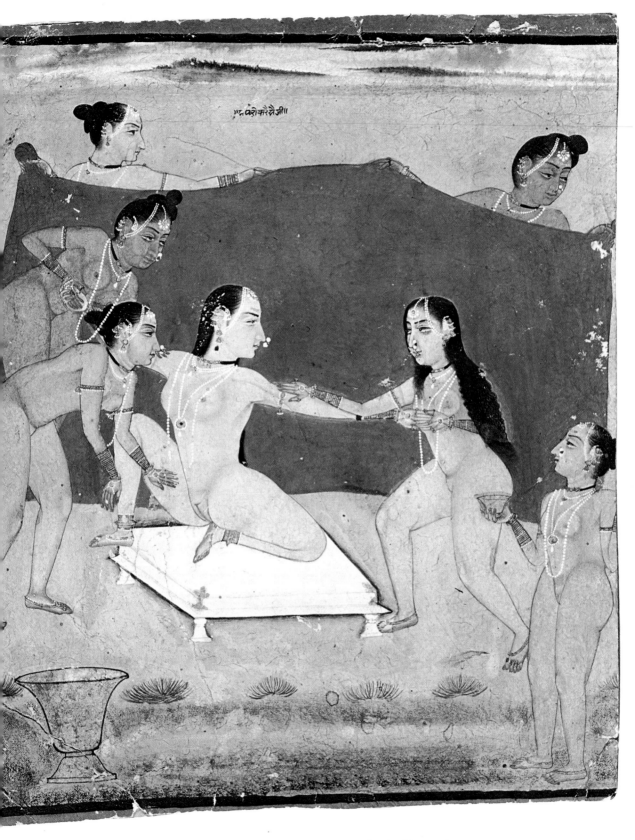

80 Anointing and massage of the body of a high-caste woman after bathing and before intercourse. Rajasthan, 18th century. Gouache on paper 9 × 7 in.

81 The sexual posture Mūla bandha. Nepal, *c.* 1700. Gouache on paper 7 × 7 in.

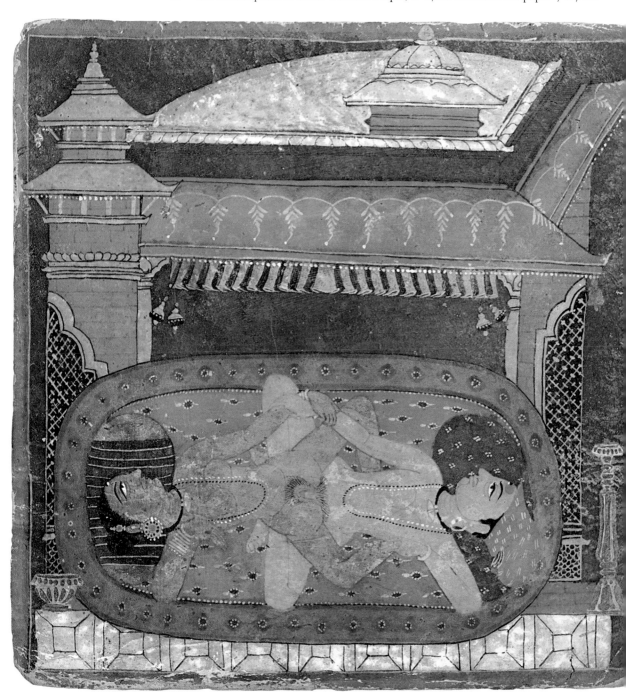

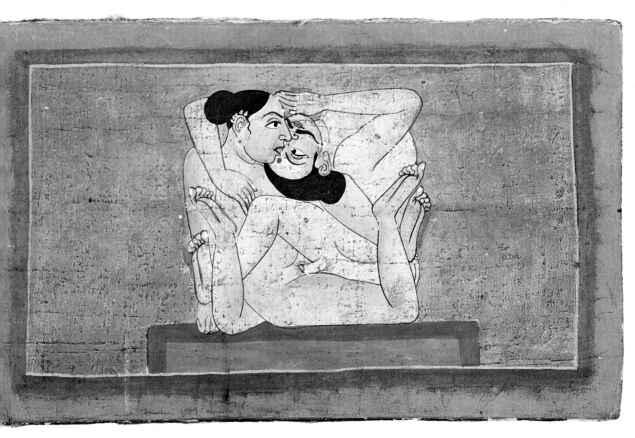

82   The sexual posture Ćakra Āsana, the twist in which affects the pattern of energies in the spinal column. Nepal, 18th century. Gouache on paper 15 × 9 in.

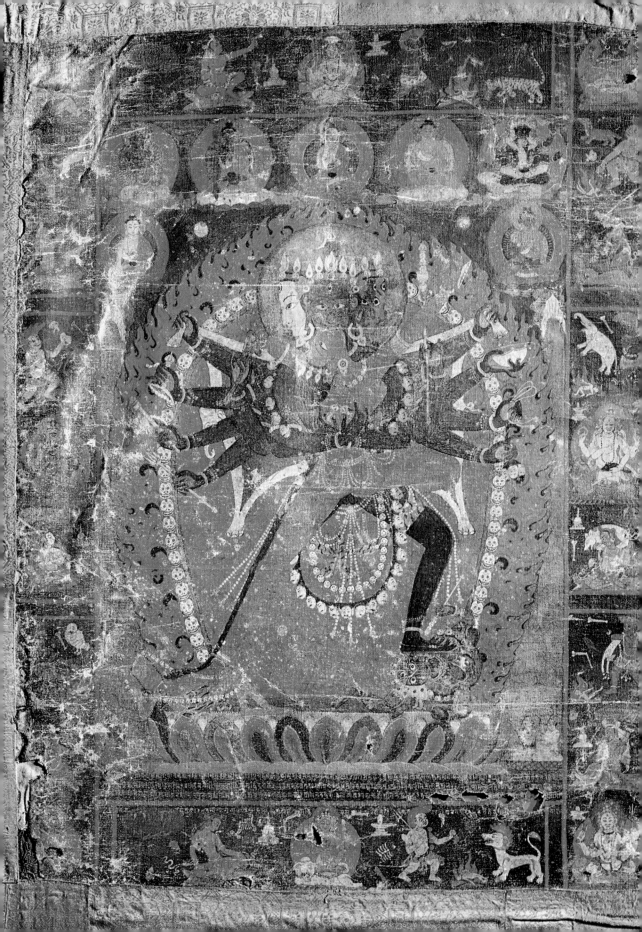

Indian social convention which it entailed. Much Bengali religious erotic poetry, both Buddhist and Kṛiṣṇa-Hindu, makes a great point of the fact that 'the beloved' (outer and inner), is of degraded caste. Buddhist poets called her, for example, Dombī (washerwoman low-caste girl), Hindus frequently called her by her own name, or 'the widow' – a type of person at a great disadvantage in Hindu society. Other aspects of caste-breaking will be mentioned later on.

In historical Tantra it seems that the transmission of spiritual initiation could run both ways, from male to female as well as from female to male. But power could also be transmitted for meditative use by means of other surviving archaic techniques. Implements, images or objects imbued with energy could be brought into contact with the genitals.                                                                74

In Tibetan and Nepalese Buddhism certain initiations are still conferred by the initiator seating the image of a Dākinī with open legs across the lap of a male initiate in act of purely symbolic intercourse.

The basic sexual rites are these. For the householding Tantrika the Ćakra-pūjā served. Ćakra means 'circle'. At this ceremony, drugs derived from hemp were sometimes taken as a sweet, as drink or smoked. Then the five powerful but usually forbidden enjoyments (fish, cooked hog-flesh, wine, cereals and intercourse interpreted transformationally as the elements of the world) were ritually taken by a circle of couples as a kind of Eucharist presided over by the       79
guru.

In Ćakrapūjā the participants forget all distinctions of caste and custom. All have to remember constantly that everything is a show of the One Brahman. The great Kula text, the Kaulāvalīnirṇāya, points out that 'all the men become Śivas, all the women Devīs, the hog-flesh becomes Śiva, the wine, Śakti. They take the five-fold Eucharist, consecrating the twelve cups of wine with evocations, and unite in sexual intercourse.' The bliss they experience is a manifestation in the body of the cosmic Bliss of the Brahman, purifying all those components of the body in which the divine energies dwell.

There has been much theoretical dispute as to whether the rite worked better if the couples were or were not married to each other. On the whole the weight of opinion favoured ritual intercourse outside the marriage bond, and in the ćakra couples could split to pair with the husbands or wives of others. The rite could be preceded by the adoration of one or more virgins in whom the presence of the Goddess was invoked. But it is also probable that in other versions of the rite a human initiated Yoginī-Dākinī played that role, and some form of preliminary intercourse was had with her by male participants. At a high level of practice, by participants of 'Vīra' or heroic status, other things might be done. Partners for intercourse might be selected at random, by picking jackets from a heap. They could be chosen out of a socially unorthodox love. A single Vīra might perform sādhana with between three and one hun-

83   Tanka representing a transformation-icon of the Bodhisattva Ćakrasambhara with his red Dākinī. Tibet, 18th century. Gouache on cloth 29 × 22 in.

78, 83

dred and eight women, some of whom he only touched. In one special 'Spider's web' ćakra the pairs might all be linked by tied lengths of cloth – an element of imagery taken over into art as radiating lines. Some of these ćakras were performed for the magical benefit of third parties, as for kings before a battle. Despite the disclaimers of some scholars, such ćakrapūjā customs must be the original Indian ritual facts which underlie the whole transformation system represented by the circular maṇḍalas of coupled devatās which appear in the Tantrik Buddhism of Tibet and Nepal. There can be little doubt that the ćakrapūjā system is very ancient indeed. In recent times it has been especially cultivated at the Rajput courts of northwestern India.

For the sādhaka who was intensively seeking release in a single lifetime as a yogī there were other rites. These involved prolonged acts of ecstatic meditation in sexual union with a female partner, whose aims matched his own. Such meditation involved liturgies, mantras, inner visualizations, yogic postures and manipulation of the conjoined male and female energies. They will be discussed later. As with all other Tantrik sādhana, at the lower stages they were performed in physical act; at the final, highest stage, as an inner realization.

Something similar is the case with herbs and drugs, such as bhang and ganjam (forms of cannabis). Like alcohol they have certainly been used in ritual since very early times, to help in finding the road to ecstasy. What they do for the Tantrika, perhaps more dependably than other physiological enhancements, is reveal something of the stark banality, the inadequacy and falseness of our everyday materialist image of the world, with its narrow cage of accepted perceptions and concepts, and its neglect of the infinite, radiant tissue of relations within the truth. In Europe an earlier generation of psychologists and Christian theosophists cultivated the use of ether and nitrous oxide to gain experience of the limitations of normal convergent thought and perception concerning the nature of time; William James used a number of their reports in his great work *The Varieties of Religious Experience*. In India Tantrikas take drugs for similar reasons. There are icons representing Śiva as Lord of the Yogīs which show him carrying his drug-jar under his arm. Like sexual intercourse, bhang and ganjam are a means to be adopted until the sādhaka's own faculties have been developed. As an indulgence they are absurd, and a fatal hindrance.

The erotic cult of the cowherd-god Kṛiṣṇa may have had origins which were not directly Tantrik; and there are certainly many Indian Kṛiṣṇa devotees who would strongly repudiate the name of Tantrika. But the great Tantrarāja Tantra, during its almost incredible effort at massive religious synthesis, declares that, from the Tantrik point of view, the entrancing person of the incarnate god Kṛiṣṇa, with which all the women of Brindaban fell hopelessly in love, was in fact a form assumed by the highest female Nityā in the supreme maṇḍala of Tantrik female deities, who is called Lalitā; the Great Goddess herself, embracing all women and entrancing the world. For Kṛiṣṇa has become the dominant erotic symbol in the whole of Indian culture, attracting to himself complete, self-abnegating adoration.

Adoration, as a religious attitude, has a long history in India. Bhakti, its Sanskrit name, is a close parallel to the Love which has played so important a part in European culture. For the result of cultivating Bhakti towards any devatā is that the mind and body are flooded with an overwhelming sweetness, the Rasa or Rāga, which is the experience of being in love not with a human lover but a divine. Kṛiṣṇa has come to serve as the outstanding object of this kind of love, and this is probably why his cult was taken up into the Tantrik complex during the Middle Ages.

The story of the incarnation of Kṛiṣṇa is long and complex.[15] It probably originated in the lascivious songs which were sung at the popular spring-harvest festival, now enshrined in the Holi ceremony, and forced itself into the Brahmin canon. An enormous number of vernacular works, especially poems, deal with his legend. The most important is the twelfth-century Gītagovinda in Hindi by Jayadeva. The essential elements are that Kṛiṣṇa was an incarnation of the high god, usually identified as Viṣṇu, who was brought up among a low-caste cattle-herding people of Brindaban on the banks of the river Yamunā. He was an adorable child, bluish of complexion for symbolic reasons; and as a young man his beauty and his flute-music caused all the women in Brindaban, both unmarried and – scandalously – married, to fall helplessly in love with him. These women are called the Gopīs, or cow-girls. The chief of them was Rādhā, wife of the cowherd Ayanaghosha, whom Vaiṣṇava Tantra recognizes as 'not different' from her divine lover.

93
94

99

Kṛṣṇa's complex simultaneous love affair with all the Gopīs progressed through many episodes, culminating in the Rasalīla, or springtime round-dance, during which all were united sexually at once with a multiple Kṛṣṇa in a state of complete self-abandon.

This love between Kṛṣṇa and the Gopīs, Rādhā especially, again represents that same pinnacle of transfigured desire mentioned earlier, but seen in a different perspective. In some of the greatest Kṛṣṇa literature there are long descriptions of the acts and postures of sex the divine lovers performed; they are presented as unequivocally necessary to the superstructure of endless transcendent Desire, the inner fire of Bhakti.

A vast quantity of the poetry of India, dating from about 1200 onwards, deals with the aspects and minutiae of the Gopīs' love affairs with Kṛṣṇa in the most intimate, delirious physical detail. Young bursting breasts, swelling hips in charming undulation, small pink-palmed wandering hands, perfumed black hair dishevelled by long nights of love, slender limbs exhausted with amorous struggle – all feature in the poetry. These poems are usually explained by academic writers as allegories of the love between human souls and god. But there can be no doubt that their aim was to raise erotic emotion and sensuous excitement in their audience to their highest peak – an aim in which music and painting also shared. For during the Middle Ages the Kṛṣṇa legend came to occupy the centre of the whole complex of Indian aesthetic expression.

Furthermore, it is no accident that a most important role in many of the stories is played by the go-between who carries messages between the lovers. She is called Dūtī, the same term as is used for the female partner in Tantrik sexual rites.

The cults and customs which effloresced around the image of Kṛṣṇa are innumerable. All were based on devotion, and many were inspired by two great teachers, Ćaitanya and Vallabhāchārya (c. 1500). All of them con-centrate upon exalting the earthly life and loves of Kṛṣṇa on to the transcendent scale, treating the earthly iconography as a reflection, in the Tantrik sense, of cosmic patterns which embody eternal truth and take place in a celestial and changeless Brindaban. There Kṛṣṇa is revealed as the high god Viṣṇu, whose footprints he left upon earth. The approach to this celestial realm of bliss, sometimes called 'Goloka', 'cow-realm', was, through a gradually intensified love, focused at first on a human lover in physical love, then shifted on to the transcendent image of which human love is a dull reflection. An actual female participant in the preliminary physical love may thus rightly be called Dūtī.

In the domestic context husband and wife, as a Vaiṣṇava marriage-service says, should look on each other as the divine lovers Kṛṣṇa and Rādhā. But a more extreme cult of love demands that social ties be broken, and that the lovers must possess each other outside the marriage bond in a relationship

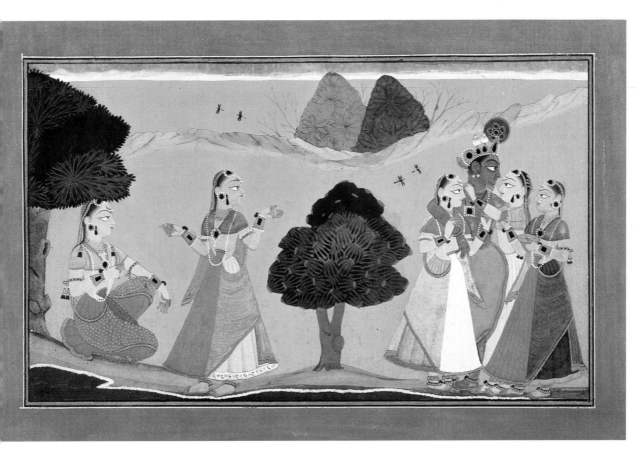

84   Album painting, representing a phase of love acted out by Kṛiṣṇa and Rādhā, as described in Banudatta's poem 'Rasamañjarī', which is devoted to erotics. Basohli, Jammu – Kaṣmir, c. 1680. Gouache on paper 9 × 13 in.

85 The footprints of Viṣṇu marked with symbols of the Universe, before which the devotee abases himself in adoration. Kangra, 18th century. Gouache on paper 4 × 4 in.

86 Icon of Chinnamastā, the Mahāvidyā arising from the joined bodies > of the Originating Couple. Kangra, c. 1800. Gouache on paper 8 × 6 in.

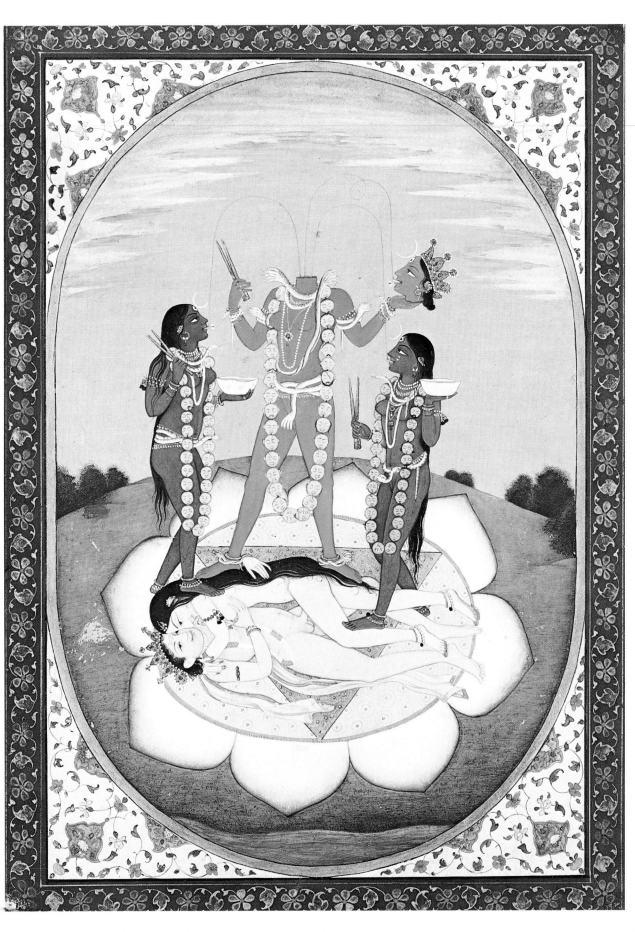

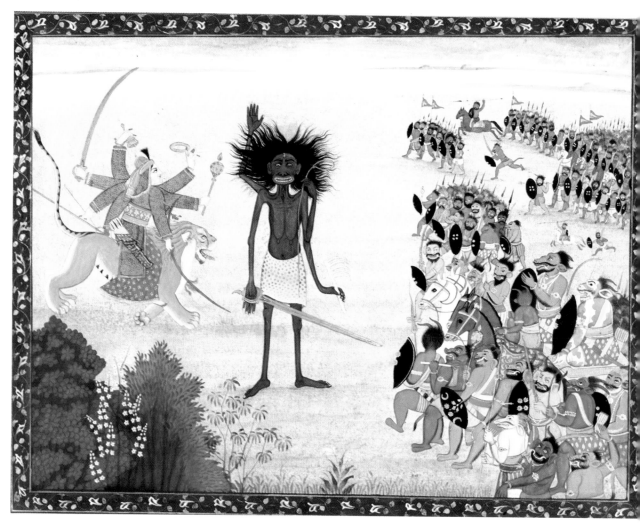

87   Album painting, representing the terrible Goddess Kālī triumphant on the battlefield. Rajasthan, Kangra style, 18th century. Gouache on paper 8 × 10 in.

88   Folk painting representing the Goddess Kālī straddled over the erect liṅgaṁ of > the corpse-Śiva. Orissa, 19th century. Gouache on cloth 15 × 13 in.

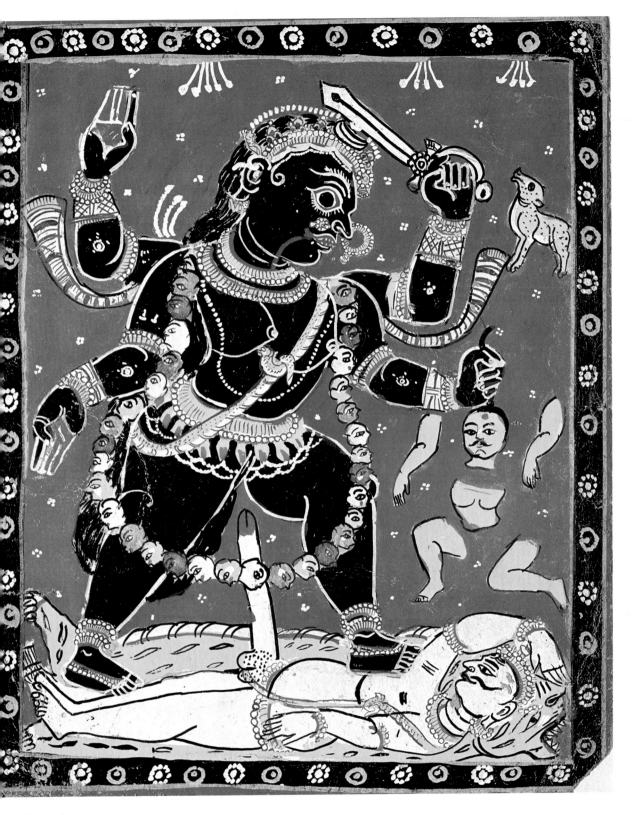

*Overleaf:*
89 Raktayamāri, a form of Yamāntaka destroyer of death, with his female wisdom.
Tibet, 18th century. Bronze h. 10 in.

90 A wrathful manifestation of the Void, in union with the abolition of selfhood.
Nepal, *c.* 1600. Gouache on cloth 56 × 38 in.

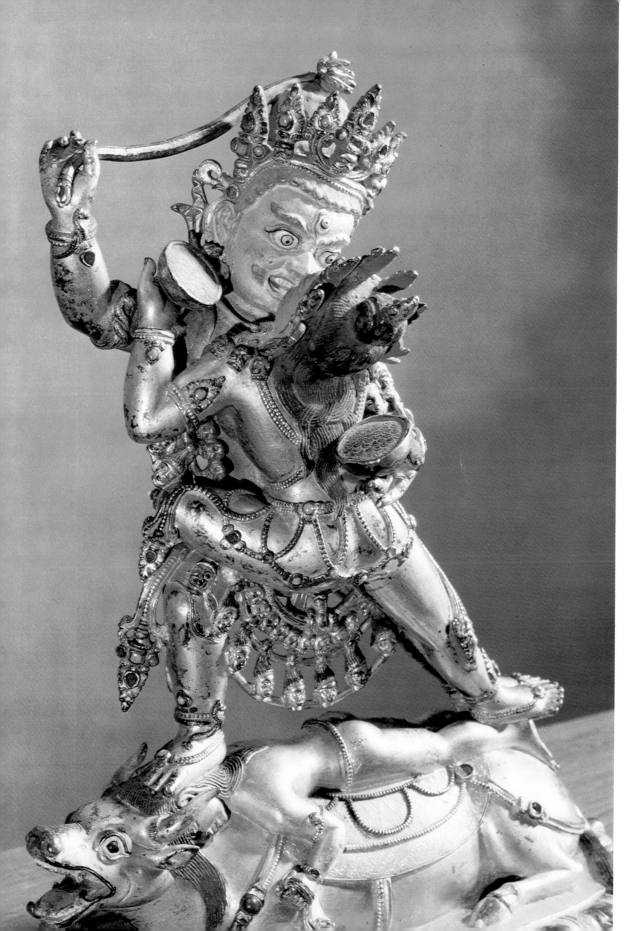

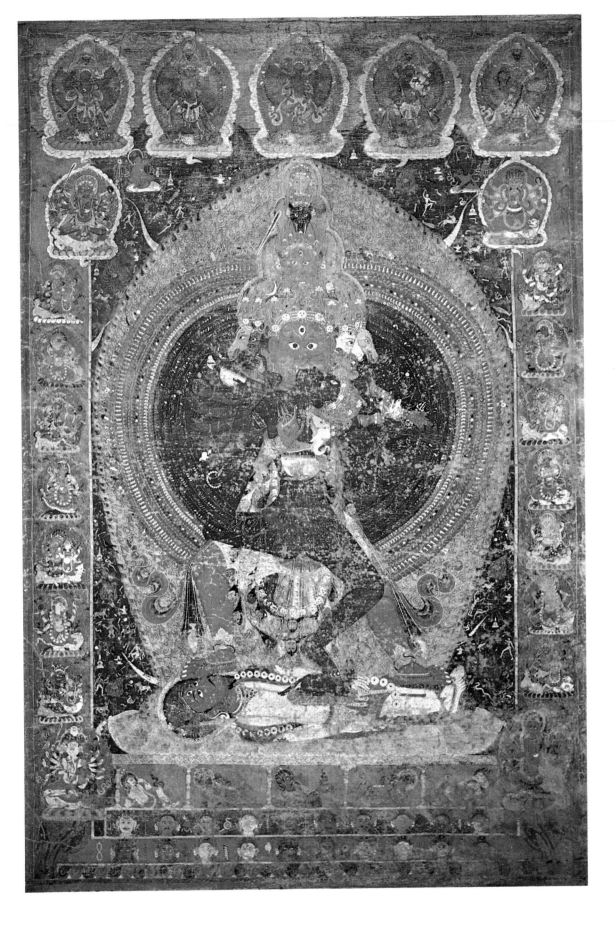

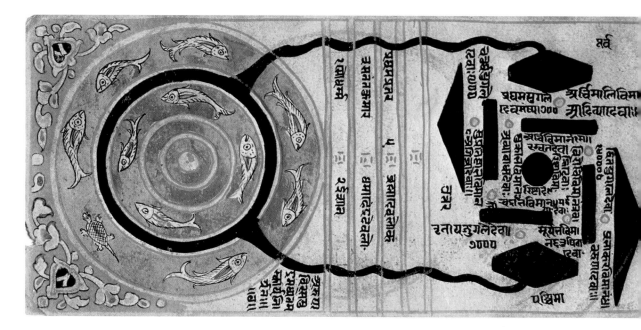

91    Diagram illustrating how the transcendent system of cosmic space, with its absolute directions E, S, W, N, is subtly related through layers of matter and space to the world of Jambudvīpa, a page from a copy of the Saṅgrahani sūtra. Gujerat, 16th century. Ink and colour on paper 5 × 10 in.

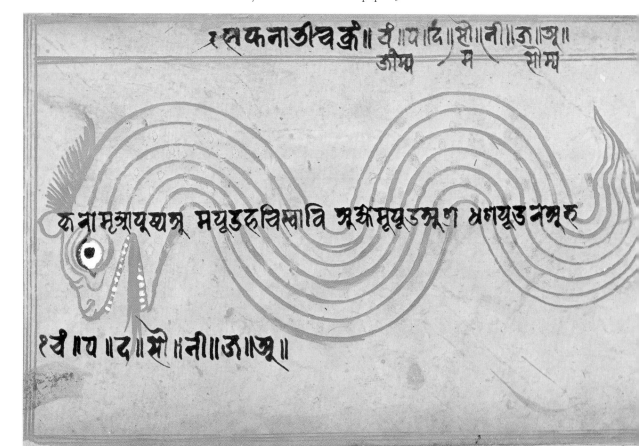

92    Diagram showing the seed-sounds for control of the flow of forces in the subtle veins. Detail of a manuscript page from Nepal, 18th century. Ink on paper $2\frac{1}{2}$ × 10 in.

called parakīyā; the emotion between the two should be fed continually by all kinds of sensuous stimulation. The culminating asceticism of the Kṛiṣṇa cult may demand that men adopt completely the lives and attitudes of Kṛiṣṇa's Gopīs to adore their divinity. For 'all souls are feminine to God'. Ascetics who follow this path dress and decorate themselves like girls, and even observe a few days' retirement each month.

An important part of such a Vaiṣṇava life was always music. Communities may sing together whole nights and days. But even 'secular' music is deeply tinged with Kṛiṣṇa devotion. The system of musical scales called Rāgas (male, the word means 'feeling') and Rāginīs (female) upon which Indian music is now based, reflects the emotional techniques of Kṛiṣṇa devotion, especially in the way it explores refined nuances of erotic sentiment through tone-colour, rhythm and melodic pattern. Similar expression appears in many of the best of the Rajput miniature paintings made at the Hindu courts of Western and Northwestern India between about 1630 and 1800. Some of the finest were made at Basohli.

84

In such paintings refined colour-groups and juxtapositions may produce varied and sensuous emotive effects. These were well understood in aesthetic theory. One painting may be dominated by a blazing red-yellow, vermilion and green, with lesser notes of blue-grey and lilac; another by scarlet, chocolate and turquoise; another may be saturated in dark greens and greys with areas of lilac and notes of orange. The objects linked by community of colour within a picture add an extra dimension of associated meanings. Such pictures can lead the spectator's feelings into differing states, which, when they are experienced in series, work on Tantrik lines.

In fact, the whole Indian aesthetic complex was based upon Tantra, even at the theoretical level. Few people yet realize this; but it is something that no one interested in Indian art should ignore. The long tradition of Indian aesthetic theory, beginning with the fourth-century(?) Nātyaśāstra (Treatise on the Dance) by Bhārata, culminated in the tremendous work of the Kaṣmiri philosopher Abhinavagupta (eleventh century). He also wrote a monumental encyclopaedia of Tantra, called Tantrāloka, having gone to Bengal to study Kula practice at first hand. His aesthetic theory suggests that art operates by arousing in the mind of the spectator the latent traces of emotions associated with events in his past life (or lives) analogous to those with which the work of art presents him. There is a spectrum of modes, covering all the possible categories of emotional experience and expression, through which art can work. The forms of art stimulate in turn latent traces belonging to these different modes, so that the mind 'tastes' them, like a juice (rasa). The tasting of these rasas in sequence puts the mind into a special state, in which it transcends its own emotive contents, and becomes conscious both intellectually and emotionally of itself. The state is called the great Rasa, which we can give a

capital R. It is intrinsically no different from the great Rasa or Mahārāga (great feeling) of Tantra. Among all the lesser rasas, the erotic is regarded as the most powerful, having more in it that attracts and less that repels. What is Tantrik about the whole theory is the way in which it makes positive use of the latent traces of memory and experience lying in the mind. Orthodox non-Tantrik Brahmin and Buddhist philosophy regarded such traces as empty, meaningless illusions, to be sternly suppressed. The second yoga-aphorism of Patañjalī, the most authoritative definition of yoga in Hindu literature, reads: 'Suppression of the movements of the mind, that is yoga.' Art, however, needs positive material to work with; and this is something which Tantra alone recognizes, seeing hidden in these traces the gestalten of our universes as spatio-temporal rhythms. It is impossible to conceive the existence of an art like that of the Rajput miniatures without the deep-laid assumptions about feeling and its expression which Abhinavagupta canonized for Indian thought.

Here, to demonstrate Abhinava's Tantrik identity, is a summary description of him which a pupil composed. It matches the description of the Tantrik Viṣṇu-Buddha seen by Vaśiṣṭha given in Chapter 1. It calls Abhinava an incarnation of the high god Śiva, who has taken bodily form in Kaṣmir. He sits in a garden of grape-vines inside a perfumed pavilion of crystal, filled with paintings. The air resounds continually with music and singing. On a golden throne, hung with pearls, Abhinava sits, playing a lute and drinking wine, his eyes trembling with ecstasy; his long hair and beard fly loose; he is surrounded by crowds of beautiful women and spiritually realized men, and spends his time devising Tantrik rituals, which he himself performs with two chief dūtīs and then dictates to his pupils.

It is obvious that such a tradition looks upon Tantrik ritual as itself a kind of art, to be developed and expanded by gifted artists.

One important episode in Kṛiṣṇa's life is described in the Bhagavadgīta. It does not fit too comfortably with the rest of the story, but it has been incorporated into the later texts, and corresponds very well with Tantrik images of the cosmic body (Chapter 10). During a great war when Kṛiṣṇa was serving as chariot-driver to the hero Arjuṇa he had occasion to help Arjuṇa over moral difficulties in connection with his military duty; he was finally persuaded by Arjuṇa to demonstrate his own divinity by showing himself in his cosmic form. This vision Kṛiṣṇa showed to Arjuṇa of himself as Supreme Being, embracing the whole of reality, became the subject of a great many icons designed to help devotees to attain a similar vision for themselves. It was, in a strange way, the object of the same kind of sensuous adoration as other more obviously beautiful images of Kṛiṣṇa. At Puri, Orissa, in the famous shrine of Jagannātha (the name means 'lord of the universe') a strange archaic type of image is the centre of devotion. It must have a long ancestry back into the primitive levels of religion. A bone of Kṛiṣṇa, who is said to have died of his own will, is set into a

136

97, 98

hollow in the temple icon. The latter is renewed every twenty years, the bone being transferred by a holy Brahmin, who always dies soon after.

One small point must be added. Indians attribute a clear set of values to different parts of the body. The head is the most valuable; the feet the least. To touch someone with one's foot or shoe is an insult. But to pay true reverence to someone, one may set their feet on one's own head, and worship them. On the transcendent value-scale it is the feet of the deity which are nearest to men. Hence, as the most direct approach to God and as an emblem of one's own humanity, one may pay worship to the divine footsole, such as the Viṣṇupada in which the created world is reflected.

85

# 8 Graveyards and horror

The imagery of the graveyard also has the essential Tantrik double aspect, outer and inner. Cremation-grounds in India usually lie to the west of a town. In them corpses are laid out and cremated on carefully constructed piles of wood, so that the spirit may move on to a fresh birth. The burning is often far from complete. Dogs, jackals, crows and vultures live there, feeding on the remains and scattering the bones. Contact with the dead, from the point of view of caste, is deeply defiling, especially if the dead are themselves of lower castes. To handle corpses is the task of the lowest members in the whole caste hierarchy. The graveyard, nevertheless, is where high and low alike end up, and is a perpetual reminder of the death which consummates life.

Here the sādhaka must encounter the reality of the disintegration of his neat conceptual universe, as a necessary prelude to experiencing the state of rational non-integration mentioned earlier.

Tantra makes use of the graveyard in several ways. The sādhaka is supposed to make it his home, at first literally, later metaphorically. He must confront and assimilate, in its most concrete form, the meaning of death together with the absolute social defilement it entails. His Goddess, his loving Mother in time, who gives him birth and loves him in the flesh, also destroys him in the flesh. His image of Her is incomplete if he does not know Her as his tearer and devourer. The hideous corpses, defiling corpse-handlers, jackals and crows scattering his bones, are Her agencies. She thus has a form he must learn to assimilate into the whole image to which he makes pūjā, and which is not outwardly beautiful at all. It is the hideous form which She assumes when the sādhaka recognizes that to him as an individual She is the girl with the axe or sword, the smallpox, cholera and famine-lady who grins as She drains his blood and cracks his spine. Her body may be black, greyish or dark blue. Her garland is of human heads, Her belt ornaments are chopped-off hands. He may call Her, among other names, Durgā (hard to approach) or Kālī (the power of time), the Goddess to whom buffalo, goats and doves are sacrificed in Her many temples, where the stinking walls and pavements run with blood.

The point is: the graveyard is the gateway to spiritual success, to regeneration and bliss (as being sacrificed is held to be for the animal victims). This fanged and bloody Goddess is the same as the other, the beautiful mother and lover.

99, 101, 103,
87
33

107

93　Manuscript of the Gita Govinda
illuminated with scenes of the loves of
Kṛiṣṇa. Orissa, *c.* 1600. Palm leaf, each 2 × 7 in.

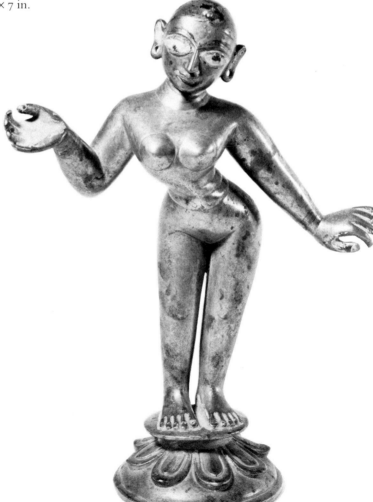

94　Rādhā, naked and adoring. Bengal,
　　　18th century. Brass h. 9 in.

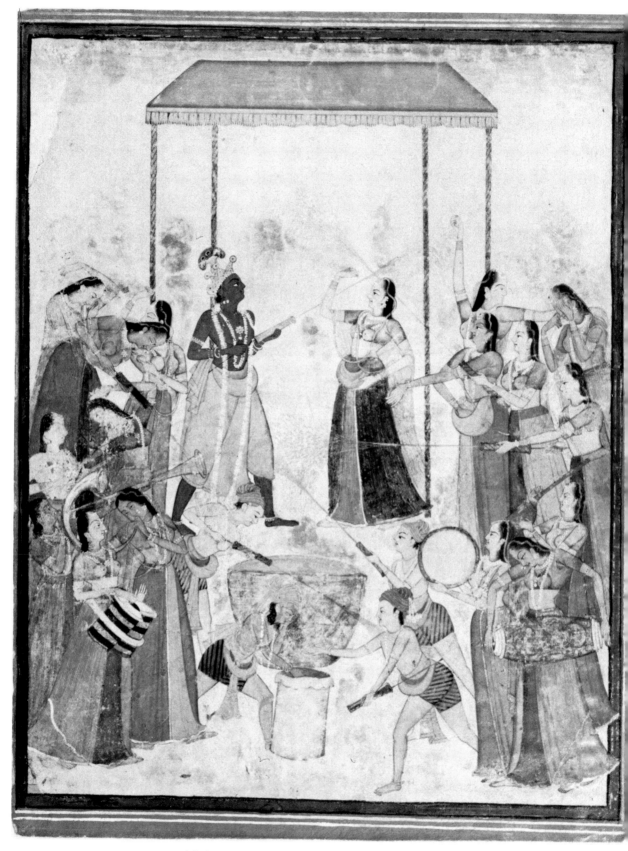

95　Miniature painting representing Kṛiṣṇa and Rādhā celebrating Holi. Guler style,
c. 1780. Gouache on paper 11 × 9 in.

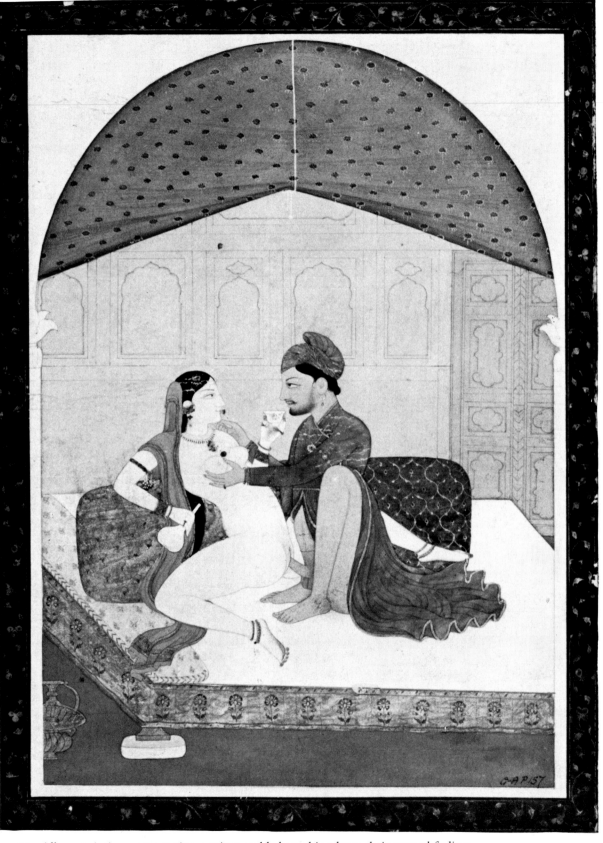

96 Album painting, representing a prince and lady making love, their mutual feeling
enhanced by their 'meeting of eyes'. Kangra, 18th century. Gouache on paper 8 × 6 in.

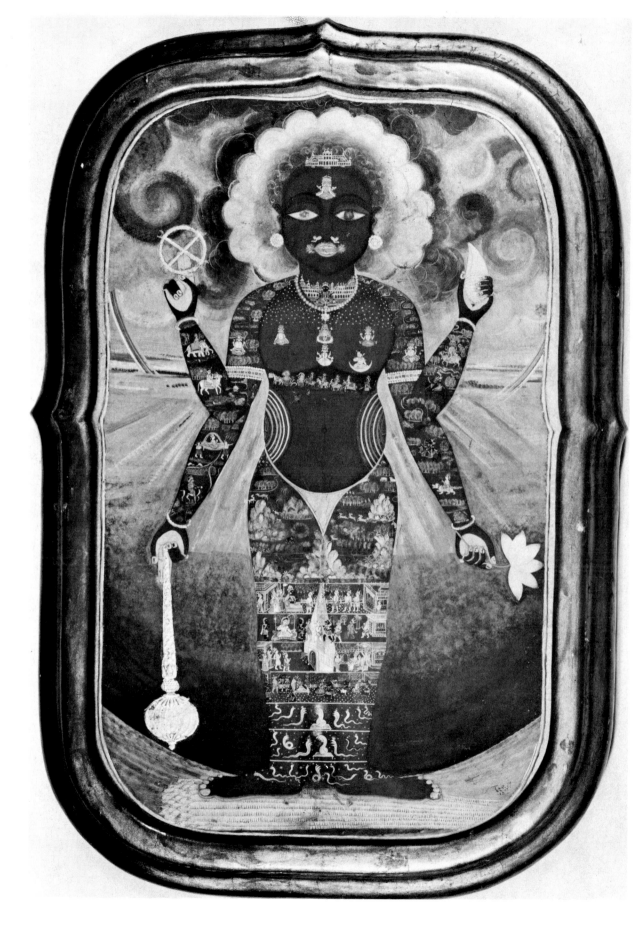

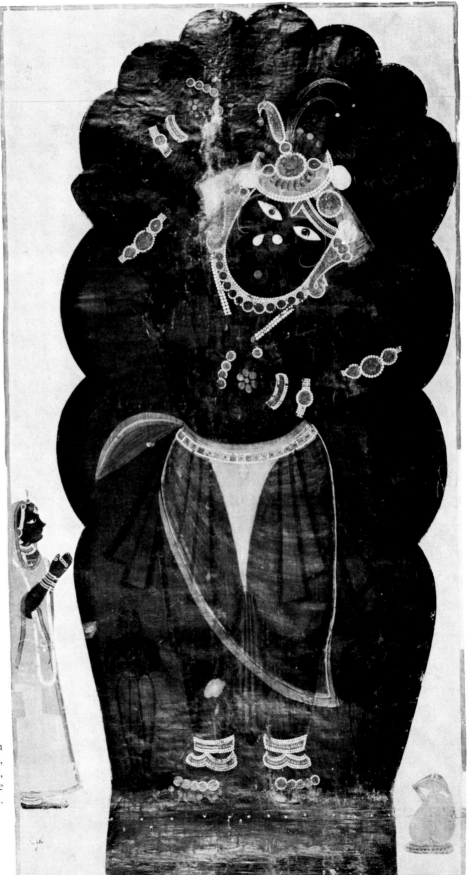

Viṣṇu-Kṛṣṇa manifesting
cosmic form. Jaipur,
1810. Gouache on paper
× 9 in.

98  Śrī Śrī Nāthjī, a form
of Kṛṣṇa as Cosmic Lord,
Purūṣottama. Rajasthan,
17th century. Gouache
on cloth, 60 × 32 in.

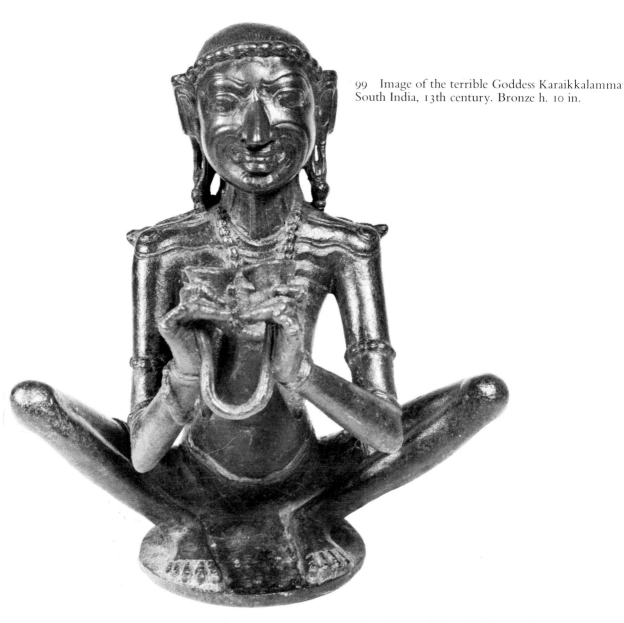

99   Image of the terrible Goddess Karaikkalamma
South India, 13th century. Bronze h. 10 in.

100   The Principle of Fire, the triangular
shapes of the flames completing the fire-
symbolism. Rajasthan, 18th century. Gouache
on paper 4 × 5 in.

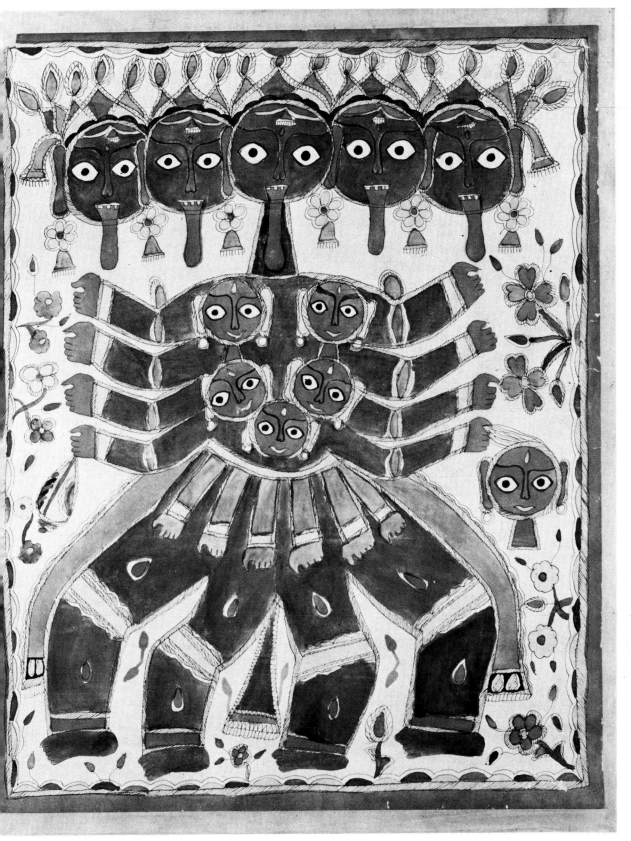

101   Painted folk-icon of the terrible Goddess Kālī, the multiple masks and limbs
expressing diffraction and multiplicity. Madhubani painting, Bihar, modern.
Gouache on paper, 28 × 22 in.

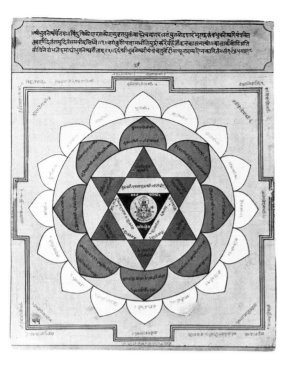

102 Bhuvaneśvarī Yantra, the Mahāvidyā seated in the central triangle. Rajasthan, 18th century. Gouache on paper 13 × 11 in.

103 Album painting, representing the terrible Goddess Kālī triumphant on the battlefield. Rajasthan, Kangra style, 18th century. Gouache on paper 8 × 10 in.

104 Mahāvidyā Chinnamastā seated on the lo which springs from the originating pair, I represented by the blue-bodied Viṣṇu and personification of all fertility Mahālakṣmī. (See also 86). Rajasthan, 18th century. Gouache on p. 12 × 8

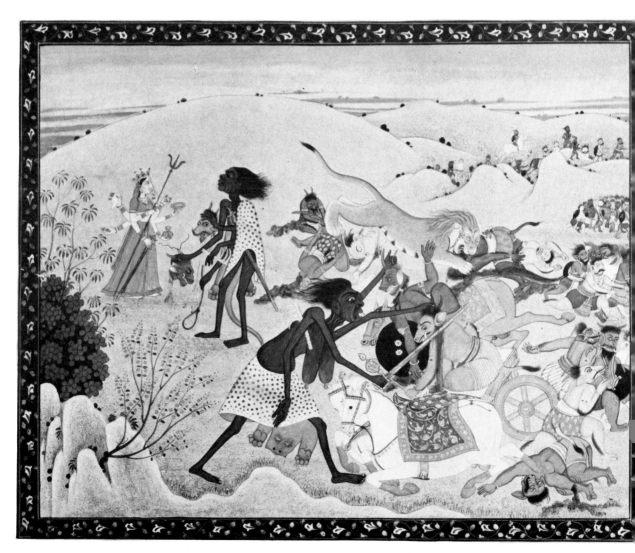

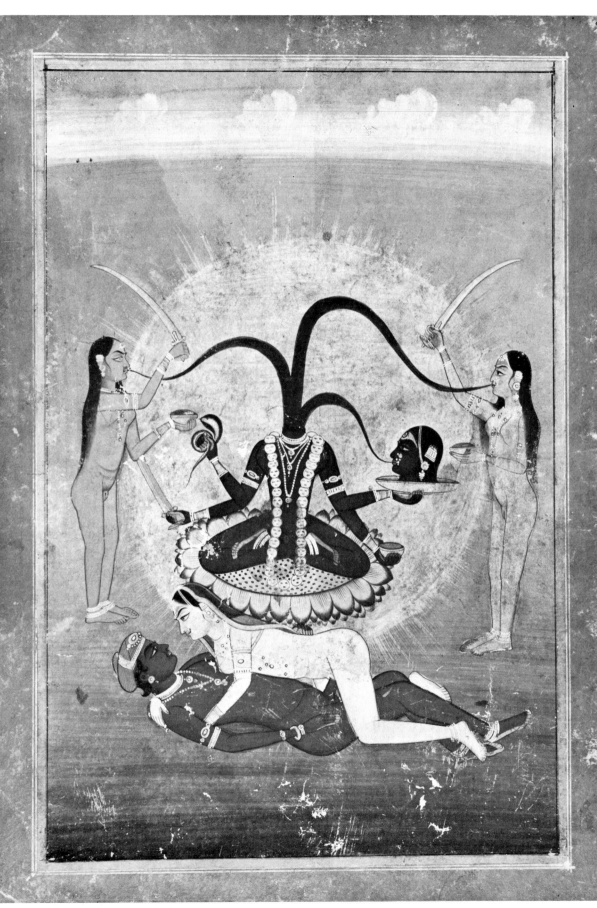

105  Icon of the terrible form of the Goddess as she is known at Kāmākhya, Assam, the sacred spot where the yoni of the Goddess is mythically supposed to have fallen to earth. Rajasthan, 19th century. Watercolour on paper 13 × 10 in.

106  Meditation carpet, with symbols of death reminiscent of the skull-enclosures used by yogīs. Himalaya (?). Wool 82 × 68 in.

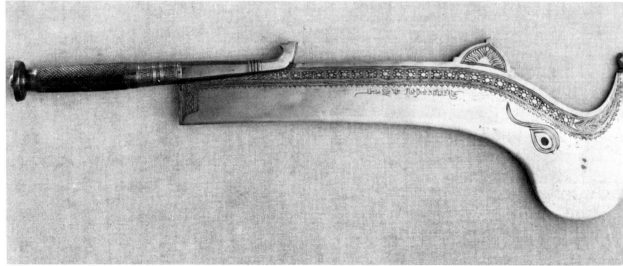

107  Sacrificial sword, as used to slaughter animals at shrines of Kālī. Bengal, 19th century. Steel l. 41 in.

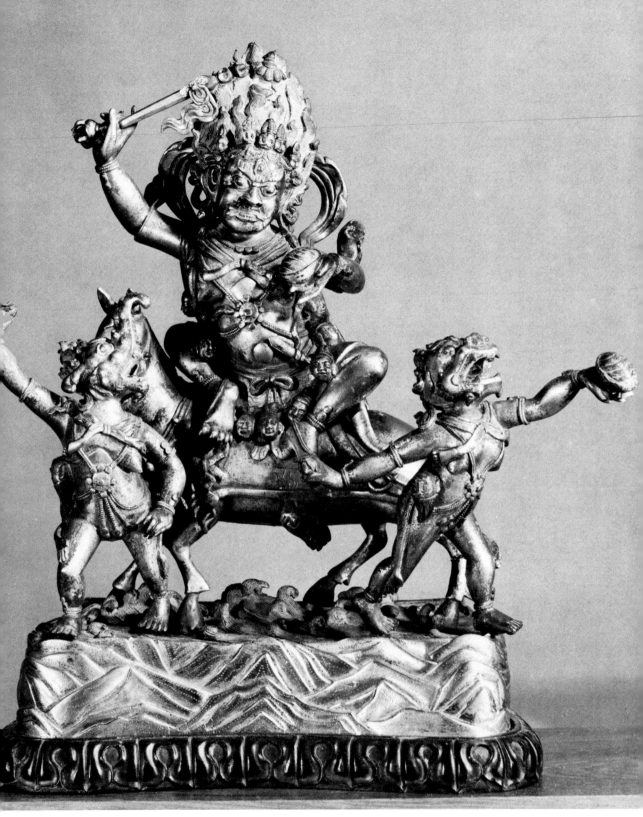

108  The terrible female devatā Lha-mo, a Buddhist form of Kālī. Tibet, 18th century. Bronze h. 14 in.

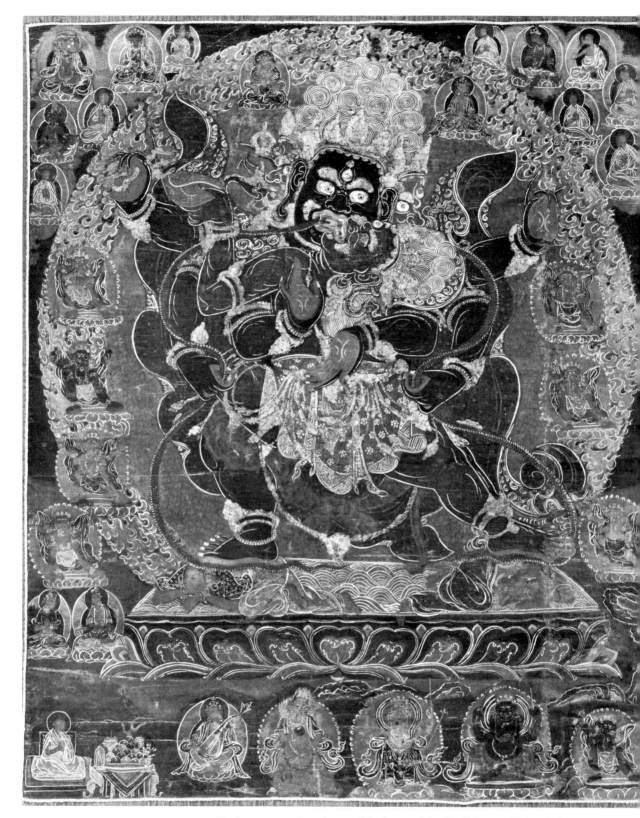

109   Tanka representing the terrible form of the Bodhisattva Vajrapāni, protector
and chief embodiment of the power of Buddhism. Tibet, 17th century. Gouache on
cotton 21 × 17 in.

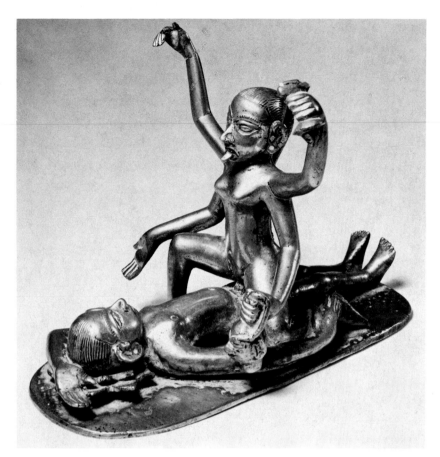

110 Icon of the terrible Goddess seated in intercourse on the male corpse-Śiva, based on a fact of ritual. Rajasthan, 18th century. Brass, h. 5 in.

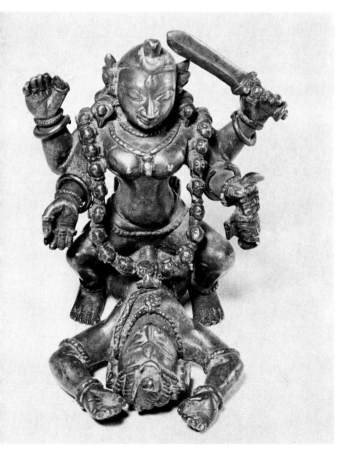

111 Icon of the terrible Goddess Dəkśinā Kālikā, seated in intercourse with the male corpse-Śiva. Orissa, 17th century. Bronze, h. 4 in.

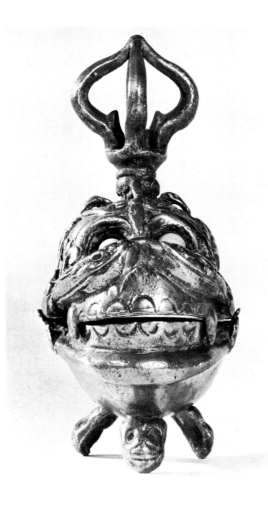

112  Horrific offering vessel.
Tibet, 19th century.
Brass, with turquoise h. 6 in.

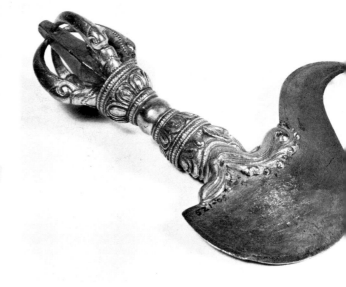

113   Gri-gug, ritual flaying-
Tibet, 18th cen
Bronze and steel l

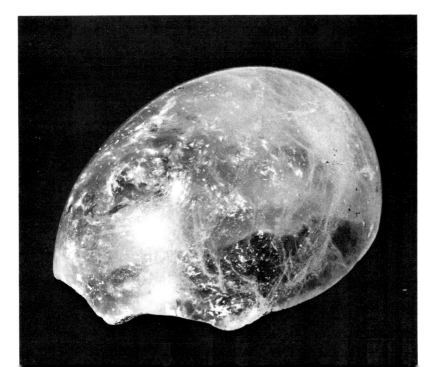

114   Skull cup used in ritual.
Nepal. Rock crystal l. 6 in.

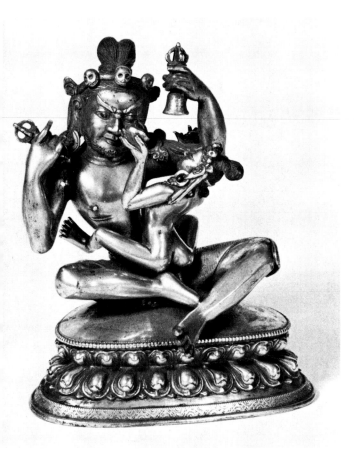

115  Mahāsiddha Gandhapa, in the
guise of the Buddha Vajradhāra,
in sexual union with his female
partner. Tibet, 17th century.
Gilt bronze h. 6 in.

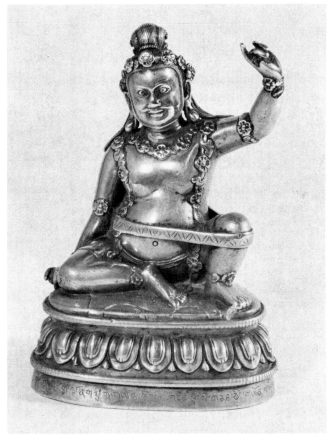

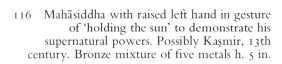

116  Mahāsiddha with raised left hand in gesture
of 'holding the sun' to demonstrate his
supernatural powers. Possibly Kaṣmir, 13th
century. Bronze mixture of five metals h. 5 in.

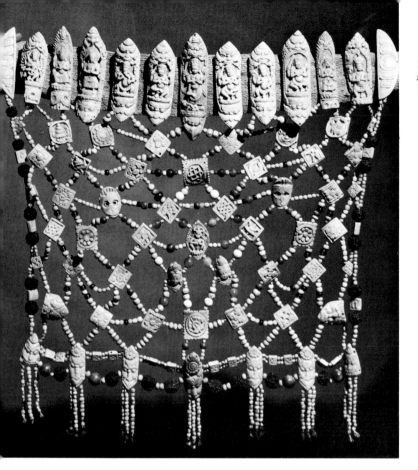

117　Magician's costume of
apron made of human bone. Tibet,
19th century. 21 × 24 in.

118　Human skull mounted as
ritual vessel. Tibet, 19th century.
Bone, with silver mounts l. 7 in.

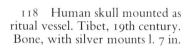

119　Ritual trumpet made of
human thigh bone. Tibet,
19th century. Bone 14 in.

To be able to superimpose and adore both images in one is perhaps the solidest beginning on the road of sādhana. The fire of the funeral pyre is a prime agent of release. Thus in many meditations and innumerable maṇḍala yantras, the first essential step is through the barrier of fire, invoked by its mantras. One can, however, only reach the significant fire after accepting that revolting dissolution of the body, that destruction of the proud and exclusive self, which the graveyard symbolizes. This is something upon which Hindu and Buddhist Tantra agree. Tantrik Buddhist legend tells of saints who gained their initiation from a Dākinī at night in a graveyard, by the red light of dying pyres. Tibetan imagery, based on that of ninth-century Buddhist Bihar and Bengal, uses cremation grounds as standard symbols, and refers time and again to meditation on or in rotting corpses – perhaps the most intimate acquaintance possible with the horrors of mortality. A meditation sequence in 'eight cremation grounds' is a standard pattern, which saints are said to have undertaken in geographical reality. Many Buddhist devatās wear flayed-off skins of animals or men, and flourish skull-cups of blood, flaying knives (gri-gug), axes and bloody swords. The most terrible, perhaps, is Lha-mo, a transformation of the Hindu Kālī; to add a further note of horror, she is said to be 'pregnant with a child of incest' which she later kills and flays to wear its skin. The famous gChöd ritual, which a solitary monk may perform far from human habitation to purge his consciousness, consists at bottom in an act of mystical self-butchery and self-feeding to all demons. Behind the Tibetan shamanized and internalized fantasy lie the extreme external Indian facts.

Indian Buddhist Tantrikas, as well as Hindu, actually did perform their gory meditations, driving themselves beyond the limits of disgust. From the history of the early and middle ages, of course, there is little documentary record. The relatively late Feṭkārini Tantra, for example, states: 'He who does japa many times on a corpse in a cremation ground attains all kinds of success'[16] and the Kaulāvalīnirṇāya gives full instructions for such meditation with appropriate mantras and yantras. But the conduct of Hindu Tantrik sādhakas of more recent times, among whom Buddhist survivals flourish, has been, if reluctantly and squeamishly, described by Europeans. The Aghorīs are known to eat bits of corpse. On the premises here stated that would be a natural Eucharist. Many Śaiva yogīs inhabit cremation grounds. Some meditate in small enclosures built of skulls. Self immolation in all sorts of ways is still extremely common. Sexual intercourse among the corpses is also practised. All are entirely consistent with the doctrine. It is, however, also true that high-born or princely Tantrikas were not averse to using symbolic substitutes for the 'nasty' reality, such as a carpet woven with a skull design instead of the bare soil and rock of a real skull-enclosure.

To Indian sensibilities they would have been even more abhorrent and disgusting than they are to ours. But, of course, they are never done for their

100

114
108

112, 113

106

own sake but for what they mean, for the sake of what lies beyond, on the other side of the fire. Only a love that has driven itself so far deserves the name of Tantrik. This is the underlying sense of the offering of a pubic hair, described in Chapter 3, from the Karpūrādistotram. It could be duplicated many times over from Tantrik text. This is part of the significance of the dancing Red Dākinī so important in Tibetan Buddhist Tantra, who is sometimes cognate with Vajravarāhī who wears a sow's head to the right side of her face. She is the horrible initiation personified, the one that really counts. Her redness, matched to that of the first of the Hindu Nityās, Lalitā, indicates her specifically female energy, complementary to the monk's own white masculine energy.

In recent centuries one particular type of Hindu image of the Goddess has become especially important in worship. It combines directly the symbolism of graveyard sexual meditation with that conception of the original double-sexed deity described in Chapter 1. The image represents the Goddess seated astride a male corpse-like figure, his penis embedded in her vagina. Numerous texts describe her as the beautiful full-breasted Kālī, 'garmented with space' (that is, naked), her hips made beautiful by a girdle of dead men's hands, the crescent moon poised on her dishevelled hair, two trickles of blood dribbling from the corners of her smiling mouth, as she flourishes a sacrificial sword and sits enjoying Mahākāla, the creative lord, both of them using a corpse as couch.

Many versions of this image are made. The Karpūrādistotram states unequivocally that it is upon such an image, at first external but later internalized, that the sādhaka should meditate at midnight, during sexual union with his female partner.

This image has been given metaphysical explanations, in terms of an expanded version of the traditional Hindu philosophy called Sāṅkhya (p. 182). The Goddess sitting alert, writhing and gesticulating, is the kinetic principle of reality, active creation, called Prakṛiti. The male who penetrates and continually fertilizes her into being and action is the principle called Purūṣa, or lord, who though remote, is yet visible, aroused and infusing creation with its qualities. Where he is shown himself lying on another inert corpse, the latter represents his alter ego; this is the completely withdrawn, qualityless and passionless state beyond all being, creatively 'previous' to the projection of the sexual pair and outside of time. The male's head may rest on a yantra of the Goddess, which symbolizes the creative pattern of her activity and suggests that the corpse is an analogue to the sādhaka's own body.

Here is a translation of a Tantrik Hymn to Kālī, from the Mahānirvāna Tantra, which illustrates how many aspects of the Goddess are combined in the Indian imagination. The hymn itself is called 'the own-form of the Supreme Goddess of Time'. Every description begins with the letter K, the Goddess's

75–7

110, 111

88

own seed sound, but it is impossible to reproduce this effect in English. The hymn begins and ends with three great mantras.

HR̥ĪM [a mantra combining the sounds that evoke Lord Śiva (H), fire (R), the great Weaver of illusory worlds (Ī), the sound which generates all others (M), and the ungraspable ultimate point (·)] O conqueror of Time; ŚR̥ĪM [the mantra of the Goddess-form of Good Fortune] O tremendous one; KR̥ĪM, O Kind giver of peace, gifted with all the arts [You are] the lotus-flower smashing the pride of this degenerate age; devoted to [Śiva] with the matted hair, devourer of that Devouring Time, you are bright as the fires that consume the Universe. Wife of [Śiva] with the matted hair, your teeth are fangs, but you are [also] the nectar-ocean of compassion; your whole nature is compassion, compassion without limit, compassion that gives access to yourself. You are fire, female deity of flame; your black body increases the bliss of the Black Lord [Kr̥ṣṇa], and as the very form of Desire you liberate from the bonds of desire. Like a bank of cloud you sustain all the female energies of the Universe, and blot out the evil of our degenerate age; pleased by the worship of girls, you are the refuge of those who worship them, and take delight in the sweet offerings they are given [in shell baskets, when the soles of their feet have been painted pink]. You wander in the Kadamba forest [as the Gopīs whom lord Kr̥ṣṇa loved] and enjoy the [brilliant yellow] flowers of the Kadamba trees [that surround the palace of gems] in which you live, wearing Kadamba flowers [over your ears]. You are young, deep-throated with a voice that resounds [with the battle mantra]. Excited with Kadamba-flower wine, drinking from a skull and wearing a garland of bones, you delight to sit on the lotus [emblem of the unfolding worlds] at the centre of which you belong, intoxicated with the lotus-fragrance. You move swaying like a swan, destroying all fear. Formed as Desire, you live in the place of [sexual] Desire and play there [as Kuṇḍalinī in the Mūlādhāra ćakra]. You are the creeper whose fruit satisfies every wish, hung with those [fruits which are] rich ornaments. Adorable image [and evocation] of tenderness, your body is delicate and small-bellied. You take pleasure in the nectar of pure wine, and give success to those who [in the Tantrik ritual] enjoy this wine [whose name also means the Ultimate Cause of every effect]. You are the chosen one of those who perform japa when high on causality-wine, pleased when it is used in your worship; immersed in this wine-ocean, you protect those who perform rituals with wine. The fragrance of musk gladdens you, your forehead is marked with its [saffron yellow]; used in pūjā musk excites you, and you love those who worship you with it. You are a mother to those who burn musk-incense; you love musk-deer and swallow with pleasure their [aphrodisiac] musk. The scent of [another aphrodisiac] camphor gladdens you, and you wear garlands made of it; your body is all smeared with a paste of camphor and [fragrant] sandal-wood [powder]. You relish wine flavoured with camphor, you bathe in an ocean of camphor, and it is your natural home. You are pleased at recitation of the powerful mantra 'HŪM', which you yourself utter [when conquering demons]. Lady of [noble] Kula family, Kula-Tantrikas adore you, and you reward them; you follow the Kula path yourself, and eagerly point out the path to its followers. Queen of Śiva's sacred city [Banaras], soother of suffering, you give Śiva what he chooses, give him delight, and overwhelm his mind with pleasure. The bell-rings on your toes jingle as you move, and you wear a belt of tinkling bells. You live on the Golden Mountain Meru, and you are the

moonbeam that shines upon it. You are enthralled by recitation of the mantra [of sexual union] KLĪM, for it is your own self. You abolish all the evil intentions and the afflictions of Kula-Tantrikas. Lady of the Kaulas, you destroy the fear of death with these three mantras KRĪM, HRĪM ŚRĪM.

Black Kālī (or Lalitā) is the first of the most important Hindu Tantrik goddess-transformations, the Mahāvidyās; they are ten in number, seven belonging to the creative manifestation-stages of the universe, three to the withdrawal. Kālī is the central deity of time. Her own nature, despite her outwardly fearsome appearance, is pure ecstasy, above all ideas of positive and negative. When in the process of creation Kālī first 'awakens' with a sense of positive existence, seeing herself as the origin of multiplicity, she takes on the aspect of the second Mahāvidyā, Tārā, who is represented as shining dark blue, short with a swollen belly, and rests her left foot on a corpse-icon of Śiva. She wears a tiger skin and a necklace of severed heads. Her face, with its three eyes, wears a terrible grimace of laughter, and her hair is in a single matted braid. She stands on the funeral pyre in which the 'world' is reduced to ashes, but is herself pregnant with the potential of re-creation; for she it is who divides the one into the many. The whole image rests on a white lotus arising from an expanse of water. Her original Buddhist connections are remembered in the small image of the Buddha Akṣobhya appearing on her headdress.

102

The next manifestation-phase is Śodaṣi, red as the rising sun, who sits above a pedestal composed of figures of the Hindu gods Brahmā, Viṣṇu, Rudra, Indra and Sadāśiva. She sits astride the body of Mahākāla (great Time) in joyful sexual intercourse with him. She is the embodiment of the sixteen modifications of desire. As the fourth Mahāvidyā, the Goddess becomes Bhuvaneśvarī, constituting the substantial forces of the material world. She is golden as the rising sun, wears the crescent moon and a crown on her head. Of her four arms two hold the noose and goad, two gesture, offering gifts and comfort; her breasts are swollen with the milk which feeds objectivity into creation. The fifth transformation is three-eyed Bhairavi, red, garlanded with heads, her chest rubbed with gore, crowned, holding a rosary and book. She it is who multiplies herself into the infinity of beings and forms, causing men to run after them for satisfaction.

104, 86

The sixth Mahāvidyā is one of the most important. She is called Chinnamastā. The sādhaka will find her in himself at the level of his navel, inside a full blown lotus containing a field 'red as the hibiscus flower', and surrounded by three circular lines. The lotus rises from a pair of figures representing pure cosmic fertility, a blue male and a female (Mahālakṣmi) analogous to Kṛiṣṇa and Rādhā, in sexual intercourse. Chinnamastā herself sits on the lotus, dark grey-blue and garlanded with heads, holding a snake in one hand, her own head in the other. From her severed neck spring streams of blood, one flowing into the mouth of her own head, others into the mouths of two naked, sixteen-

year-old female figures at each side of her, who hold skull cups and snakes. The female on the right is golden, and called Barṇini; the one on the left is called Dākinī, and is bright vermilion. This transformation-icon shows the goddess distributing her life-energy into the universe, a process symbolized by the streams of blood which pour from her self-severed neck into the mouths of the other two female images to form and nourish them. All three are functions of the Goddess in intercourse with the male. They can be matched philosophically with the triad of preliminary patterns which creative energy is felt to adopt. They can also be looked at from two directions, which correspond to our two approaches to the ladder of Genesis.

These three are, from the side of the material world as the ordinary man knows it after he has climbed high on his conceptual ladder, the dark inert (Tamas), the brilliant and active (Rajas), and the radiance of Being (Sattva). These are called the qualities of objectivity (Guṇas), the most fundamental attributes of reality. From the side of the Goddess they extend themselves from her own nature as, respectively, desire (Icchā), action (Krīyā) and knowing (Jñāna), coloured dark blue, red and bright yellow or white. These particular forms will appear again in later discussion of the cosmic plan.

The seventh Mahāvidyā is the smoky one, the widow Dhūmavatī. She is tall and grim, pallid, agitated and slovenly. Her hair is tangled, her breasts droop and her teeth are gone. Her nose is big, her body and eyes crooked; she rides in a crow-chariot. Horrid and quarrelsome, she is perpetually tormented by hunger and thirst. And so it is she who generates that stage of being where individuals forget their origin, lose contact with their source, and suffer continually the agonies of unsatisfied appetite and defeated hope. This is the bottom, the nadir of creation.

The three next transformations embody the process of return. Bagala sitting on a throne of jewels is yellow, the colour of hope. She is covered with ornaments, and holds a club in one hand with which she belabours an enemy whose tongue she holds with the other. In her, illusion and deceptive conceptualization are recognized and attacked. The ninth transformation, Mātaṅgī, is the incarnation of emotional frenzy. Her complexion is dark, her red eyes roll in her head; drunken and reeling with desire she stumbles like a furious elephant. For she is the phase where the world falls under the intoxication of mantra, Tantra and the longing for unity with Śiva. Finally, as the tenth Mahāvidyā, Kamalā, the lotus-lady, Śakti appears as pure consciousness of self, bathed by the calm water of fulfilment, which four golden elephants pour over her with their trunks. She holds a pair of lotuses, and her whole body is golden. She is enjoyer and enjoyed, the state of reconstituted unity.

These Śakti-transformations may be worshipped separately, in series, or even in combined images symbolic of transitional stages. Each one of them represents a limitation of the total persona of Kālī herself, but is an inevitable

part of that whole. Without the drastic experience of disintegration, no search for integration means anything. Kālī must be known in the full gamut of her transformations. For:

'As white, yellow and other colours all disappear in black, just so do all beings enter Kālī.'[17]

A special adaptation of the graveyard symbolism is found in many Nepalese Tantrik diagrams and paintings. Nepal has long occupied a special place in relation to Tantra, for the Muslim invaders who drove the Tantrik Buddhists out of Northeastern India in the twelfth century never conquered that kingdom. Tibet and Nepal, as well as Bhutan and Sikkim in the Himālaya, welcomed Tantrik Buddhist monks and refugees from the plains. But whereas Tibet, Bhutan and Sikkim became completely Buddhist, incorporating the residuum of shamanic cult, such as Bon-po, into their new religion, Nepal also remained Hindu. So in Nepal Tantrik Buddhism and Hinduism have flourished side by side, influencing each other, and combining their doctrines in a quite individual way. Nepalese art combines the iconography of Hindu Tantra with that of Buddhism more intensively than any other, so that, for example, the Buddha-families of Indian and Tibetan Vajrayāna are often found integrated with Hindu symbolisms, even including that of Kṛiṣṇa.

In Nepal the graveyard symbol was synthesized for meditative purposes with the ancient Vedic sacrificial ground. Diagrams of this appear in many manuscripts which give prescriptions for meditative acts. The Hindu altar with its fire assimilates the symbolism of the pyre towards which the inner pūjā is directed; and all around the graveyard are placed mixed Buddhist and Hindu emblems, arranged in directional patterns. The meaning of all such maṇḍala forms will be discussed later, in Chapters 9 and 10.

11, 89

In both Tibet and Nepal a number of devatās, both male and female, appear in the iconography wearing furious expressions, often having grossly swollen bodies with exaggerated sexual organs. Far the greater part of these are of Tibetan inspiration, and are imbued with a spirituality which is not of an Indian type. Since this survey is not broadly concerned with Tibetan art, only that aspect of these deities which has a special bearing on Indian Tantra will be discussed. But first it might be as well to mention that the Buddhism with which they are associated has been reduced by the German-born Lama Anāgārika Govinda[18] to a superbly developed abstract system, mobile and not at all static, beautifully co-ordinated with the enormous volume of other westernized Buddhist scholarship. But all such work, despite its great intellectual and intuitive beauty, must lack for us the dimensions of real life. Institutionalized and schematic as it is, Tibetan Buddhism in practice works within an all-embracing context of lived ritual; its monks are everywhere seen to be flesh and blood, and in the minds of its followers its imaginative *dramatis personae* are rich with that meaning and experience which can only be absorbed

from living culture, and can never be conveyed in Western conceptual prose. The mysteries of meditative experience are always meaningless without a base in reality. So extreme has the process of conceptualization become in the interpretation of Tibetan Tantra that Westerners are in danger of losing touch altogether with its existential base. For this reason what will be stressed here is the root of the art in actuality, rather than its scholastic refinements which can be studied elsewhere. One must never forget that even the most obliquely metaphysical iconography can only mean anything at all by virtue of its ultimate semantic reference back to the realities of human experience. Where Oriental art is concerned, the stronger that connection can be made the better. Buddhist authorities, like Hindu, have developed a glib verbalism of their own which can flatter the sense of achievement without committing one to real effort. The intrinsic negativity of Buddhist modes of expression causes the greatest semantic difficulty for the arts.

The two main classes of object which constitute the Tibetan type of art are the small bronze shrine-image and the tanka painting. Both are intended as temporary dwellings for the spiritual, but at the same time illusory, beings into which this Buddhism projects its analysis of the nature of the world. They are thus not aesthetic objects but roosting places, actual dwellings for energies projected into them with the aid of mantras, which are often inscribed on the objects; the power of those energies can thus be canalized towards the Buddhist goal. The shrine images were meant to be set out on altars in arrangements which met local, seasonal or purely temporary magical and spiritual needs. They could thus make three-dimensional maṇḍalas, for example. The tankas could summarize very large-scale arrangements in two dimensions which would be impossible to realize in three. The brocade mounts in which these painted icons are contained had an important magical function. They symbolize the cosmic 'doorway', its pillars and the radiance of the deities represented.[19] Tankas could more easily be used by monks for personal meditation than the shrine images. And since Tibetan meditative rites always incorporate long sets of moving and complex visualizations, resembling a kind of internal cinema-film, tankas could provide the monk with patterns necessary for his inner imagery in its many stages.

The horrific deities probably have their roots in the old Tantrik cult of the Mahāsiddhas, great successful Tantrik saints. They appear in numerous stories and texts which recount their lives, and a canonical number of eighty-four has been fixed. Most were probably historical characters, gurus in one or other tradition, though a good deal of myth and symbolic fantasy surrounds them. They are the ones who have lived successful Tantrik lives, performing innumerable rituals, and reached the goal. One of the most important is Padmasambhava, the founder-guru of the Red Hat sect in Tibet in the ninth century AD. He is often represented on Tibetan tankas. Such saints are not at all like the

11, 90, 108

109,
115, 116

24

saints of most other religions. They have features in common with the description of Abhinavagupta (p. 110); above all, their icons display an immense, quasi-demonic energy in their strong, well-cared-for bodies and violent eyes. They probably embody folk memories of the magical dances performed by shamans possessed by spirits. Certainly the images of horrific deities from Tibet owe a good deal to such shamanic cults. And in all of Buddhist Tantra the doings of the Mahāsiddhas are bound up with ćakras, graveyards, initiations and magic; the very term applied to one group of the principal horrific Tibetan devatās, Herūkas, was originally a term applied to high-ranking sādhakas. For all their heightened attributes, the Mahāsiddhas were at bottom real people.

117–19

With the violent figures of Tibetan and Nepalese art, however, the connection with reality has been stretched to breaking point.

The expressions of passion or rage which the horrific devatās wear signify an inconceivable degree of energy; their immensely swollen bodies, violent gestures and copulations demonstrate their limitless libido; while their aureoles of flame and smoke refer symbolically to supernatural energies released in the cremation ground. Such devatās are evoked into their painted or sculptured images primarily when power is needed, either for protection or for carrying out magic. The very exaggeration of their appearance to the point of caricature shows that they belong to a world of projected fantasy; though the people who use them, of course, do believe in the existence of demonic elemental beings. But even when such images are meant as outward guides to inner forces and realities, the high key of their expression can only be acceptable on the assumption that they have left all flavour of real act behind. No meditator could experience such intensity and live. They are graphic symbols, not invitations to the same kind of self-identification as Hindu images.

109
11

This means that, apart from a number of basic canonical patterns, Tibetans may make relatively free use of their iconography. Fresh combinations of imagery can be composed by the painters for different people and occasions. The demonic figures are, so to speak, a reservoir of characters from which any number of metaphysical ritual dramas can be woven, so long as certain accepted lines of transmutation are followed. There are stories and paintings which recite, say, how a symbolic demon is defeated by a Buddha who transforms himself into a terrible male Bodhisattva, who couples 'without attachment' with circles of hideous female guardians of the castle of evil; the females have beast heads, and their progeny share the nature of their father and mothers; the Bodhisattva then ravishes the demon's hideous wife at the centre of the castle, breeding from her, and finally enters the demon, splitting and transforming him. Such mystical allegories of the 'spirit' making its own use of the violent and horrible energies of 'matter' may be extremely absorbing to

us, who do not share their inventor's lives, as fantasy. But they may seem to depart a long way from any familiar actuality in which Tantrik transformation can be rooted. Their truth, however, is meant to lie in the subjective insights they induce. One may remember that Buddhism does not claim any sort of 'higher objectivity' for its images.

# 9 Cosmograms

In this chapter are discussed diagrams of the world, which provide a background to sādhana. Many writers and collectors have come to think of them as the essence of Tantra art. In fact they illustrate ideas which are Indian rather than Tantrik, and in so far as they affect Tantra belong to a grade of expression which is calculating rather than emotive, dealing with the cosmos in terms of an ancient and stereotyped popular imagery. Far the larger proportion of them are Jaina; and Jainism is not interested in important aspects of Tantra. Jainism believes in a world composed of separate entities, some of which may obtain release, and is therefore interested in numerical calculation. It also holds that each of the infinitely great number of entities in the Universe is related to all the others, and that to know even one truly demands an intuitive knowledge of all its relations to all the others. Hindus and Buddhists, of course, do not believe in the existence of separate entities, but that every apparent entity is only a ripple on the surface of an undefinable whole. So they have not the same interest in pure calculation as the Jainas, though their sense of scale is no less developed. Thus where Tantra is white-hot vision the Jaima diagrams are cold reckonings; where Tantra is kinetic, the diagrams are static; where Tantra involves emotion, they are conceptual. They represent the most intellectualized and outward-looking aspect of the Indian world-image, at the point where it is perhaps at its weakest in relation to modern scientific constructs. Such images are not necessary for Tantra. Major texts do not bother to mention them; and twentieth-century Tantra cannot work within their patterns. But they do have important transformation functions which are consummated in the imagery of the Universal subtle body discussed in Chapter 10.

The flat, circular diagrams illustrate versions of a widespread Indian idea of the layout of the earth. It is, so to speak, the same sort of *a priori* map of the world as was drawn by medieval European scholastics before exploration or mapping had progressed very far, save that it is conceived on a vastly larger scale. It is called Jambudvīpa.

Some Hindu diagrams relate this image to the development of the contents of the Cosmic Egg, an old Indian notion of Genesis appearing in Upaniṣad, notably the Chandogya, which is not strictly Tantrik but is relevant to a large number of Tantrik objects. It resembles an Orphic cosmogony which

survives from Greek antiquity. The first division of creation, it says, was between 'that which is', in the form of a radiant egg, and 'non-being', in the form of dark waters. The egg consisted of the condensed mass of all the gross and subtle elements which were to compose the world. It then split apart to make the silver earth and the golden sky, its veins becoming the waters of earth, in the manner of the Jambudvīpa diagrams. Progressive sub-division of such an egg is one of the ways in which the process of differentiation and creative evolution can be expressed by bands and areas of colour.

This image is easily reconciled with Tantrik thought, and the symbols of the cosmic egg are readily identified with those of the Svayambhū lingam described in Chapter 12.

At the centre or hub of the expanding Universe is the mythical Mount Meru, around which is Jambudvīpa, with its continents, countries, great rivers, seas, circling planets and constellations. This arrangement cannot be said to be in any way objective. It simply will not serve any longer as a genuine point of junction between the 'objective' cosmos as we now conceive it and the valid 'subjective' cosmos which Tantra projects. However, the significance of these diagrams is purely subjective. They mean that the 'reality' to which they point in a generalized way has no value or meaning, and is not a valuable act of theophany. For Tantra their message is that one should gather the outer world into a single contemplative act. The Mount Meru at the axis should be identified with the centre of the inner body through which runs as axis a subtle spinal tube called 'Merudaṇḍa' or 'Suṣumnā'. The implication of the diagrams is thus that the possible Universe each man knows is a flat 'circle' radiating from his own axial centre.

In fact the same cosmic image underlies the ground-plan of the normal Hindu and Jaina temple. The spire above the main icon, through both of which the axis passes, represents Mount Meru; around its lower slopes the 'heaven bands' filled with sculpture are slung like garlands. Away from its plinth stretches the earth, with its continents, rivers and seas – which are in this case 'actual' and convincing, instead of purely 'notional' as in the diagrams. By the same link of the 'Merudaṇḍa' temple and body are likewise equated. As is explained in the first chapter, cosmos and body are seen in Tantra as functional variants of the same energy-pattern.

This axis is the creative centre from which the expansion of the world is reckoned as taking place, as the petals open in a lotus flower. Therefore the axial centre is often shown as occupied by the central image of each particular religion, the Jina in Jainism, the Buddha in Buddhism, a lingam, a temple or 'Oṁ' in Hinduism (and sometimes in Jainism). The saint is a saint because he has become identified with the centre. He also knows the outer beyond, having stepped across the limits of the Universe. Hence saints may also be shown at the cardinal points on the edge of the diagram. In Hindu and Buddhist

120

Tantra the seminal devatā is the invisible centre. The Goddess is the energy which makes real the outer and inner worlds, the complementary images of object and subject, spinning them out from the centre, as a spider spins a web from its own body, into the open space of Being. Metaphorically, she gives them continual birth, while she herself is continuously infused with impregnation from the subtle, self-originated liṅgaṁ, which conveys into all her activity the seed of Being hidden beyond and within. The ordinary Jaina cosmic map, which is intended more as a piece of stupendous reckoning, can thus be used by those who know how as a Tantrik maṇḍala, to focus their attention upon that centre point, the subtlest of the subtle yet all-embracing, from which is generated the whole of reality. And that Jaina reality may include number carefully calculated in concrete elements of time and space, of the order of 10,000,000,000,000,000,000,000,000,000,000,000,000.

Obviously each actual man, each temple and each diagram would seem to us to have a different centre in objective space. The Indian notion, however, is that there is no such thing as a dead, external objective space. All spaces are subjective; all worlds exist in relation to men, and, according to a universal relativity, there is no non-relative absolute point of reference to which they can all be related. Every centre is thus an epiphenomenon, an adequate location where anyone can relate to the 'real' centre; and provided a man can identify himself adequately with his own centre, maybe with the help of a maṇḍala diagram, he can begin Tantrik work. This will also involve him in a movement upward, along the vertical direction of the axis, as it were, from the central summit of the Meru-peak. His psychic energy gathered at the central point is able to penetrate upwards out of the realm of material form. This three-dimensional movement will be discussed in the next chapter.

Certain of the diagrams here, however, take a more philosophical view of the cosmos. They show it in a metaphysical side-elevation (as well as in ground-plan) as a kind of flower-calyx, a world-tree, or as the section through a layered tube. Here too the central thread is the infinitely subtle creative world-axis; and its successive envelopes illustrate stages of progressive 'density' in which that axis is enclosed (called Kośas) as the 'world' crystallizes around it. These, though diagrammatic to the scholastic eye, can be seen by Tantrikas as images of the Goddess-function, alternative icons of her joyful play.

Truly Tantrik use of the flat cosmic diagram in meditation is described in the Tantrarāja Tantra. It places the great Goddess Lalitā, the highest of the Mahāvidyās, at the centre, above the golden Meru. Around this radiates the vast circuit of earth with its rivers, all surrounded by successive oceans of salt-water, sugar-cane juice, wine, clear butter, curd, milk and plain water. Obviously such an image is no mere calculation diagram, but a representation 'drenched' in symbols for sense-appeal. The special Tantrik vision comes, however, with the outermost circuit which envelops all these. It is the gigantic

122

126, 127

123

wheel of time, set into complex motion by the creative desire of the Goddess. It has twelve shining spokes summarizing the months, and in it are incorporated the planetary cycles and the motions of sun and moon. To move from the outside towards the centre of such a maṇḍala is, of course, to move beyond the partitioning scope of time.

All the diagrams discussed so far are spatial. They picture the extension of the world into surrounding space as if it were eternal and changeless. This, of course, is only a necessity of human thought. Nothing exists in space without existing in time; and time is seen by Tantra as a field no less important, but far less representable, than space. Creation is time; the Goddess in her function as 'measurer' (Māyā) weaves the substance of events in time, just as she does in space. It must be admitted that all Indian thinking on time, including Tantrik, is far less sophisticated than that on other aspects of creation. This, as was explained in Chapter 3 (p. 41), has to do with something that might be called the 'boredom of immensity'. On the vast time-scale imagined by Indian thinkers, variation and individuality seem to mean nothing. Each apparently unique pattern of events is felt to be the result of overlapping cycles of differing rhythm, conceived, perhaps, somewhat too spatially, always reproducing eventually a resonance they must have produced before. We must be aware that in our own physiology life, with all its rhythmic functions of breath, heartbeat, peristalsis and cell-change, structures each animal's sense of time in a way which may be paralleled on the cosmic scale. Even among stellar events, however, there may seem to be a process which demands instability, non-recurrence, and perpetual if often scarcely perceptible changes of rhythm, the essential asymmetry of time.

Observing the movements of the moon and planets and the (apparent) movements of constellations is the chief Tantrik method for recording and relating individual histories to cosmic rhythms. The reason for this is that astrology, as a means for calculating a person's destiny and prescribing his best course of action at given times, has always been taken very seriously in India by followers of all religions. The market-astrologer is a common sight in every town. Kings have built large observatories to increase their astrologers' efficiency. Conclusion-sheets from the Jaipur observatory founded by Jai Singh, as well as brass astrolabes from Rajasthan, especially Jaipur, are well-known examples of this diagrammatic art.

In addition the Tantrik sādhaka, according to certain traditions, should relate his pūjā, meditation and magically effective rites to the days, the phases of the moon, the times of the year and the positions of the planets and constellations. Many Tantrik works of art therefore contain elaborate calculation-systems resembling coloured checker-boards by which the sādhaka can work out the necessary correspondences. These 'magic square' devices are also used as a way of producing an incalculable variety of mantra-combinations, by

128, 132

92

125
25

inscribing or imagining devatās or mantras in the squares of such a checker-board, coloured in symbolic colours, and doing japa across the board according to different patterns and parameters. This is a subject which still needs investigation by mathematically-minded Sanskritists.

Time, it must always be remembered, however it is calculated, is still to the Tantrika the field of the Goddess's play; her most important name is Kālī, 'Time'. One of Śiva's names is Mahākāla, 'Great Time'. Hence it is most important for sādhana to incorporate a comprehensive imagery of time. This can be done by making and meditating on a special kind of yantra.

Here is one description of how the whole system of worldly time can be summarized and incorporated into such a yantra. It includes visualizations that can be used for identifying iconography. The passages, which are translated from the Mahānirvāna Tantra, are put into the mouth of Śiva himself.

Now I shall speak of the yantra of the Planets, which promotes all kinds of peace. If the guardians of the directions and all the planets, Indra and the others, are worshipped in it they grant all desires. Three triangles [two downward pointing, one upward] should be drawn [intersecting to give nine smaller triangles] with a circle round them, and eight petals touching the circle. Then around it should be drawn a beautiful city-plan with four gates. Between the east and north-east corners a circle should be drawn . . . and another between the west and south-west corners. Then the nine triangles should be filled in with the colours of the nine planets, and the left and right sides of the middle triangle should be made white and yellow, the base black. The eight petals should be filled in with the colours of the eight governors of the quarters [of the world]. The walls of the city-plan should be decorated with white, red and black powder, and, O Goddess, the two [extra] circles . . . should be coloured, the upper red and the lower white. . . . In the inmost triangle the Sun should be worshipped, and in the angles on the two sides his Charioteer [Aruṇa] and his Radiance [Śikhā]. Behind the Sun with his halo of rays the standards of those two fierce ones should be worshipped.

Then worship [the Moon] the maker of night in the triangle above the Sun on the east; in the south-east Mars [Maṅgala], in the south Mercury [Budha], in the south-west Jupiter [Bṛhaspati], in the west Venus [Śukra], in the north-west Saturn [Śani], in the north Rāhu [the ascending node where the moon cuts the ecliptic in passing northward], in the north-east Ketu [the moon's descending node], and last, encircling the Moon, the crowd of Stars. The Sun is red, the Moon white: Mars is tawny, Mercury pale yellow-white, Jupiter yellow, Venus white, Saturn black, Rāhu and Ketu variegated. . . . One should meditate on the Sun as having four hands, one pair holding lotuses, the other pair making the gestures of dispelling fear and of blessing; the Moon should be visualized as holding nectar in one hand, giving with the other. Mars should be slightly bent, holding a staff in his hands. Mercury, the Moon's son, should be meditated on as a boy with locks of hair loose on his forehead. Jupiter [who is the Guru of the Gods] should be seen to have a sacred thread [like a Brahmin], holding a book in one hand and a rosary of Rudrakṣa berries in the other. Venus, who is the Guru of the Demonic beings, should be blind in one eye, and Saturn should be lame; Rāhu should be visualized as a severed head, Ketu as a headless trunk, both deformed and evil.

When one has worshipped the planets in this way the eight Governors of the directions should be worshipped. First, Indra [in the east], he of a thousand eyes, his body yellow and dressed in yellow, holding a thunderbolt, sits on the elephant Airāvata. Then Agni [in the south-east, the god of fire] sits on a goat holding his axe; Yama [god of death] is black, holds a staff in his hand and sits on a bison [in the south]. Nirrti [in the south-west] is dark green, holds a sword, sitting on a horse. Varuṇa [the god of the waters in the west] who is white, sits on a Makara monster, holding a noose. Vāyu [the god of air] should be meditated on as radiantly black, sitting [in the north-west] on a deer, holding a goad. Kuvera [the god of wealth] is golden, sitting [in the north] on a jewelled lion-seat, holding a noose and goad in his hands, surrounded by spirits singing his praises. Īśāna [in the north-east] sits on a bull, holding a trident in one hand, giving blessings with the other. He wears tiger-skins, and glows like the full moon. When one has meditated on these deities and worshipped them in order, Brahmā [the creator Devatā] should be worshipped in the upper [red, extra] circle outside the maṇḍala, and Viṣṇu in the lower [white] one.

Then the guardian gods at the city gates should be worshipped. Ugra, Bhima, Pracaṇḍa and Īśa are at the eastern gate; Jayanta, Kṣetrapāla, Nakuleśa and Bṛhatśiraḥ at the southern; at the western are Vṛka, Aśva, Ānanda and Durjaya. Triśirah, Purajit, Bhīmanāda and Mahodara are at the northern gate. All have armour and weapons, to protect the gates.

But listen now to the imagery of Brahmā and Ananta [Viṣṇu the eternal]. Brahmā is the colour of the red lotus, with four arms and four faces. He sits on a swan [Haṁsa, whose name relates to ahaṁ, meaning 'I' or 'self']; with two hands he gestures dispelling fear and granting requests, with the two others he holds a garland and a book. Ananta is white like snow, Kuṇḍa blossoms and the moon. He has thousands of eyes and feet, thousands of hands and faces [as Cosmic Form], and he should be meditated on by all Gods and demonic beings . . . Now listen to the mantras in their order [and the acts of pūjā appropriate to each devatā].

The above description should show clearly how Tantra thinks of the forms by which we reckon time, and should explain its interest in astrology. Like the Hellenistic and Renaissance Neo-Platonists of Europe it saw the time-scales and rhythmic systems of the cosmos as an important aspect of the 'clothing' or 'narrowing down' by Śakti of the Puruṣa. It interprets all the 'clocks' of the Universe as functionally related to man. To us nowadays the symbolism may seem inadequate. But we have yet to conceive the symbols for setting our own whole selves into a valid relationship with the intellectual concepts by which we record our knowledge of parts of our cosmos. Tantra is meant to set the mind in a position from which it can assimilate forms extended in time. If the circuits of time and space which constitute the human world of experience are represented as plane discs centred on the axial thread, the vertical co-ordinate of the thread itself can be used to express the relationship of that world to the creative energies which shape it. The three-dimensional image which results may be conceived in two ways, following the principle of equating cosmos and human body. First, from the outside, by the Jaina's calculation, the

cosmos may be recognized as a vast analogue to the human body, macrocosm to microcosm. Second, by the essential Tantrik approach, the subtle form of the human body may be seen as a subtle form of a cosmos no less vast but totally alive.

The disc of the experienced human world is imagined by the Jainas as radiating from its axis on the level of the genitals, at the bottom end of the spinal Merudaṇḍa. The vertical dimension is used in Jaina diagrams to express the relationship between the two eternal principles which the archaic Jaina philosophy recognizes. Pure spirit at the top is involved with pure matter which sucks at it from the bottom. The vertical dimension from top to bottom thus expresses the notion of progressive density and inertia. The human world-disc lies part-way between the 'highest' levels of the most remote and subtle radiant principle and the 'dark' and more 'inert' levels of existence which culminate at the bottom in total darkness and dissolution. It is possible for men, in the course of their many rebirths, to perform their Jaina ritual duty and struggle up the stages through the upper levels to blaze finally into release. They can also subside, if they fail to try properly, through the lower stages towards complete inertia in the embrace of uttermost matter. The checker-board patterns give an imaginative reckoning of the colossal periods of time the spirit must pass at any level. Added together they amount to the entire time-cycle of the cosmos. The Jaina does indeed see the achievements of his saints in a perspective at which the numerical imagination boggles. And it may well be that it is the 'materialist' and mathematical formulation of the Jaina diagrams which gives them such a special appeal for modern Westerners.

Although such detailed structures of the cosmos are best known in Jaina works, a similar pattern can also be found in Buddhist and Hindu psycho-cosmograms. In general, however, neither Hindus nor Buddhists believe in an absolute matter.[20] Even the very lowest levels of existence are themselves functions of the highest principle. Indeed the Indian philosophical structure to which Jainism is most closely related, the Sāṅkhya, is that which gives Tantra its special character. The difference between the two is primarily one of value. The ultimate principles, Puruṣa as pure spirit, Prakṛiti as pure matter, are the same in name. But Jaina philosophy refuses any further intuition, and following its belief in separate entities, asserts first that Puruṣas are many, so that the spirits incarnated successively in all the orders of living creatures are all distinct from each other even when they are released, and second that Prakṛiti, the matter in which these spirits are entangled and from which they struggle for release, is absolutely undesirable and valueless save for the lessons it can teach.

Tantra holds exactly the opposite view. Puruṣas are all sparks of the one ultimate Puruṣa; Prakṛiti is the creative Goddess, herself a projection from the original One; she is in a sense void, because that which contains everything

131

134

60

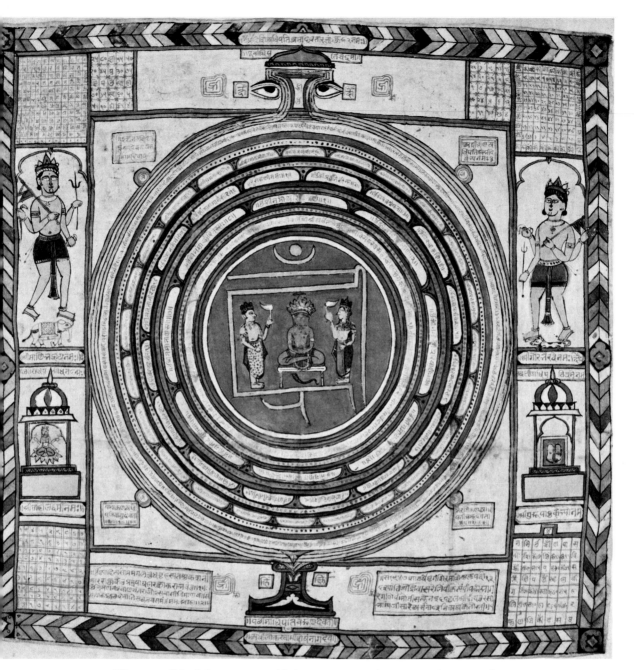

120  Diagram of the Jaina cosmos with its seven separating oceans, interpreted as a cosmic body, with 'Oṁ' at the centre. Rajasthan, 19th century. Colour on cloth 27 × 29 in.

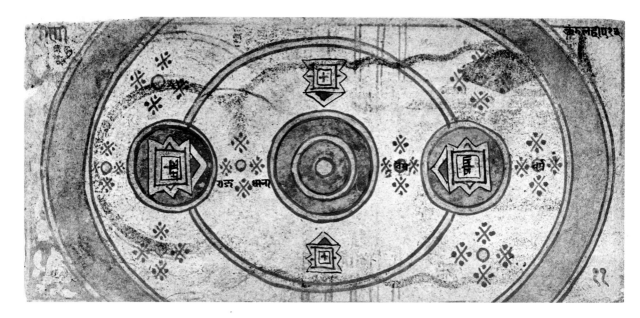

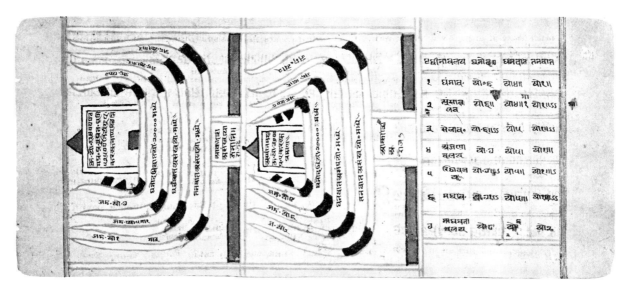

121 Diagram illustrating the directional conformation of the worlds and heavens as they crystallize and separate from within the cosmic egg. Rajasthan, 18th century. Ink and colour on paper 5 × 10 in.

122 Jaina diagram from a page of a Samārariganasūtradhāra illustrating a 'side-elevation' of the Jambudvīpa world, with envelopes of progressive density towards the centre, where Mount Meru stands; the base-square is the region of moving aether. Gujerat, 16th century. Ink on paper 4 × 10 in.

123 Jaina diagram illustrating the stream of subtle moving aether passing through envelopes of increasing density to a world-sphere. Rajasthan, dated 1712. Ink and colour on paper 4 × 10 in.

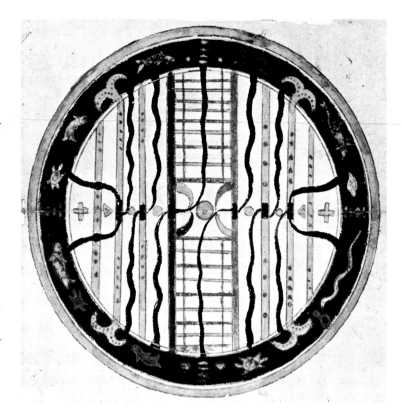

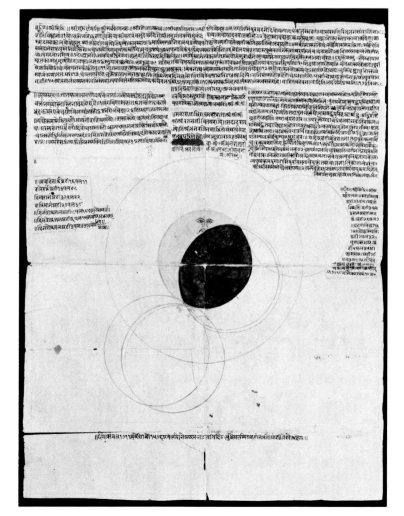

124 Diagram of the world of Jambudvīpa with its seven streams of water, Mount Meru at the centre. Rajasthan, 18th century. Ink and colour on paper 9 × 9 in.

125 Astrological diagram of an eclipse. Rajasthan, 16th century. Ink and colour on paper 24 × 19 in.

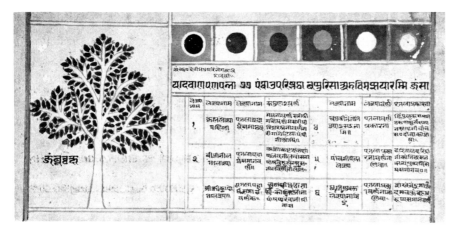

126 Diagram from a Jaina manuscript illustrating the Jambuvṛikṣa, the radiant world-tree whose growth is reflected in the different levels of the Universe. Gujerat, 16th century. Colour on paper 4 × 10 in.

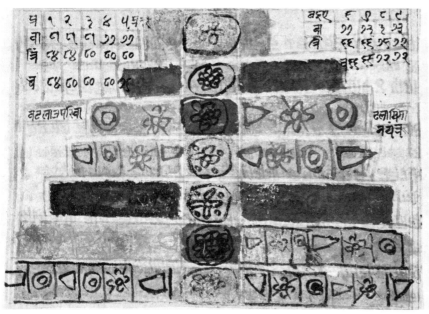

127 Schematic Jaina diagram of the successive levels of the radiant world-tree, Jambuvṛikṣa, at which the levels of the Universe are reflected. Rajasthan, 18th century. Ink and colour on paper 4 × 6 in.

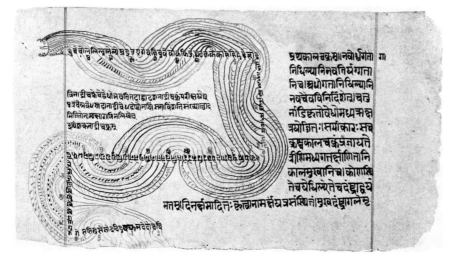

128 Jaina diagram illustrating the eternal recurrence of the sevenfold divisions of the Universe as a cosmic river of time and reality, from a manuscript of the Samārangaṇasūtradhāra. Rajasthan, 1712. Ink on paper 6 × 11 in.

129 Maṇḍala of the Sun God Sūrya (Nepali dynastic deity) as supreme measure of time. Nepal, 16th century. Gouache on cloth 21 × 17 in. >

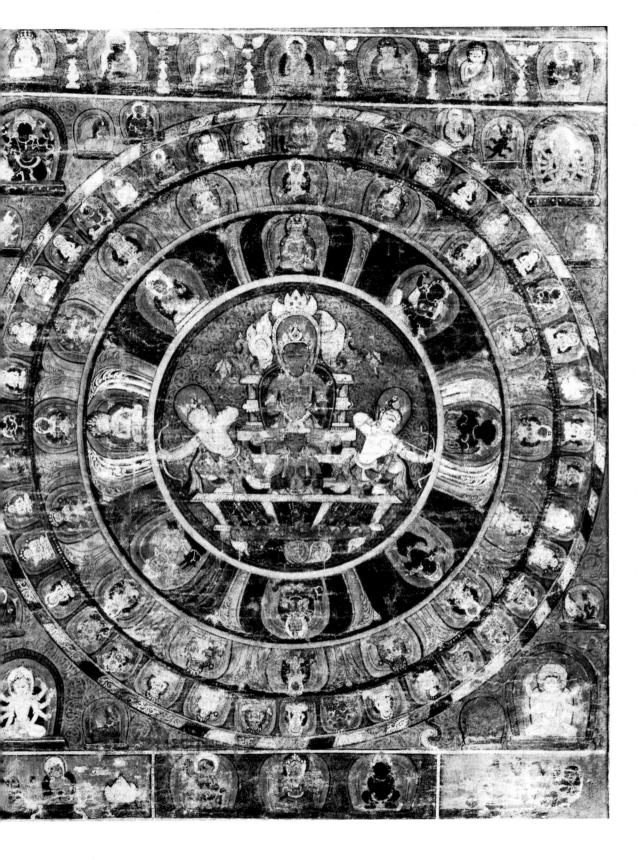

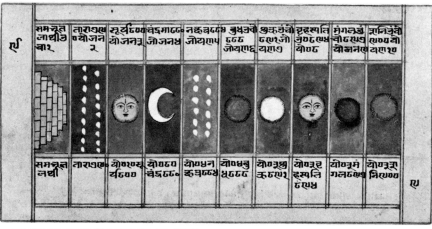

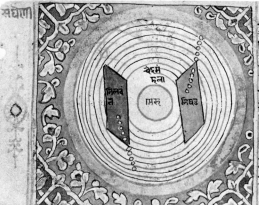

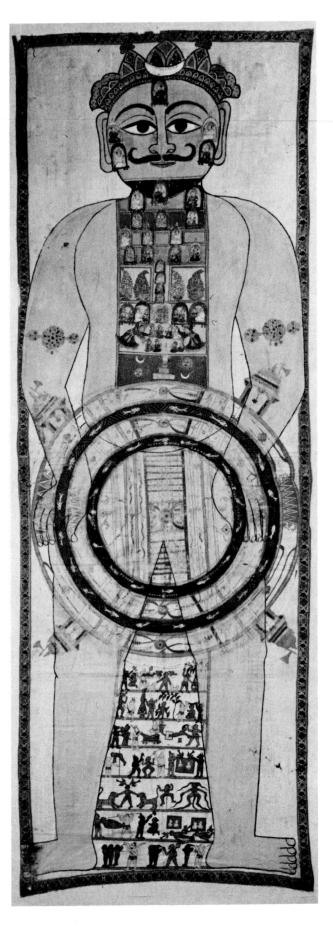

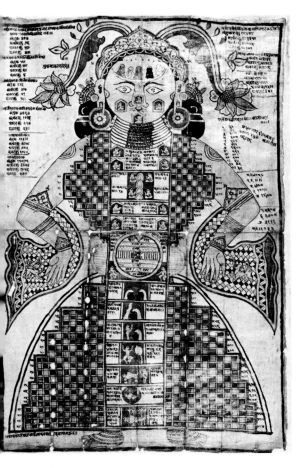

Jaina diagram of the bands of progressively [de]nser matter projecting from outer space into the [u]niverse. Rajasthan, *c.* 1800. Gouache on cloth [ ] × 5 in.

[ ] Jaina icon of the Jina as released spirit. [Ra]jasthan, 18th century. Brass h. 9 in.

[2] Chart of the different regions of the heavens [in]dicated by stars, sun, moon and planets, from an [ast]rological manuscript. Rajasthan, 18th century. [In]k and colour on paper 5 × 11 in.

[3] Diagram illustrating the occultations of the [mo]on behind two great mythical mountain ranges [di]viding the world which flank Mount Meru; from [a m]anuscript of the Samāraṅganasūtradhāra. [Ra]jasthan, 18th century. Ink and colour on paper [ ] 10 in.

[4] Jaina diagram of the Purūskara Yantra, [re]presenting the formula for the constitution of the [lib]erated spirit. Rajasthan, 18th century. Gouache on [cl]oth 15 × 11 in.

[5] Diagram of the cosmos incorporated into the [co]smic Purūṣa. Western India, 19th century. [G]ouache on cloth 92 × 32 in.

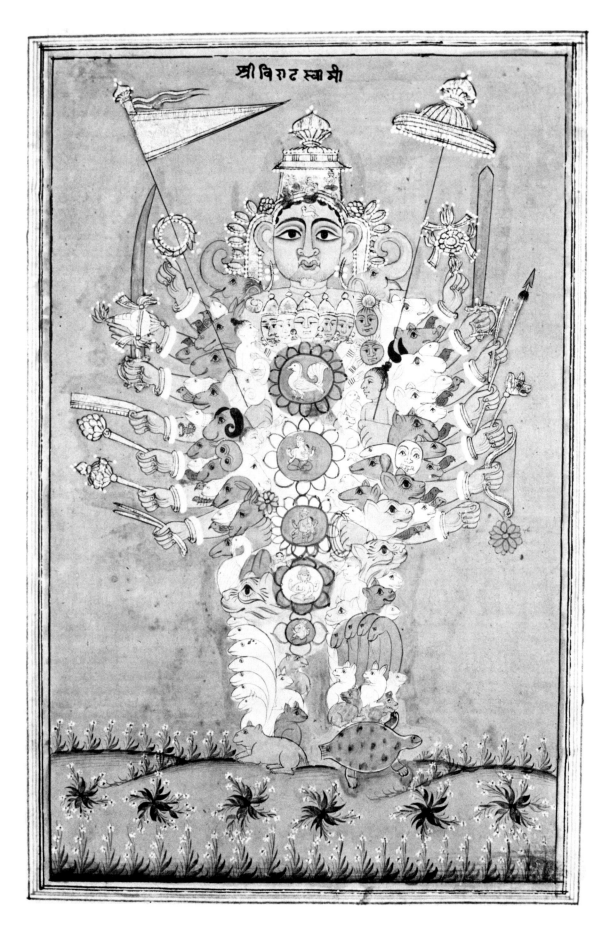

specific cannot itself be specific; and the released individual is released by realizing that he is one with both principles. Thus, in so far as Jaina diagrams are Tantrik, they are not Jaina. True Tantrik diagrams based on similar ideas have, however, also been made.

They are usually expressed as versions of the Cosmic Man, or Purūṣa, an idea which can be traced back to one of the most important philosophical Hymns of the ancient Ṛig Veda, and which also lies behind the image of Kriṣna as Supreme Body, mentioned earlier. The Hymn describes how 'the Gods' formed the cosmos by sacrificing and cutting up the Primal Purūṣa. His different parts were transformed into different parts of the world. Tantra thus equates that 'original' partitioning with its own descriptions of the way 'the world' is projected around himself by each 'person' (purūṣa). The image of the Cosmic Man thus becomes an image of the original Purūṣa which each individual may reconstitute within himself by sādhana. Such a Tantrik image is closely correlated with that of the 'subtle body' described in the following chapter.

135

136

136  Cosmic form of Viṣṇu-Kriṣṇa with ćakras of the subtle body; from a book. Rajasthan, 19th century. Gouache on paper 9 × 6 in.

# 10  The subtle body

136

The subtle body is probably the most important subject of Tantra art. It illustrates the structure of the inner human body used in yogic sādhana, which has the essential Tantrik double value. From the aspect of Genesis it is the means by which his world is made real around him for every individual. It is thus closely analogous to the Cosmic Body. From another aspect, that of sādhana, it is the fundamental mechanism by which the individual can work on the reconciliation between what he may think of as spirit and as matter, as subject and object, or as Sāṅkhya calls it 'I' and 'That'. The purely philosophical diagram of the Tantra-Sāṅkhya system (p. 182) bears a close resemblance to the patterns of the subtle body illustrated in the Tantrik diagrams. It should be mentioned that, once again, the Tibetan Buddhists assert that there is a significant difference between their pattern of the subtle body and the normal Hindu one, which will be discussed later. The two systems, however, definitely share the same fundamental ideas, and both demand an intensive culture of the body and its faculties. Some orders of Tantrik Hindu yogīs carry such culture to the extremes of possibility.

These ideas, like so much in Tantra, are generically Indian, and are not the property of any one religion. Indian medicine, which had developed extremely sophisticated practices by about AD 400, with surgical instruments and fracture beds which modern doctors would recognize, shared this view of the 'inner man' with the Hindu and Buddhist religions. It is found very clearly expressed in many of the relatively late Upaniṣads composed probably during the late centuries BC and the early centuries AD, such as the Tejobindu, the Varāha and the Yogatattva. The following is a description of the basis of the system translated as far as possible into Western terms.

The Ultimate Transcendent Ground of reality and life, whatever it may be called, and however it may be conceived, is thought of as separated from the everyday world by a kind of surface, just as the earth is separated from the air by the surface of the soil. The earth here symbolizes the Ultimate Ground of Being and the air the everyday world. The human person is thought of as resembling a plant growing from that soil out into that air upside down, so to speak. The crown of his head is the place where the root-stem penetrates the surface between the everyday and the transcendent. The body, out in the air, is

fed with vital energy from the 'Ground' beyond through an invisible opening situated in the dome of the skull. From this place in the crown of the head a system of subtle channels or veins, called nadīs, spreads throughout the body like the veins through the leaves of growing plants, distributing the vital energy out to the smaller tips of the members. At special places in the sense organs, including the hands and genitals, important channels terminate. The nadīs branch off from various points on a principal nadī which runs down the spinal column and is called Suṣumnā. This is the same as the Merudaṇḍa mentioned in Chapter 9 which is the axis of the world-disc. The currents of vital energy running through these nadīs are called the Prāṇas, sometimes mis-leadingly translated as 'breaths' or 'airs'. Certainly such figurative terms are used metaphorically to describe them even in Sanskrit; and controlling the outward physical breath is one of the chief ways used by yogīs to control their Prāṇas. But 'air' is not what is meant at all and different regions of the body are thought of as having different special Prāṇas, the most important being the Prāṇa of the chest, the next the Apāna in the genito-anal region. The reality of these inner energies is a matter of direct inner experience.

In the ordinary man or woman, absorbed in his or her everyday life, these currents of energy distribute existential power to all the sense-faculties, sight, hearing, touch, taste and smell, to the mental activities of perceiving-con-ceiving, and to sexual-procreative activity. They are what makes a world actual to them. Extreme idealist and monist philosophy would say that a so-called world only exists through the projection of this energy out through a person's faculties, rather like a multiple cine-projector throwing its images out through sense-lenses. It is certainly true that, as is pointed out in Chapter 1, whenever we talk of a real world we are talking of our idea of a real world, never of the thing-in-itself. But Tantra points out that something like a cloud-screen is first necessary if the inner 'projectionist' is to be able to see the images he is pro-jecting. This screen Hindu Tantra calls the root Prakṛiti, the fundamental 'objectivity', intrinsically void of particular objects, but which nevertheless makes it possible for a person to experience what he projects as objective. This is the first thing to be projected in Genesis, the red female principle, the Nityā-Lalitā, or Parvatī the 'wife' of Śiva. In successful sādhana it is the last thing to be merged into the experience of unity, as can be seen from the diagram of the Sāṅkhya Tattvas (p. 182).

This energized projection of a world is, according to the theory of yoga which forms part of sādhana, waste. Some texts refer to the wastage as a rat or a bandicoot which yogīs feel surreptitiously sucking away the energies they wish to conserve. What the sādhaka must learn to do is to control the currents, and withdraw from what he experiences the power which makes it seem 'real'. When he has withdrawn the reality-energy he must concentrate it, performing a 'turning back up' (parāvṛitti, a key-term) along the nadī system of the

condensed force, and drive it to the subtle point in the crown of his head where it will cleave wide the opening into the Ultimate Ground of Being. Through this an infinitely bliss-creating nectar will then drip down to flood his body and mind with the thicker substance of Rasa-juice, a condensed cream of Truth rather than the dilute energy which originally flowed through his nadīs. This is what constitutes the ultimate inner-erotic experience, when Purūṣa and Prakṛiti are united in a transcendental intercourse in a way suggested by outer erotic images. This nectar may be represented as milk from the udder of the Kāmadhenu, the 'cow of desire' in manuscript diagrams. In Buddhism this juice appears as the Bodhicitta, 'enlightenment-consciousness', analogue of transcendent semen, sometimes known as a white flower. To achieve all this no Tantra, Hindu or Buddhist, ever expects the sādhaka to destroy his body with asceticisms. He must keep it in good trim so it can be of vital assistance. The successful sādhaka does not cease to be the person his friends know. What happens is that to his human personality is added an immense superstructure of extra dimensions of the mind. None of his sensuous or emotional faculties must be lost; on the contrary they must be cultivated and expanded. And as this kind of sādhana is never a matter of mere thinking or imagination, the added dimensions of the 'mind' are states of knowledge as concrete in their own way as any worldly experience.

The details of the subtle-body mechanism are as follows.[21] Along the Suṣumnā nadī are strung a series of maṇḍala-discs; these are often known as the ćakras, or wheels, and they are usually represented in art as open lotuses with differing numbers of petals. Hindu and Buddhist systems vary in the number of ćakras they recognize. Hinduism knows a basic six, Buddhism sometimes confines itself to four. In more elaborate Hindu systems a number of ćakras may be developed in the divine realm above the highest ćakra in the human subtle body, beyond the head. The basic six can easily be discovered by a modest act of introspection. They are, in fact, a special type of yantra. Chinese Taoism knows a similar subtle body, with a spinal channel, gateways and differently symbolized regions through which an inner circulation passes.[22] And the Sufi symbolism of the inner 'illustrated tower' must refer to a subtle body.[23] The pictures in the rooms of each of its seven floors parallel the ćakra system, and individually resemble the Greater Trumps of Tarot cards. Both these systems, as they are now known, may owe something to Indian Tantra; but they also may contain independent strands of ancient tradition.

The lowest Tantrik ćakra, at the base of the spine in the anal region, is congruent with the world-wheel on its axis, the Merudaṇḍa (Chapter 9). In Hindu Tantra this lowest ćakra is called Mūlādhāra, 'root-support'. When a yogī sits to begin his pūjā and meditation he may first of all perform a rite which 'establishes' or 'fixes' the place on which he sits as his solid centre-base on the earth. This links his own inner forces directly to the earth and his world;

155

147

140, 141

145

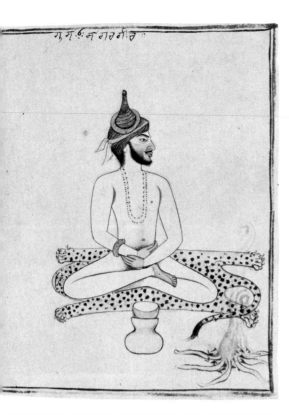

137 Śaiva Yogī called Gosain Sagagir.
Mankot, c. 1730.
Gouache on paper 9 × 7 in.

138, 139 Two details from an illustrated
book of Yoga postures.
Rajasthan, 18th century.
Gouache on paper 64 × 8 in.

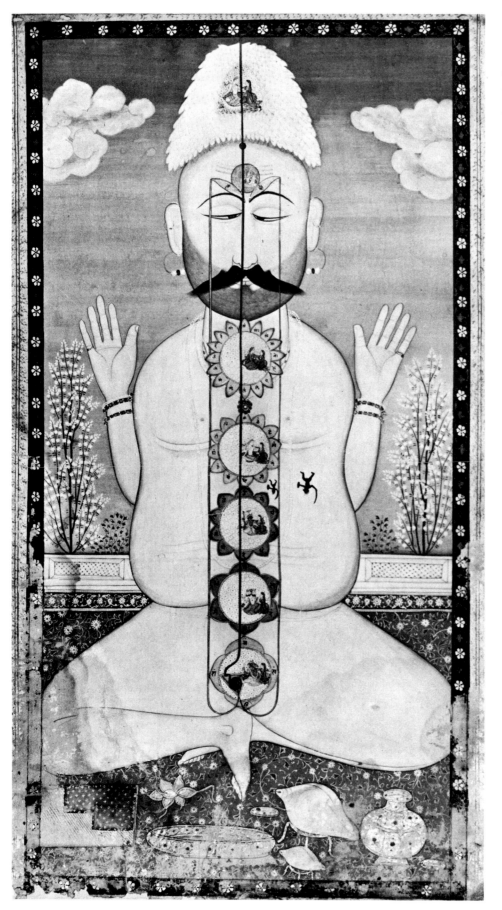

140  Diagram of the si[x]
ćakras in the subtle bod[y].
Kangra, Himachal Pra[desh],
18th century. Gouache
on paper 19 × 11 in.

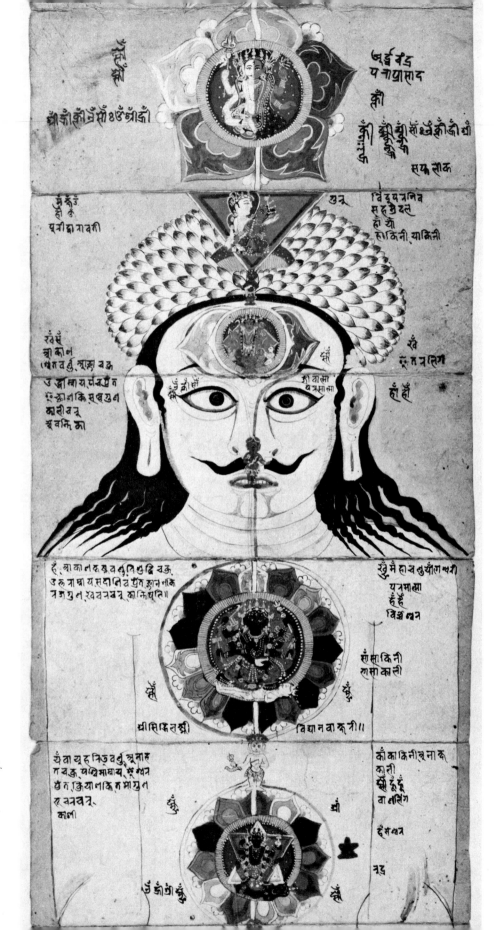

141 Illustrated book representing the ćakras in the subtle body and auxiliary symbolisms of the transcendent realm. Nepal, 17th century. Gouache on paper 140 × 11 in.

142–4    Three from a set of seven paintings of the meditative series of ćakras, once forming a continuous scroll, of which the last represents the void Prakṛiti. Rajasthan, 18th century. Gouache on paper each 16 × 11 in.

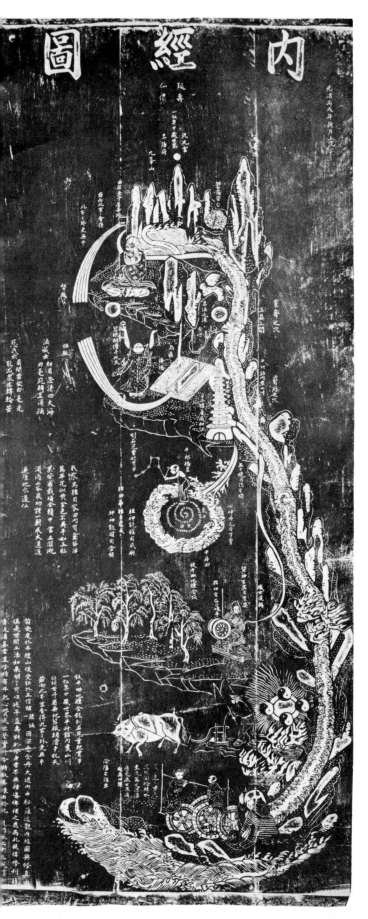

145 Diagram of the Chinese Taoist
subtle body. China, 18th century.
Ink rubbing on paper 47 × 20 in.

146 Kuṇḍalinī coiled about a liṅgaṁ
Banaras, contemporary.
Stone h. 7 in.

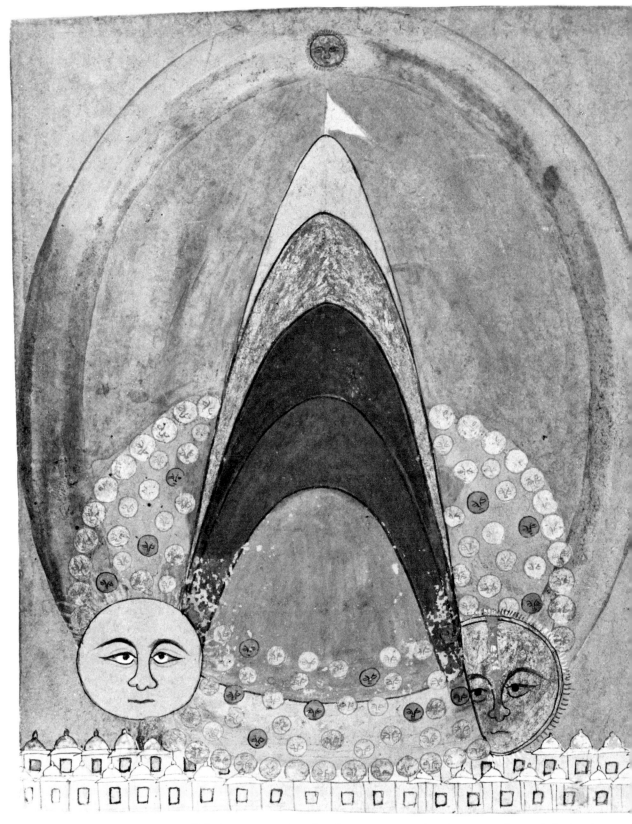

147 Painting representing the elements penetrating into space beyond the head region. Rajasthan, 18th century. Gouache on paper 7 × 6 in.

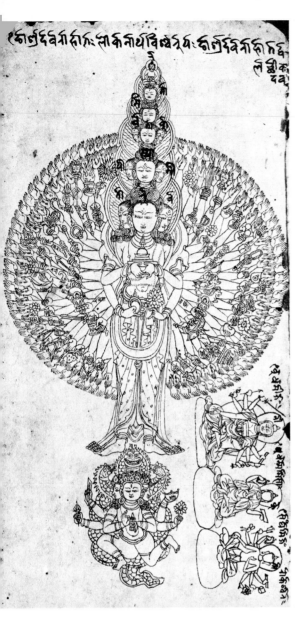

148   Image combining the attributes of the thousand-armed Avalokiteśvara, from an artist's drawing-book. Nepal, 16th century. Ink on paper 11 × 5 in.

149   Painting of hands holding skull cups, symbols for the five elements. Nepal, 18th century. Gouache on cloth 4 × 8 in.

(Overleaf)
150   Tanka representing Kālaćakra, the presiding Devatā of the cycle of time with Vajradhāra above. Tibet, 19th century. Gouache on cloth 25 × 15 in.

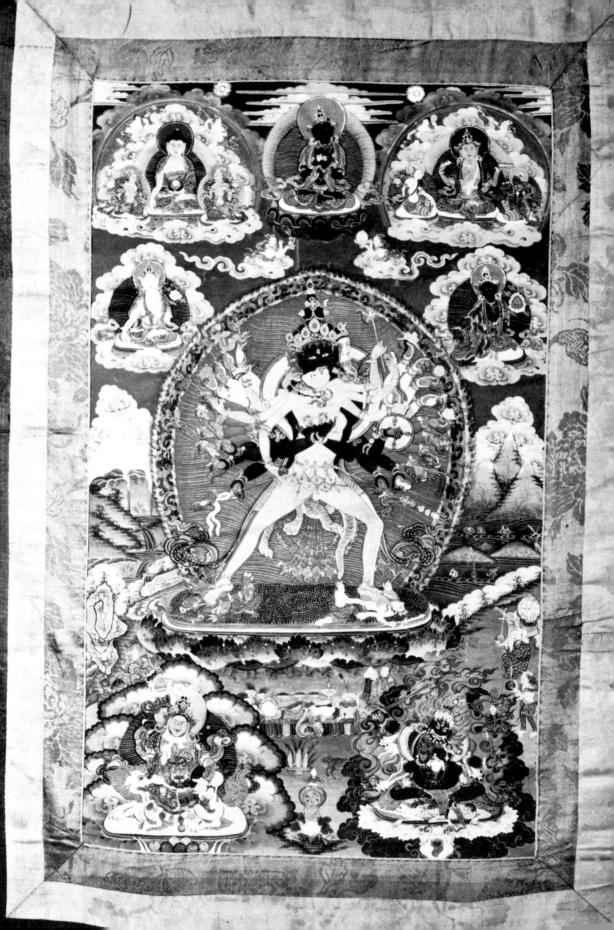

it is symbolized in diagrams by a tortoise. More thoroughgoing sādhana may invoke the protection of the spirit of the locality:

> The Devatā of the spot [chosen for meditation] should be meditated on as four-armed, huge of frame, his head covered with matted hair, three-eyed and ferocious; he wears garlands and earrings, has a vast belly, long ears and a hairy body. He wears yellow garments and holds a mace, trident, axe and a staff with skull on top . . . red like the rising sun, and [looking] like the lord of Death to his enemies, he sits in the lotus posture on top of a tortoise, surrounded by . . . armed followers.[24]

This is also the pattern adopted for icons of innumerable Tibetan local spirits. The sādhaka then concentrates upon the energies which are flowing out around the root of his Merudaṇḍa projecting his world, at the centre of which he is now firmly located. He proceeds to use the inner image of his lowest ćakra as a maṇḍala-yantra with its mantras to withdraw and concentrate his outgoing energies.

First he must set up a system of inner circulation along a pair of nadīs which spiral from the top to bottom around the Suṣumnā, passing points congruent with the left and right nostrils. These are called the nadīs Iḍā and Piṅgalā, sun and moon, the right white, the left red. When this is done the outward-flowing world-energies can then be withdrawn into the ćakra's circuit of petals, then into a central downward-pointing female yoni-triangle. The sādhaka, having externalized his worship of this yoni, performing a special contraction of his perineal muscles called yoni-mudrā, becomes aware of and controls this yoni in himself, as the subtle generative organ of his world. Finally the energies are concentrated into the form of a subtle female snake, called Kuṇḍalinī, who is in ordinary people asleep after having propagated their world around them by many active coilings.[25] She is said, by using the fifty Sanskrit letters as the strings of her instrument, to 'sing her song' out of which are woven all the forms of the worlds. Anyone who can hear it for what it truly is, in fact becomes liberated.

The sādhaka's aim is to awaken and, by using yogic postures, muscular actions and sexual intercourse, vitalize Kuṇḍalinī, compelling her to straighten out and enter the bottom end of his Suṣumnā nadī. 138, 139

Occasionally an elephant is shown in the Mūlādhāra ćakra, which seems to represent the entire body of the senses which is to be transformed through the upper ćakras. Kuṇḍalinī is also shown, when asleep, as being coiled around a standing inner liṅgaṁ at the centre of the ćakra, covering its orifice with her mouth – the same orifice through which she has to enter the Suṣumnā. 146

The ćakra has four petals, and its 'presiding devatā' is that same red Dākinī who represents the fundamental Tantrik initiation. In Buddhism the 'earth' colour is yellow, and its characteristic form is square. This 'presiding deity' can provide the first transference in the process of internalizing the external 75

woman. Complete transference can only take place after prolonged and repeated acts of this pūjā and meditation.

77

142–4

The continuation of the meditative process consists of 'driving' Kuṇḍalini (or, in Buddhist theory, some other female personification of the 'energy' such as Vajravarāhī) onward up the Suṣumnā into each of the higher ćakras or lotuses in turn where 'radiating' meditations take place in other-worldly dimensions. In each of them a 'transformation' occurs, concentrated by maṇḍala-yantras of the ćakra and reinforced by mantras. Different traditions allocate different devatās to each, symbolizing by lotuses with varying numbers of petals the successive transformations of the principles from gross to subtle. In Buddhist traditions Buddha figures which represent the meditator's own personality in a state of full consciousness of each level occupy the elemental stages. But here a subtle and mobile displacement occurs; for the Buddha who 'presides' in each realm is, in fact, the Buddha whose own realm (and colour) is the one next below. The meaning of this refinement can be found explained by Lama Anāgārika Govinda.[26]

149

This process is sometimes called Laya, 'absorption', and the whole technique may be called Laya yoga. The significance of the successive transformations is best expressed in terms of the five 'elements' recognized in Oriental theory. These are not material elements in the Western scientific sense, but represent stages of progressively more subtle states of matter to the experience of which correspond progressive states of bliss. They match exactly the 'elements' known to European Neoplatonic and Alchemical thought, save that the order of the third and fourth is, for a special reason, reversed thus: earth, water, fire, air, aether. The ascending series, in Buddhist yoga, is displaced upwards by one, since Buddhism prefers to omit the centre at the genitals. Mūlādhāra is the Hindu ćakra where reality is experienced as solid matter. At the six-petalled Svādhisthāna, which Hindus place behind the genitals, Buddhists at the navel, reality is known in its dissolved, lunar, watery state, the presiding devatās appearing in fresh forms, and time being seen as a true dimension not a mere sequence. The colour of this realm is white and its characteristic shape in Buddhist Tantra is a circle.

At the level of the navel is the ten-petalled Hindu Maṇipura ćakra. Its name means 'jewel city'. The 'maṇi' is the same word as that which means both 'jewel' and 'phallic principle' in the famous Tibetan mantra mentioned in Chapter 5, 'Oṁ maṇi padme Hūṁ'. This centre is at the heart in Buddhist Tantra. Here is the region of the mystical fire, and in Hinduism its devatās are the patrons of the cremation ground.[27] At the level of this ćakra the world is consumed and transformed through the agency of flame generated by the upper and lower psychic energies in combination, and time is transcended; in Buddhist Tantra its colour is red and its shape an upward-pointing triangle. At this level is carried out the famous gTum-mo ritual of Tibetan Lamaism

which arouses the inner fire for all sorts of magical purposes, including keeping warm among the snows.

At the level of the heart on the Suṣumnā is the Hindu Anāhata ćakra, with twelve petals. In Buddhism it is at the level of the throat; its colour is green and its shape is a semicircle. Here reality is gathered into a single subtilized image of the smoke-like principle of air, the realm of undefined possibility in space and time in which the most fundamental cosmic sound-frequencies generate their first vibration-patterns. The Hindu Goddess-transformation here is yellow 'like lightning among monsoon-clouds'. Most important of all, in the Hindu centre is a golden female triangle with, inside it, the self-originated Śiva liṅgaṁ which has no base on which to stand, being oval; it is here generating itself, expanding from nothing, inside the most primal phase of materialization. Here, therefore, resides the root of the sense of 'I-ness', distinct from 'the other'. Immediately below this ćakra Hindu Tantra sometimes recognizes another smaller one, containing a jewelled altar, where prolonged acts of mental worship directed towards the devatās of the Anāhata ćakra may be performed. This is held to be the island stronghold of personal selfhood, its eight petals symbolizing the eight cemeteries mentioned in Chapter 8.

The sādhaka may meditate on this island of gems, even as an alternative to full Kuṇḍalinī yoga. It floats, the Kaulāvalīnirṇāya says, in the ocean of nectar encircled by a beach of golden sand. It is thickly grown with trees of jewels, golden lotuses and blossoms, full of birds. At the centre is the Kalpa or aeon tree composed of the fifty letters of the alphabet, often represented in Tantra art. At the foot of this tree stands the splendid maṇḍala-temple of light with walls of gold, hung with jewels and garlanded with beautiful women. It is entered by four doors that are guarded by gods. Silken whisks and banners float in an incense-perfumed wind. On a jewel-altar at its centre is the great symbolic vase, overflowing with nectar. To this he may offer all kinds of pūjā.

The throat ćakra in Buddhism is the region of air. In Hindu Tantra it is called Visúddha, sixteen petalled and coloured a smoky purple, symbolizing the region of aether, the state of knowledge beyond all possible physical expression. At its centre is a white circle. The presiding devatā is the half-male, half-female form of the original two-sexed principle in a state existentially prior to separation into distinct male and female. The Goddess-form is pure white. This elemental region of aether, however, Buddhists locate in the crown of the head, and give it the colour blue, with a flamboyant nasal dot-shaped mantra. Most Hindu Tantra, since it locates the aether realm in the throat, envisages two further ćakras above, one between the eyes, white, with two petals, called the Ājñā, the other in the crown of the head, called Sahasrāra, the thousand-petalled.

In the Ājñā, the place of the 'third eye' of wisdom, the sādhaka's faculties reach a state of formless contemplation. The subtlest state of mind is there; the

161

mantra is 'Oṁ' itself. Devatā appears only as a yoni (vulva shape) enclosing an elliptical pure white liṅgaṁ. Here the sādhaka achieves union of the two absolute principles into the unitary Brahman. This is probably the most important meditative ćakra of all to the Hindu Tantrika.

Beyond it is the Sahasrāra, its thousand petals encircling the point of uttermost brilliant light which opens onto the engulfing void of supernal space. Its rays are the nectar of immortality. As experience it is Nirvāna. It is the gate of Being itself, through which men and their worlds are sustained, the place alike of release and Genesis. It can only be reached by male and female joined in sexual union. As to whether the union needs to be outward and physical as well as purely inward and symbolic there is disagreement. The most archaic strands of Tantra that survive today only among a few Hindu sects almost certainly recognized that outer union was the most powerful medium. The two lovers were said each to give the other, quite literally, what the other lacked of completeness. Joined, they may become more than either can be alone. Other sects, especially the Tibetan Buddhists, require that the union be entirely subjective, combining within the single person the elements of 'active compassion' as the male, 'wisdom' as the female, into a comprehensive insight.

Above the Sahasrāra some late traditions have added a series of further ćakras, 'where only the Gods reside'. These must be explained as corresponding to inward psychic experiences; but they may also represent a speculative device for breaking through the barrier of definitions conditioned by the noun (see Chapter 3), which must have grown up when literary descriptions of the 'highest place' had become over-familiar and obstructive.

The Tantrik Buddhism (Vajrayāna) of Eastern India, Tibet and China involves its own special sets of devatās organized into maṇḍalas placed in the ćakras. Its great early text, the Guhyasamāja Tantra, describes how when the subtle energy (Bodhicitta) becomes united with the void of wisdom, the sky of the mind fills with infinite visions and scenes. Then like sparks seed-mantras emerge and crystallize gradually into complete and glowing living forms of devatās, beautiful or terrible, which confront the meditator. Their only relationship is with him; they act out no notional interpersonal drama independent of him. Once they are thoroughly realized in meditation, they never leave the sādhaka. They become like extensions of his faculties, advancing his meditation, and helping him to produce physical effects in the world. In fact 'the form of a devatā is nothing but an explosion of the void, naturally nonexistent' (i.e. beyond the scope of convergent logic), but depends on a chain of particularization within the void which makes a particular stretch of the psychic and cosmic whole available to the meditator. They present themselves like visions within a supernatural clouded or flaming space, superimposed upon a landscape setting, the three dimensions of the former quite inconsistent with those of the latter – the basic pattern of the Tibetan tanka picture.

151　Diagram of the ćakras in the subtle body. Kangra, Himachal Pradesh, c. 1820. Gouache on paper 12 × 9 in.

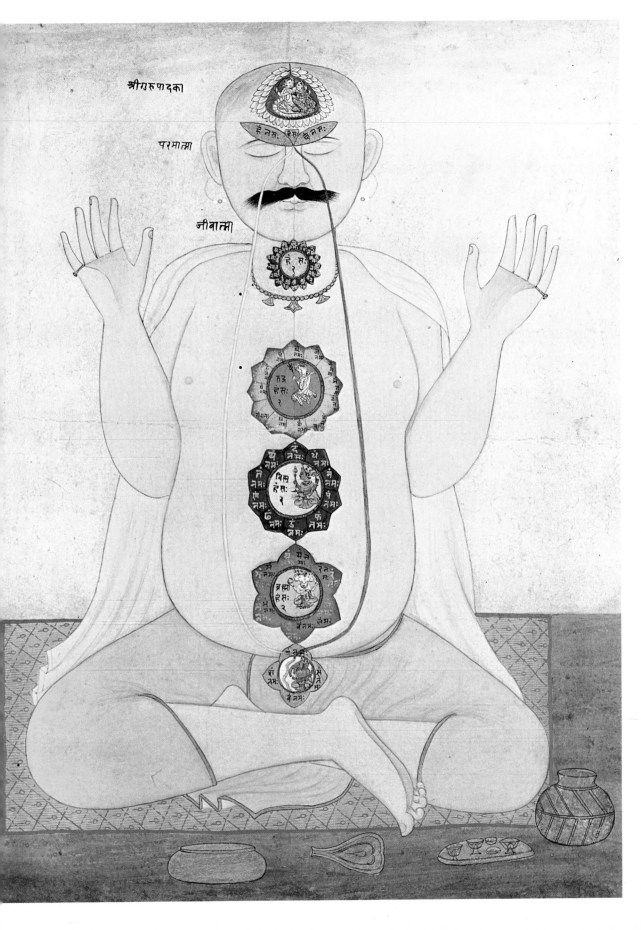

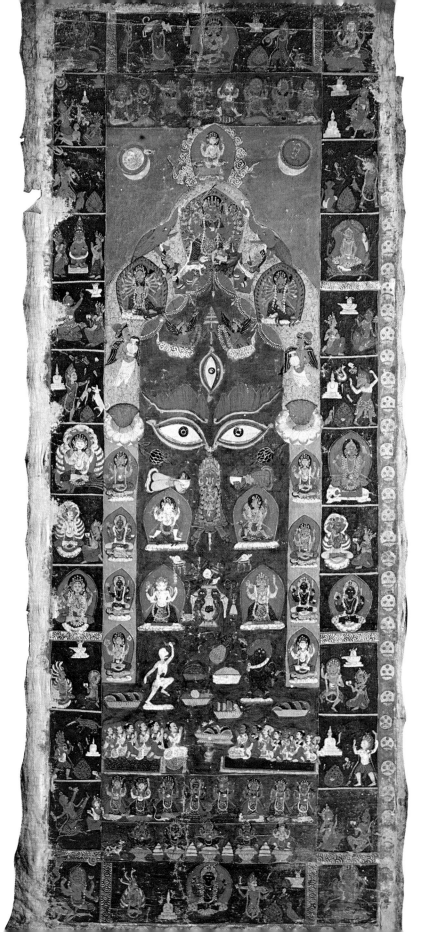

152 The combined subtle and cosmic bodies in the form of the 'elements', as Svayambhūnātha, the self-originated lord. Nepal, 17th century. Gouache on cloth 74 × 30 in.

153 Tanka, depicting the maṇḍalas of the Peaceful Buddhas, of the Knowledge-Holder and the Wrathful Buddhas. Tibet, 18th century. Gouache on cloth 29 × 22 in.

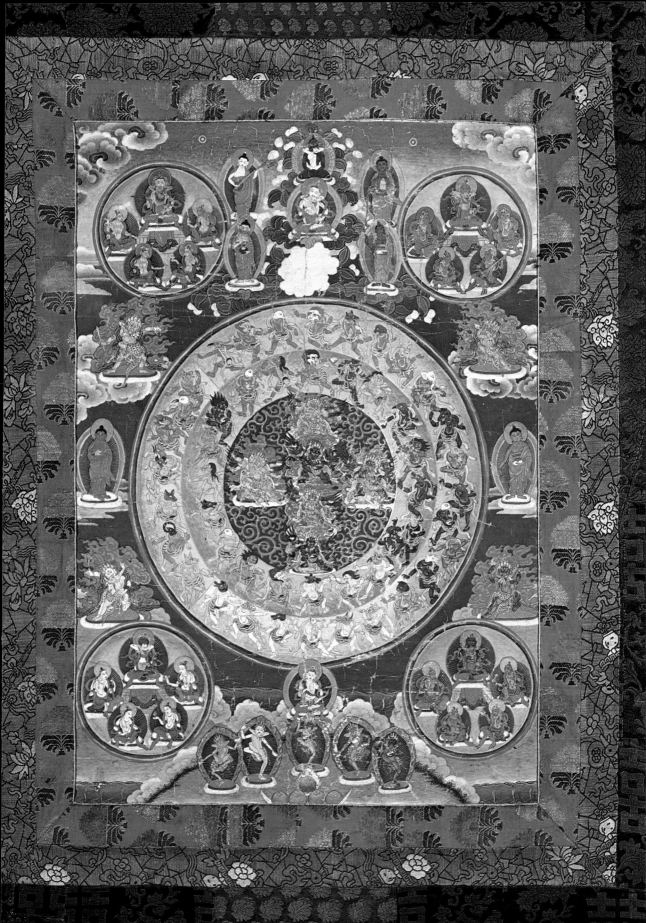

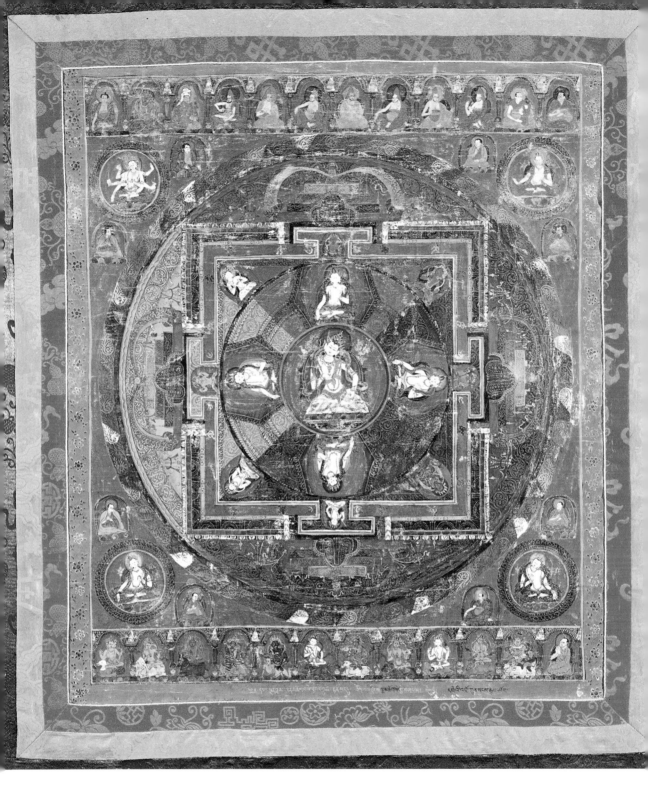

154 Tanka, representing the maṇḍala of the Supreme Buddha Vajrasattva, meditation upon which can generate the ultimate condition of knowledge. Tibet, 18th century. Gouache on cloth 21 × 17 in.

155 Vajrasattva in union with the Supreme Wisdom Vajradhātviśvarī. Tibet, >
16th century. Gilt bronze with jewels. 11 in.

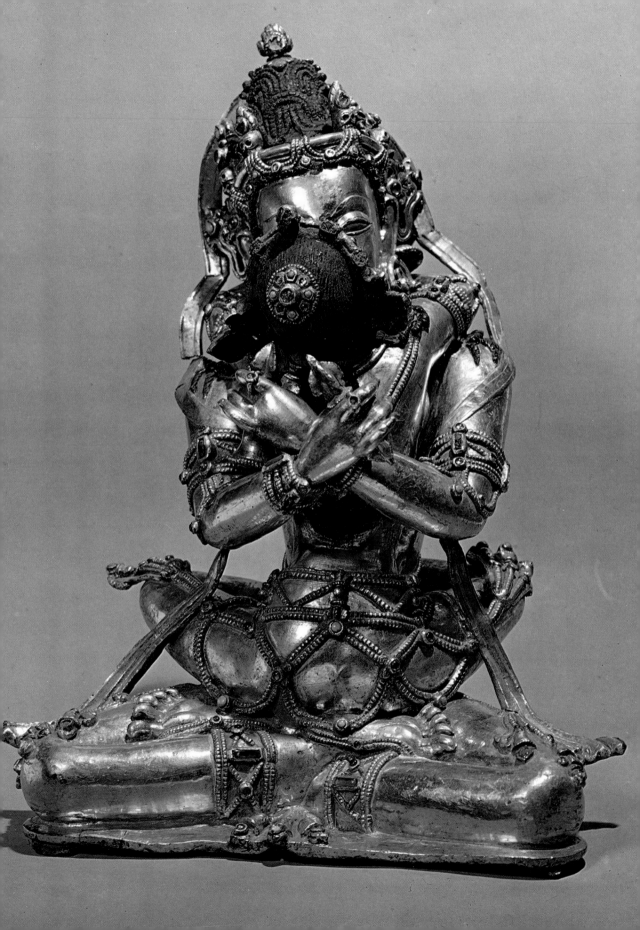

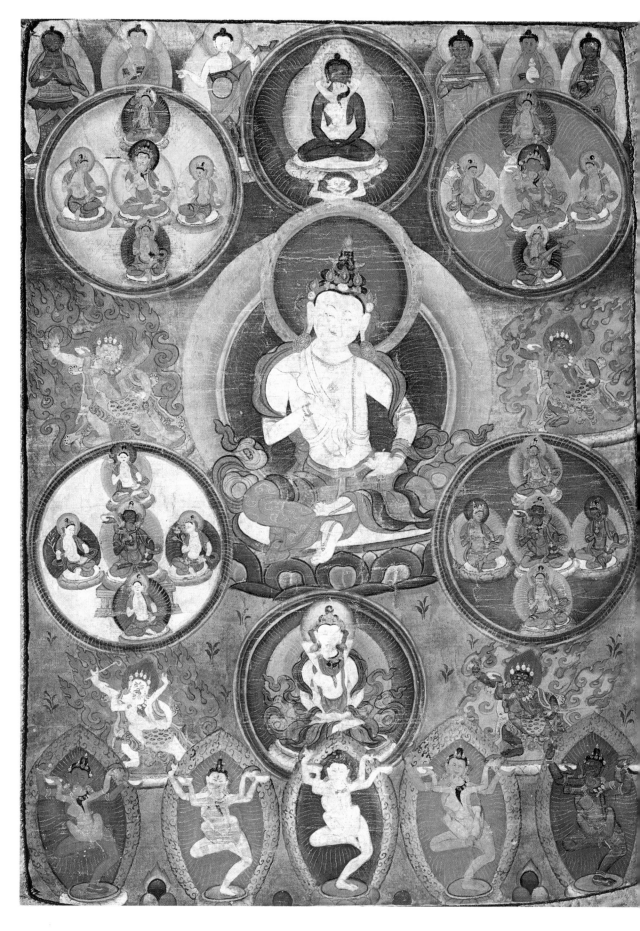

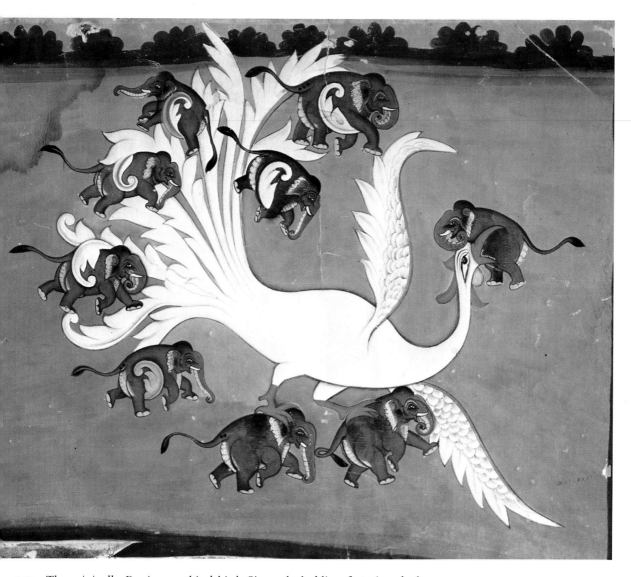

157 The originally Persian mythical bird, Simurgh, holding fast nine elephants symbolizing lower constituents of the partial self. Kangra school, 18th century. Gouache on paper 10 × 12 in.

< 156 Tanka representing the Supreme Buddha Vajrasattva generating maṇḍalas. Tibet, 18th century. Gouache on cloth 26 × 18 in.

158–9  Two from a set of thirteen leaves from a manuscript illustrating the processes of projective-evolution of the Universe. Western India, *c.* 1700. Gouache on paper 10 × 5 in.

This idea of iconography led to special developments within Tantrik Buddhism. Large numbers of special maṇḍalas were developed during the sixth to twelfth century, many recorded *c.* AD 1100 by the great Indian sage Abhayākaragupta and preserved in Tibet.[28] These co-ordinated innumerable variations of devatā figures. The largest collection of artistic icons illustrating the figures, made in the eighteenth century, was found in Peking in 1926. It originally contained 787 images. The lists upon which the maṇḍalas were based are often quite inconsistent; the 'sixteen Bodhisattvas', for example, can differ drastically according to different usages. These inconsistencies may indicate local variations among the traditions which have been collected. But the idea behind this Buddhist maṇḍala system is always the same. Any maṇḍala or ćakra of devatās, thoroughly realized in meditation, becomes a permanent property of the sādhaka's inner being, an added dimension to his total condition.

The course of an individual's spiritual history may demand that he learn and assimilate a given maṇḍala for a special occasion. The maṇḍala itself, as a diagrammatic complex structured around a central point, focuses the energies it contains upon the meditator's central Suṣumnā; while the different figures gyrating within it crystallize stretches of psychological experience and meaning. In a sense, therefore, the more maṇḍalas a sādhaka can realize and absorb, the greater his endowment.

There is, however, one leading pattern which co-ordinates all the many possible maṇḍalas of this Buddhism, which is often (wrongly) believed to be the only Vajrayāna maṇḍala. It is that of the peaceful or Dhyāni Buddhas, supplemented by matching maṇḍalas of 'Knowledge Holders' and 'Wrathful' devatās. Again, not all the surviving versions are totally consistent. Their symbolism and manipulation are extremely refined, and known to very few masters even in the Tibetan sects. Some indication has already been given (p. 136) of parts of their meaning; other parts also relate to specific points of Buddhist psychology and metaphysics. The important thing here is that none of them *in itself* alone represents enlightenment. All three maṇḍalas need to be superimposed and fused together into a single image.

Those maṇḍalas occupy Vajrayāna's three upper ćakras – of fire at the heart, of air at the throat and of aether in the crown of the head. Each maṇḍala must be inwardly 'realized', with its full complement of meaning, at its appropriate ćakra-level of knowledge. They are all conceived as groups of five circles roughly on a plane, one at the centre and one at each of the four directions, south, east, north and west of each maṇḍala. Each circle is again an elemental region occupied by its own presiding Buddha of appropriate symbolic colour, in symbolic sexual union with his female wisdom-condition, i.e. in a specific state of intuition. The Buddha-states in each maṇḍala are focused in the figures at the centre; and each maṇḍala represents a transformation of the others. Each

153

of the set of five at all three levels represents the modification and sublimation of grades of the five major human emotional hindrances, correlated both with the sense-realms and with the psychological categories (skandhas) to which all experience is reduced according to Buddhist tradition. Each also has a special kind of insight; the names are meaningless without a knowledge of the condition. The five regions are: in the blue centre region Buddha Vairocana, whose emotional realm is 'fascination', sense-field 'sight' and skandha 'visible form'; in the yellow southern region Buddha Ratnasambhava, whose emotional realm is 'pride', sense-field 'touch' and skandha 'feelings'; in the white eastern region is Buddha Akṣobhya, whose emotional realm is 'rage', sense-field 'sound' and skanda 'intellectual discrimination'; in the green northern region Buddha Amoghasiddhi, whose emotional realm is 'envy', sense-field 'taste' and skandha 'traces of habit-energy from past lives'; in the red western region Buddha Amitābhā (or Amitāyus), whose emotional realm is 'lust', sense-field 'smell' and skandha 'ideas'. Each 'direction' save the centre has its own special terrifying guardian figure, also represented in sexual union with a female counterpart. These last are the particular deities of the people, of those on the outside of the circle of initiates.

All the Buddha-figures may themselves have their own maṇḍalas, of which they are the focal centres; and all have several of their own special anthropomorphic 'reflexes' or 'projections' into the lower grades of spiritual life. Chief of these are the Bodhisattvas, figures of infinite compassion. The most important are Avalokiteśvara-Padmapāṇi, a reflex of Amitābhā, Samantabhadra of Vairocana, and Manjuśrī of Akṣobhya. There are female Bodhisattvas too, among whom may be ranked the various coloured Tārās. The name 'Tārā' means 'She who causes one to *cross*', the word 'cross' implying safely reaching 'the other side' of the stormy torrent of existence which is alluded to in the most ancient Buddhist Mantra of Supreme Wisdom.

The Knowledge-Holders are usually represented as figures matching the colour of their equivalent Buddha-region, dancing in sexual intercourse with different-coloured Dākinīs; their faces wear slightly 'enraged' expressions. Their meaning is always kept particularly secret, but it is clear from their partners, who are always Dākinīs, that they symbolize the whole gamut of initiatory states. The significance of the topmost maṇḍala of big-bellied and raging 'Wrathful Herukas', each dancing with his female reflection, his gross phallus thrust into her, hair bristling long and wild, aureoled in flame, has been suggested earlier on (p. 136). But the fact that these Buddha-transformations inhabit the highest region in the Buddhist subtle-body, called variously the 'Ocean of reconciliation', 'the self-originated Universal Body', 'the Totality of the Void', gives them a special character. Their colours are all darkenings or negatives of the colours of their corresponding Buddhas – brown, tawny, black, dark-green, red-black. Their 'condition' is the opposite of the 'Peace' of

the Dhyāni-Buddhas. Thus they represent the ultimate 'cancelling through' of all the obvious virtues which outward teachings name and propagate. Their general aspect connects them with the image of the completed Tantrik sādhaka with which this book ends (p. 197). The special kind of 'integration' symbolized by the initiations of the Knowledge-Holders is transformed at this level into an apparent freedom, an identification with originating vortices within the Void. Their names and those of their females are all formed from the names of the esoteric emblems which link all the stages of Buddha-transformation (C. Buddha, S. Ratna, E. Vajra, N. Karma, W. Padma, symbolized by wheel, jewel, vajra, sacrificial sword and lotus).

Since the general character of these 'Wrathful' figures somehow expresses generic 'rage', there is always felt to be a special connexion between them and the Buddha Akṣobhya of the East, whose emotional realm is 'rage' and family Vajra: so much so that Akṣobhya, although his is not the central position in his own maṇḍala, is often said to be the 'originator' of the other four. Since the 'Wrathful' images are placed higher in the subtle body and hence higher in the existential chain of Vajrayāna, 'originator' here must mean that he is the link between his own peaceful maṇḍala and the higher maṇḍalas where a transcendentalized 'rage' prevails. This is probably the reason why Akṣobhya is given a central position in some sub-Tantrik Buddhism (e.g. in Japan), the original justification for this having been eliminated along with the pure Vajrayāna teaching. It also helps to explain the importance in Tibetan Buddhism of the terrible form of his Bodhisattva-reflex, Vajrapāni, the protector and chief embodiment of the power of the Vajrayāna.

109

One further Tantrik Buddhist maṇḍala representing the subtle and cosmic body should be mentioned. It is that of Kālaćakra, the 'wheel of time'. It seems to have been evolved as a deliberate attempt to reconcile Buddhist and Hindu maṇḍala-symbolism, and was especially cultivated in Nepal. Its concentric circles and radial ranks of images include Hindu deities and Vajrayāna principles carefully correlated with each other. The blue-black Kālaćakra himself occupies the centre of the maṇḍala, dancing in the embrace of his red female counterpart Viśvamātā, 'mother of all'. There is some obscure connexion between this, and the Hindu planetary ćakra, described earlier, in Chapter 9.

150

Each major tradition of Tibetan Tantra envisages a supreme Buddha form (some envisage two, one above the other) which personifies the state of being and consciousness in which the entire imagery of these great maṇḍalas, with all their complex significance as condensations of experience, is known as a unitary whole. Two are represented as transcendentally tranquil, in the state of uttermost awareness, their minds irradiated by the light of all the transformations in the great maṇḍalas. Their names are Samantabhadra and Vajradhāra. A third, Vajrasattva, may appear as 'active'. None of the three

154–6

represents a 'creator', as Hindu supreme principles do. Buddhism is only concerned with states of consciousness, of which enlightenment is the highest. Its pragmatic methods, dealing as they do with the emptiness of every possible inner and outer phenomenon, never suppose a creator. Their Great Whole is the Void.

The ultimate goal is described by every form of religion in its own terms; and the arts of different religions locate at the crown of the head the emblem they use to indicate it. Buddha images are given a swelling at the top of the skull, called the uṣṇīṣa, which has been identified since at least the third century AD as an outward physical index of inner enlightenment. Burmese and Siamese Buddhas have flame-shaped uṣṇīṣas. Tibetan Buddhism has a devatā of supreme wisdom called Uṣṇīṣavijayā, 'she who is born from the Uṣṇīṣa'. Kṛṣṇa-worshippers locate the celestial reality of the transcendent Goloka, 'cow-world', there. Some Hindu images set Śiva and his 'wife' there.

170
157

By an interesting transference the old Persian Simurgh, a great mythical bird used as a Sufi symbol of the highest divinely spiritual element in man, became known in India with the coming of Islam.

Sometime after 1600 it was assimilated to an older Indian image of a great vulture-bird called Garuḍa, whose chief earlier role had been to symbolize the celestial air and light upon which the high god Viṣṇu was borne. By the eighteenth century Garuḍa had taken on something of the significance of the Simurgh, which also survives as a spiritual symbol in some parts of India where Islam has flourished.

There are numerous Tantrik icons which summarize the whole structure of the subtle body. Apart from the many anthropomorphic diagrams which illustrate the ćakras with their mystical significances there are yantras and schematic diagrams which lay out the multi-dimensional symbolisms on a plane surface. Tibetan paintings may define the psycho-cosmic elements.

48

So too may Buddhist stupa-emblems. These last may be on many scales, ranging from large works of architecture to small bronze objects. Built stupas in Nepal even have eyes painted on them to reinforce the meaning. The gigantic stupa of Borobodur in Java (ninth century) represents a psychocosmogram in entirely Buddhist terms, but not, however, really Tantrik. It offers a path of ascent up its many sculptured terraces from the world of discrimination and error towards the shining emptiness of Nirvāna at its peak. The essential feature of a Tantrik stupa cosmogram is that the ascending series of inner 'elements' is referred to by the three-dimensional forms of which the stupa is composed: a cube for earth, rounded dome for water, cone for fire, bowl or disc shape for air and curling finial for aether.

Earlier on the process whereby man's world of reality is developed has been described in various ways. Here, close to the root of the process, Hinduism recognizes a number of distinct early stages. The diagram (p. 182) of the essential process as it is conceived in the developed Sāṅkhya philosophy of Tantra will link them together. It should, perhaps, be mentioned that Buddhism has no contribution to make to this aspect of Tantra. The subtle categories discussed here are regarded by Buddhism as empty and meaningless, and their absence is the reason why Buddhism elides the two upper čakras in the subtle-body system.

Many Hindu Tantrik images represent the first division of the creative urge into male and female, white and red. This first division was described earlier (pp. 73–4), in connection with yantra.

But perhaps the most important philosophical issue in connection with the whole idea of the double-sexed primal divinity is this. The point where an ultimate division can be intuited is a logical and phenomenological necessity, since without that division there can be no experience. Experience must be experienced by an experiencer; and he must have something to experience. This is the vital issue secreted in the quotations from the Bṛihadāraṇyaka Upaniṣad given above (p. 74). The 'one' who desired to create, to enjoy, to possess and to act had 'first' to divide himself into subject and object. Those two terms are correlative; neither has any sense without the other. The subject is what experiences the object, which is defined as that which is experienced by the subject. At the highest level of sādhana the object may indeed be a most concentrated and remote idea, such as that presented in the Śrī Yantra. But the relationship of subject and object is there. Without the division there can be no love, no activity or field of action, no pūjā can be made. In Indian philosophy, since the time of the oldest Upaniṣads, subject and object have been called 'I' and 'This', 'ahaṁ' and 'idaṁ', equated with male and female, Śiva and Śakti, male and female dancer. The ultimate recognition is that 'I' and 'This' are not separate. But this is a point of realization to which no one can leap by a single act of intellect or will. If he pretends to he is a fool. Tantra provides a ladder towards that point. The Tantrikally modified Sāṅkhya offers a philosophical system which can authenticate it.

74

2, 65

All-embracing Parasamvit

Brahman
without qualities

Śakti    Śiva
Vimarṣa    Prakāśa

Brahman
with qualities

All distinctions are
the work of Śaktis
deriving from the
original Śakti

Other
Śakti with   'I'   Self
eyes closed

Śakti with
eyes open

Descent=
Genesis by
limitation

'That'    'I'   Self

Mantra zone

Māyā

Śakti of
illusory division
with 5 Kañchukas

Kāla : separates in time
Niyati : produces dependence
Rāga : attaches to separate "things"
Vidyā : knows separate "things"
Kalā : causes diffused action

Prakṛti
with 3 guṇas

Sattva
Rajas
Tamas

'I'

Puruṣa
Principle diffracted
by Māyā and Kañchukas

4 Modes of mind
Awoken    Active
Conscious    Self-conscious

| 5 Sense organs | 5 Sense perceptions | 5 Organs of action | 5 Energies |
|---|---|---|---|
| Ear | Sound | Mouth | Prāna |
| Skin | Touch | Hand | Apāna |
| Eye | Form | Leg | Udāna |
| Tongue | Taste | Bowel | Vyāna |
| Nose | Odour | Genitals | Samāna |

Instruments by which each individual
Purusa believes it experiences
an objective world

'I'

'I'

Purūsas which
believe themselves
separate

'I'

'I'

'I'

Ascent=
Re-integration
by Sādhana

The system of Tattvas,
essences or reality-functions

*Sāṅkhya Tattva diagram, illustrating the manifestation processes of creation*

The lower levels of the Sāṅkhya Tattva diagram define all the various sub-functions and categories through which the original flow of Being-energy is channelled and subdivided to make up the experienced world of forms and time. It is, in fact, a full phenomenological 'synthetic *a priori*' system, and it matches the pattern of the subtle body remarkably. It explains the meaning of many of the diagrams of world-evolution reproduced here, illustrating how the categories defining form are cut and shuffled out like differently coloured playing cards from the single deck of the possible. Indian playing cards are round. An important point has always to be remembered. In every experience of every objective 'This' by every experiencer the female qualifier is absolutely necessary; but so too is the male reservoir of energy, which supplies the 'Being' from the side of the objective, the unitary consciousness of self from the

158 159

side of the experiencer. Within every yoni, every active world-as-woman, is buried the liṅgam, the phallus, without which there would be no energy to inflate her pattern. To a primary male spark of Being (Prakāśa) the Goddess offers Herself as the 'Pure Mirror in which He reflects Himself' (Vimarṣa).[29] There are innumerable icons in India which represent the Divine Pair either as a male and a female, He with erect organ, She holding a mirror, or as a single double-sexed being, divided down the centre, the right half male, again with an erect organ, the left half female.

170

161

Philosophy, however, must not be allowed to delude itself with its own constructions. Whilst it may theoretically assume an original spark within the reflection, the moment it seeks to attribute to that spark any character or form it falls into delusion. For: 'Whatever power anything possesses, that is the Goddess. . . . Into the hollows of her hair-pores millions of cosmic eggs constantly disappear. . . . She grants the desires of sādhakas by assuming various forms in play.'[30] But 'She who is absolute Being, Bliss and Consciousness may be thought of as female, male or pure [neuter] Brahman; in reality she is none of these.'[31] Even these are simply forms She assumes to make sādhana possible.

And so, if in his pūjā the sādhaka does everything in the appropriate way, he can reach a state of concentration which enables his focused mind and eyes to sink into the depths of the image; the Devatā will then enter the image. But this means, properly understood, that anything can be treated as an image. For the energies which fill the universe, which are all the different Śaktis radiating from the original seed through the cosmic anatomy of the Goddess, are parts of Her, and reside in mountain, tree, shrub, creeper, river and sea; one may worship Her in any of these objects, looking on each as another sort of yantra, or instrument. It is, of course, She who must be worshipped in the objects, not the objects themselves. And so She can be reverenced in those jackals, kites, graveyards, corpses, women, cows, fire and so on, of which Tantra's art is full. Everything (according to the summary in the great Puruṣa hymn of the Ṛig Veda) from Brahman to a grass-blade, including stone, wood, axe, spade, fruit and rice, should be worshipped. She is thus absent nowhere. For this reason many natural objects can be interpreted as the Goddess in manifestation, especially those which play a special part in the transformations of the world and in which a sexual analogy is present, such as the stones converted into rice pounders illustrated here.

160

In reality[32] there are no such two things as Śakti and possessor of Śakti. There is no evidence of, nor is there any necessity for, the existence of the two things. Male, female, and neuter, all are Śakti. Body, senses, mind, and self, all are manifestations of Śakti. Consciousness as self is, like the orb of the sun, the condensed and massive form of Śakti; while body, senses, mind, and other things, like sun's rays diffused into space, are but fluid parts of that great massive Śakti. Although the sun is really energy in substance, yet for common under-

standing such expressions as 'the sun is possessed of energy' and 'the sun's energy' are used. Similarly, although self is Śakti itself in substance, yet in order that living men may the better understand, Śāstra has used such expressions as 'self is possessed of Śakti' and 'self's Śakti'. This is the only difference between Śakti and the possessor of Śakti. In a spiritual sense, nothing exists as possessor of Śakti besides Śakti. Even the Purūṣa-form, which you and I, according to our language and understanding, know as the possessor of Śakti, is but another or changed form of Prakṛiti. Other evidence is unnecessary. The Supreme Lord Himself, the sole and best Purūṣa in the world, who presides or dwells in all Purūṣas, has said in the Nirvāna Tantra:

> Just as trees grow on the earth and again disappear in it; just as bubbles are formed in water and again disappear in water; just as lightning is formed in clouds and again disappears in them; so at the time of creation Brahmā, Viṣṇu, Maheśvara, and other gods are born of the body of that beginningless and eternal Kālikā, and at the time of dissolution they again disappear in Her. O Devī, for this reason, so long as the living man does not know the supreme truth in regard to Her who plays with Mahākāla, his desire for liberation can only give rise to ridicule. From a part only of Kālikā, the primordial Śakti, arises Brahmā, from a part only arises Viṣṇu and from a part only arises Śiva. O fair-eyed Devī, just as rivers and lakes are unable to traverse a vast sea [that is to say, however strong their currents may be, they all lose their individual existence entering into the vast womb of the sea] so Brahmā and other Devas lose their separate existence on entering into the uncrossable and infinite being of Great Kālī. Compared with the vast sea of the being of Kālī, the existence of Brahmā and the other gods is nothing but such little water as is contained in the hollow made by a cow's hoof. Just as it is impossible for a hollow made by a cow's hoof to form a notion of the unfathomable depth of a sea, so it is impossible for Brahmā and other gods to have a knowledge of the nature of Kālī.

Brahmā, Viṣṇu, and Maheśvara, the text continues, are the presiding Devas of the three periods of creation, preservation, and dissolution; but none can master with his intellect the nature of that Kālī with whose playful glance even Mahākāla, to whom the three periods of time are but three twinkles of His three eyes, appears at one moment and disappears at another. Neither Brahmā, nor Viṣṇu, nor Maheśvara knows Her fully.

This should make the essential point that the 'projecting' of a 'world' around the individual is not subject to his own will. It may be produced through the instrumentality of his personal desires; but these themselves, and his own notion that he *is* an individual with desires performing acts of will, are themselves the work of the Great Whole. The world must therefore contain many things which to the individual are repugnant, hostile and horrible.

160  Rice-husking stones, worshipped as male and female. Bengal, modern. Stone 10 in.

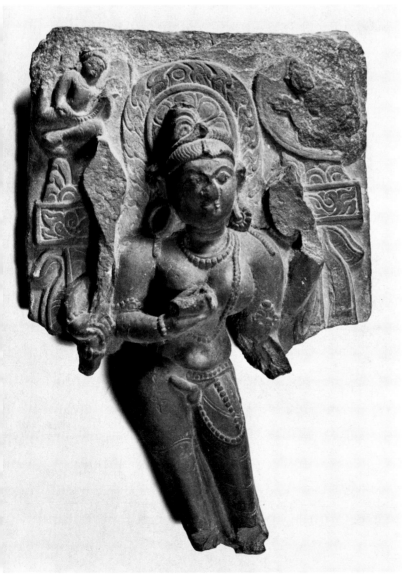

161  Ardhanarīśvara, deity half-male, half female. Bengal, 13th century. Sandstone h. 16 in.

162–3 Cosmic sun and moon, obverse and reverse.
Tanjore, 18th century. Wood, painted h. 12 in.

164 The Primal Light. Deccan, 18th century.
Gouache and gold on paper 11 × 7 in.

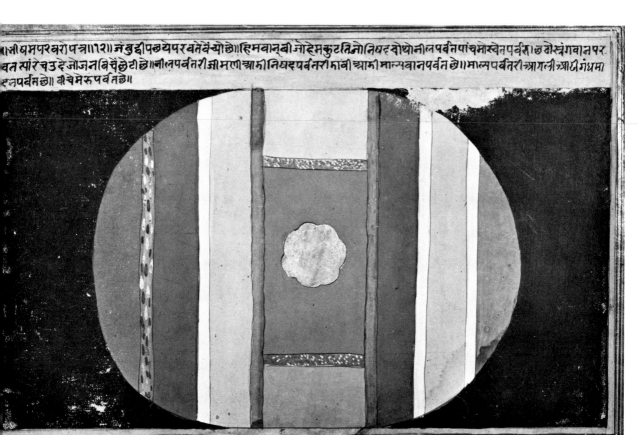

5  Primary divisions within the fertilized world-egg. Rajasthan, 18th century. Gouache on paper 11 × 17 in.

6  Painting illustrating Brahmins as the Knowers of Brahman in the presence of golden eggs. Rajasthan, 17th century.
Gouache on paper, 9 × 15 in.

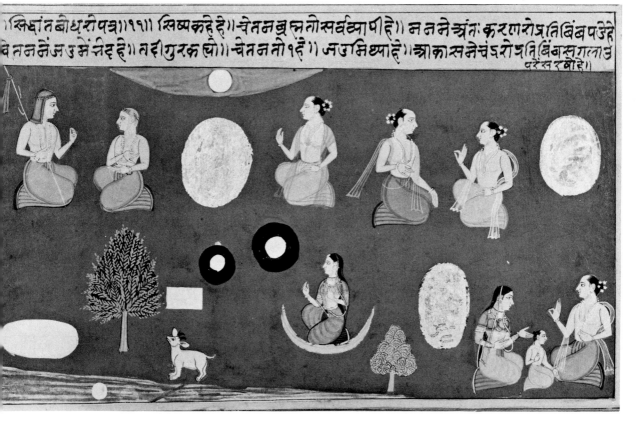

167 Egg of Brahman or Svayambhū
liṅgaṁ. Banaras, age unknown.
Stone h. 7 in.

168 Egg of Brahman or Svayambhū
liṅgaṁ, with yoni-shaped flash of red.
Banaras, age unknown. Stone h. 7 in.

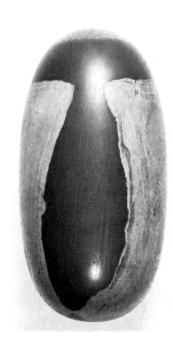

169 Painting illustrating the legend
of the Expanding Liṅgaṁ. Rajasthan,
18th century. Gouache and gold on paper
13 × 16 in.

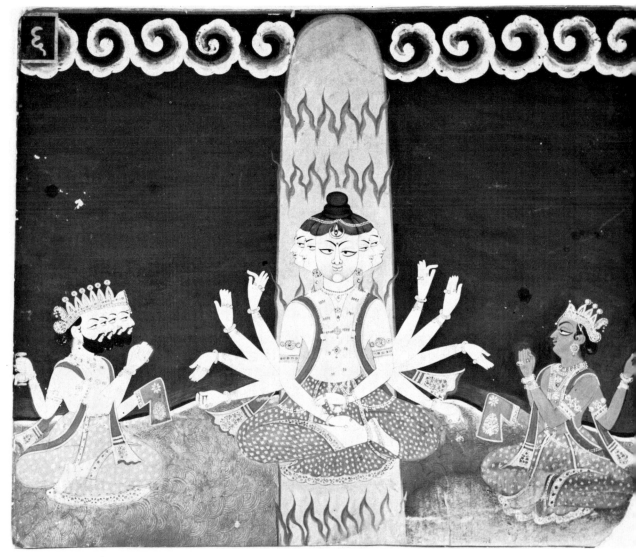

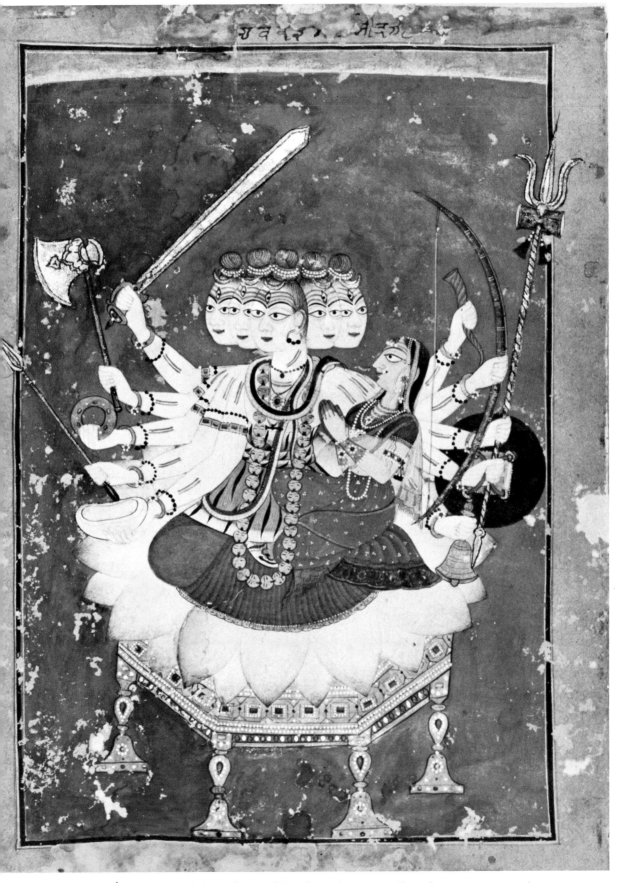

170　The God Śiva seated with his wife. Basohli style, 17th century. Gouache on paper 10 × 7 in.

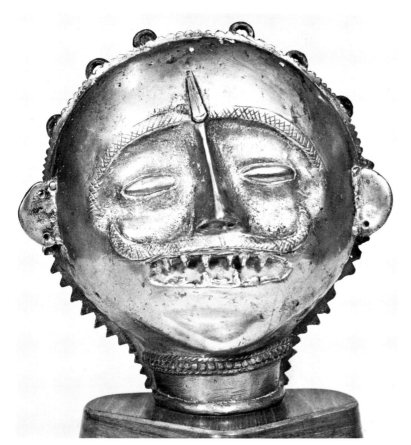

171 Head of Śiva as Bhairava, the Destroying Power of Time. Bhil tribe, Rajasthan, 17th century. Brass h. 13 in.

172 Liṅgam, engraved with Śrī Yantra, probably used as initiation instrument for female Tantrikas, and for meditation as symbol of the emergence of creation, symbolized by the incised Śrī Yantra from the undifferentiated Ground of Being. Rajasthan, 17th century. Rock crystal h. 3 in.

173 Liṅgam in yoni-basin, symbolic of the united male and female principles. Banaras, modern. Rock crystal h. 1 in.

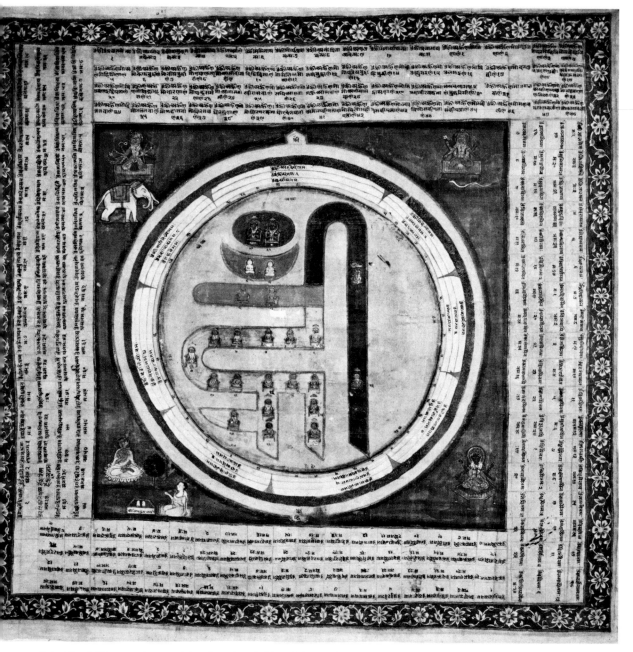

174 Oṁ-Hṛīṁ Yantra, the combined seed-syllable of the Universe, containing devatā principles. Rajasthan, 18th century. Gouache on cloth 35 × 35 in.

175  Vaiṣṇava emblem of the conch shell, radiating glory. South India, 16th century. Gilt bronze h. 11 in.

176  Natural shell trumpet, emblem of the Creative Sound. 19th century. l. 6 in

The Tantrik view of the cosmic ultimate is expressed in the Kurma Purāṇa: 'The truth which is the conclusion of all those people [imbued with] the Veda and its highest philosophy [Vedānta] is that which yogīs see as the One, all-pervasive, subtle, beyond qualities, motionless and static; it is the ultimate state of the Great Goddess. What yogīs see as the eternal unwasting, solitary, pure, supreme Brahman, that is the ultimate state of the Great Goddess. That all-embracing existence, higher than the highest, universal, benevolent and faultless, which is in the yoni of Prakṛiti, that is the ultimate state of the Great Goddess. That which is white, spotless, pure, without qualities and distinctions, that which is realized only in the Self, that is the ultimate state of the Great Goddess.' She may appear as 'He who acts out the drama of the Universe, who is awake when the world sleeps [that is: when each creation is withdrawn], the One, the Supreme Lord.'[33]

166

He is thus the invisible dancer whose dance is the world, His activity being Kālī, She being himself as action. In the inner self He puts on his costume and make-up. The successful sādhaka, by looking inward, is able to watch the drama mounted in his own eyes and senses by the activity of the One Lord.

This is the ultimate condition: 'He who has *seen* his true self looks down upon transmigrating existence as upon a rolling chariot-wheel.'[34] But in fact, '[The Self] is unthinkable, formless, unfathomable, concealed, unassailable, compact, impenetrable, without qualities [Guṇas], pure, brilliant, [but] enjoying qualities, terrible, unproduced, a master yogī [sapphire-bodied], all-knowing, all-giving, immeasurable, beyond beginning or end, illustrious, unborn, intelligent, indescribable, creator of all, the self of all, enjoyer of all, ruler of all, inmost being of everything, the Supreme Light.'[35]

This Ground beyond all names and forms is behind everything which exists, supplying it with the possibility of being. In Tantra it is indicated by the seed bindu. There are, however, full-blown images which attempt to suggest ways of thinking of it symbolically. Chief of these is the liṅgaṁ, the phallic emblem, in its special form as Svayambhū, 'self-originated'. This is most subtly curved in its surface, and rounded at top and bottom to show that it does not 'stand' or 'arise from' anywhere in our space or time. It may thus look egg-shaped, and recall the Cosmic Egg mentioned earlier. Stone icons of this form are made at

167, 168

several places in India, especially Banaras, and are sold for pūjā images. Ancient examples are treasured by individual families. Some represent the stage where separation has taken place into pure male and female. These white marble liṅgaṁs, made during the last century or so, may be worshipped laid on a red cloth. Here the symbolic colour-polarity of white and red is at its purest. White is the nucleus of Being, red the active, the passionate attachment which creates and projects out into space and time.

However, the stage preceding separation is symbolized in a special group of natural stone icons of the same shape from the Brahmaputra valley. When they are worked and polished, the metallic oxides they contain appear on the surface as vivid flash-patterns. These indicate the first stirrings of differentiation which appear within the Great Whole of the Self-Originated-Liṅgam-World-Egg. On the sādhakas' upward path towards experiencing the source of Genesis these stones symbolize the penultimate intuition of the Great Whole which contains all things in time, reducing them to a single thought; in this there may be the danger that the true vastness of the self-originated may be forgotten. What removes this danger is the attentive pūjā for which these deeply symbolic icons are made. The yogī should actually entertain this single thought together with its meaning.

The forms which the flashes on the surface may take are extremely interesting and important, and each stone gives its own particular intuition. Sometimes the flashes may be carefully calculated to imitate the pattern of the sūtras, the surface-divisions on the actual male penis. But more often they suggest an astronomical vision of apparently random cosmic explosions or drifting clouds of incandescence in the remotest space, at an early stage in their concretion into galaxies, stars and worlds. As surface-flashes, however, they are essentially mere changes in the skin of the Self-Originated.

Many sculptures and paintings attempt to indicate complete existential primacy by legendary images based upon the liṅgam. In the remotest reaches of space, one story runs, the high gods Brahmā and Viṣṇu were disputing who was the higher. Suddenly there appeared beside them a colossal radiant liṅgam. The two gods separated to try and measure its length; but no matter how far and how long they plunged and soared they could never reach either of its ends. Then Śiva appeared within it in person, having thus demonstrated his own overwhelming primacy. Another legend, unfortunately not illustrated here, from Purāna, recounts how on another occasion the combined efforts of all the Hindu gods could not subdue a violently leaping and raging fiery liṅgam. At length the Goddess did, by quenching it inside her vagina. These two stories give some impression of the way in which important Tantrik ideas were expressed at the popular level. They also indicate that the 'power' of the liṅgam can be shown in human form, as a forceful male figure whom Tantra sometimes calls by the name of Mahākāla, 'great power of time', the 'great

black one' and sees as terrifying. Such a gross image, popular in conception, certainly helped to inspire the terrible devatās of Tibetan Buddhism, which adopted Mahākāla, and in fitting him into its system degraded his significance.

The lingaṁs for public pūjā which are the focal icons of so many Hindu temples share in the ideology of transcendent energy. Since they stand on the earth, often within a cell cut from the body of the earth as cave or masonry, they cannot represent the original Svayambhū, which exists 'before' anything else. But they do represent the psycho-cosmic energy of Being after the first stage of separation has just taken place, when the male and female principles can be seen as distinct. Individual people carry with them or keep at home small lingaṁs made of many different symbolic materials to which they make private pūjā.

Collections of carved lingaṁs kept in temples, and a number of miniature paintings, illustrate the idea that all the many lingaṁs which may exist, large and small, share in the radiant energy of the cosmic lingaṁ-principle. Paintings may show in profile many smaller lingaṁs springing, as it were, from the Great Lingaṁ. All of them may be of that form which shows the phallic shaft standing encircled by the female yoni-basin. This basin, in the case of small lingaṁs for private pūjā, may be made in the form of a separate ring which is slipped down over the shaft of the lingaṁ while mantras are chanted.

Stones from numerous sacred sites are collected and ritually sanctified for pilgrims to carry away with them. Some of these, especially the Śālagrāmas containing ammonites, may sometimes be bored with twinned holes suggesting the opening-out of space and time at the root of creation. All are meant to serve as focal points for the imagination, and reminders of the ultimate, many of them relating to the World Egg. Even when they are not shaped much like it, they are usually thought of as emblems of the Svayambhū lingaṁ, which itself represents the crystallization and stasis outside creation of the desire from which creation springs. They are self-contained objects which offer the simplest yet most inclusive form the mind can grasp.

The last and the first, most subtle symbolism of all for the remote and absolute principle of energy, is expressed in terms of sound. Mantra systematizes the resonances of the created world, and makes the sādhaka able to control them. This implies a view of the existent material world which tallies very well with recent Western imagery. The topic was discussed in a special strand of tradition in Tantra devoted to Nāda, 'sound'. Whereas the other symbolisms illustrated here have been primarily visual, this tradition thinks of the world of reality as consisting of an immensely complex web of vibrations and 'resonances' ('dhvani' in Sanskrit) which all originate, in a logical not a temporal sense, from a single self-originated point of sound, the Nādabindu, analogous to the creative point in the centre of the Śrī Yantra. The variety of vibration-patterns which constitute the world of experience evolve from its modifica-

36, 173

tions: in sādhana they can be reversed to the original all-inclusive vibration in the realm of that subtlest form of matter called aether. One metaphor for the remotest creative sound is the tinkling anklet of the female dancer (Lalitā-Prakṛti) whose dancing, according to Sāṅkhya, weaves the visible pattern of the world. The spreading resonances and interference-patterns, as their variety increases, constitute the grosser forms of matter down the scale: air, fire, water, earth, which are perceived by the grosser senses. Mantras control and organize these resonances just as yantra organizes the visual patterns. The mantra system can thus lead the consciousness by stages of condensation towards an inner perception of the primal vibration (symbolized by the double drum) and the single Nādabindu. The highest reaches of subtle sound are embodied in the

174–176

mantra 'Oṁ', whose physical symbol is the chank or conch-shell that can be made into a powerful ritual trumpet, and elsewhere in Indian culture symbolizes Lakṣmī, fruitful mother of the waters of Creation.

'Oṁ is the whole world . . . past, present and future . . . all is Oṁ . . . whatever else transcends time . . . is Oṁ.'[36] And so 'By joining the breath to Oṁ one may go aloft up the Suṣumnā . . . two Brahmans may be meditated on, the sounding and the soundless. The soundless is only revealed by sound . . . the sound-Brahman is "Oṁ".'[37] Ascending by it one reaches an end in the soundless . . . passing beyond sound, men vanish in the supreme soundlessness, the unmanifest Brahman. There they lose all qualities, becoming indistinguishable like juices blended into honey . . . the sound-Brahman is "Oṁ". Its peak is tranquil, soundless, fearless, beyond sorrow, blissful, immovable . . .' at the apex of the crystal column of the Suṣumnā. The point at which consciousness touches the ultimate through sound comes at the end of the long-drawn, skull-penetrating vocalization of this seed-mantra of the cosmos, the sharpest vibration of the nasal hum with which 'Oṁ' concludes, written in the Sanskrit alphabet as a dot. Here merge the points of sound and light, indescribably fine and small, but also comprehending the whole world of manifested things in cosmic history.

The audible phase of sound is only the first manifestation of the activity of the Śakti-Goddess. The seed is beyond sound. Hence to look at it from the point of view of Genesis, memory is the actual vehicle of the power of Selfhood in the living creature's mind; indeed both our conscious and unconscious percepts, concepts and memory-traces as well as the 'world' we construct with them, are all more or less recent memories. The hidden state of the female power of mind-and-memory is resonance (dhvani), the outward form of which is sound. Primary resonance is the first shoot of sound, and of the person's vital force. 'The universe of moving and static things is knit together by this Śakti, who is Resonance. . . . She it is whom yogīs know as Kulakuṇḍalinī moving inside them, continually making an indistinct sweet murmur like the humming of a bee in the Mūlādhāra';[38] or like a swarm of black bees drunk on honey, whose

resonances evolve the fifty letters, and from them, all poetry and all realized form, filtering out down the Suṣumnā. It is the oscillation of resonance which causes the breathing of all living beings. For breath is the gross form of time (Kālī).

Tantra's world of interpenetrating and interacting systems of vibration and resonance accords well with the world our Western mathematical sciences present to us. The difference is that, whereas we view our world with cold curiosity, complacent self-congratulation or fear, at best with dispassion, the Tantrika views his world with an acceptance into which all human feeling is interwoven. For him the resonances of art, its metaphors, rhythms and time-lines, are no less significant than the interrelations canalized in abstract systems. To live continuously aware of this entire interfused structure of Reality is Tantrik bliss. No amount of uninspired ritual, no amount of abstract reflection, can produce liberation. Only the awareness, in the fullest sense, that 'I am Brahman' *is* liberation.

The truly successful Tantrik yogī, says the Kaulāvalīnirṇāya, can only beg in order to live. He is always in a state of bliss, conscious of his identity with Śiva-Bhairava, so that it is impossible for anyone not equally developed to know his true nature. When alone he is as though mad, dumb or paralysed; in the company of others he sometimes behaves like a good man, sometimes like a wicked one; on occasion he even seems to act like a demon, because he is working towards an immensely complex long-term end. He is always pure and anything he touches is purified. Detached from his body and immersed in his vision he plays with the senses, which to others would be as dangerous as poisonous snakes. Whenever he sees flowers, food or perfumes he automatically offers them to the great Goddess. He has no outer worship, performs no vows. He knows he is complete in himself, that he has reached the inmost ravellings of Śakti and become eternal bliss, the undying, unlimited Self, free from divisions and unchanging. He understands all religious texts instinctively, does good to everyone. 'On his left he has the woman skilled in the arts of love, on his right his drinking cup. Before him is hog-flesh cooked with chillies. On his shoulder is the well-tuned Vīṇa, with its melodies. This Kula doctrine containing the teaching of the great Guru is deep and difficult even for yogīs to attain.' In such an abstruse symbolism are hidden the beginning and end of Tantra.

# Appendix: Kāmakalāvilāsa translated

The diagram on page 182 will be found helpful in understanding this short Tantra devoted to the Śrī Yantra.

One outstanding characteristic of late Sanskrit is the way it sets up a wide variety of relations between words which can only be translated by the English verb 'be'. Readers will discover that the string of 'identities' this text conveys can be best understood almost as a set of 'mixes', to use a term from film technique.

My translator's explanatory additions are enclosed in brackets [].

1 May He [Śiva], who in blissful play is awake in his [cosmic activity of] creating, sustaining and dissolving all at once, protect you, the Great Lord whose nature is the subtle original spark [Prakāśa], within whom is contained the universal unfolding [Vimarṣa].

2 She the primordial Śakti is supreme, whose nature is unoriginated and undisturbed joy, eternal [in that She transcends the divisions of time], utterly incomparable [hence indescribable], the seed of all that moves or is motionless, the spotless mirror in which is revealed the [radiant] form of Śiva.

3 She the Supreme Śakti has the form both of the seed and the sprout of the revealed coming-together of Śiva and Śakti; subtlest of the subtle, She is contained in [all that lies between] the first and the last letters [of the alphabet, which contains the original root forms from which the names of everything in the world are compounded].

4 When the mass of the sun-rays of Supreme Śiva is reflected back [to Him] from the mirror of the unfolding [vimarṣa-Śakti] the great radiant seed-point appears on that wall which is Consciousness, by the reflection of [His own] brilliance.

5 Selfhood is of the nature of that Consciousness, manifested in the mutual combination of [what is enclosed between] the first and last letters [of the alphabet]; it is the dense mass of the coupled Śiva and Śakti, and contains within itself the circuit [maṇḍala] of the whole universe.

6 The two seed-points, white and red, in secret mutual enjoyment, are Śiva and Śakti, now closing together, now opening out in manifestation [of a universe]; they are the cause of the manifestation of both lettered sound and of what it means, now penetrating, now separating from each other.

7 The self of the point [bindu] of selfhood is the sun formed by the coupling and interfusion of these two; these seed-points combined of fire and moon constitute both the Erotic goal [Kāma—male] and delight [Kalā—female].

8 Now here is given true Insight [vidyā] into the great Goddess [Kāmakalā] setting out the order of Her circuits [ćakras, of which the Śrī Yantra is composed]; he who gains [this Insight] becomes released, identical with Great Tripurasundarī Herself [whose name means 'triple-natured beauty'].

9 From the red bindu as it swelled emerged the sprout of the Sound-Brahman [Nāda]; from that [then] came [the elemental principles] Aether, Air, Fire, Water, Earth and the letters of the alphabet.

10 [But in fact] the white bindu is equally the origin of Aether, Air, Fire, Water and Earth; the whole universe from the most minute to the [all-embracing] sphere [of the cosmic egg] consists of these five transformation-modes.

11 Just as the two bindus are without intrinsic separation or difference from one another so too are the Insight [mentioned above, registered by a fifteen-letter mantra] and the [Goddess] it intuits not different.

12 Lettered sound and meaning are eternally joined to one another, as Śiva and Śakti are; creation, sustaining, and dissolution are divided as three on the pattern of the three bindus [the joint Supreme bindu, the white and the red].

13 He who intuits, the intuition and the intuited are the three bindus and forms of seed [bīja]: the three lights [sun, moon and fire], the three pīthas [Kāmagiri, Purnaśaila and Jālandhara, transformations of the Goddess as consciousness], the three śaktis [or energies, Icchā, desire, Jñāna, knowledge and Krīyā, action] are that by which [the bindus] are known.

14 In each of these in order are the three liṅgaṁs [Bana, Itara, and Para], and the three mātṛkās [Paśyantī, Madhyamā, Vaikharī]. She who is this threefold body is the Divine Insight, which is the fourth pītha [a transcendent state of consciousness] as well as the source of all differentiation.

15 Sound, Touch, Form, Taste and Smell are the [non-substantial] realms of sense [called bhūtas]; each gives rise to the one that follows [and remains present in it]; each is called the guṇa [quality-nature] of the respective elemental principle [in the series given in verses 9 and 10]. Hence they total in order fifteen guṇas.

16 It is the Goddess [Tripurasundarī] who is Herself the [mantra of] fifteen letters and is intuited in the realms of sense. She is surrounded by her fifteen functional aspects [nityās, as goddesses], who each correspond to one of the fifteen guṇas.

17 These fifteen nityās also correspond with the fifteen days [in each month] when the moon appears, which themselves are a union of Śiva and Śakti, consisting of days with nights; the nityās are also the letters of the mantra, and all have the doubled Prakāśa-Vimarṣa nature.

18 She the Divine Insight [vidyā] is of the nature of the three bindus, and is composed of the series of vowels and consonants both as collective unity and as distinct forms; She is the very self of the range of thirty-six tattvas [see diagram on page 182] and stands alone transcending [all of] them.

19 This is what She whom we seek to know is like, the infinitely subtle Goddess Tripurasundarī; noble [sādhakas] sustain a direct intuition of the eternal un-

dividedness of [Her as] their knowledge [vidyā] itself and she whom they seek to know [vedyā].

20   The Great Lady [Maheśī] is the Supreme whose inner nature transcends thought, yet is a triad when She manifests Herself as the three mātṛkās Paśyantī and the others, and distributes Herself into the circuits [of the Śrī ćakra diagram].

21   Enlightened men experience no difference between the ćakra and the Great Lady; for the Supreme Herself is the subtle form of both; nor is there any difference between the subtle and the gross [physical] forms.

22   [Here is given a description of the Śrī Yantra]. Let the Supreme be at the centre of the ćakra; this is the biṇḍu-tattva; when it is ready to evolve it develops into the shape of a triangle [point downward].

23   The triangle is the source of the three [mātṛkās] Paśyantī and the others, and is the three bījas too. [The female devatās] Vāmā, Jyeṣṭhā, Raudrī, Ambikā and Parāśakti reside in one part [composed of the five downward pointing triangles or yonis].

24   [The śaktis] Icchā, Jñāna, Kriyā and Śāntā [the pacified] reside in the other part [composed of the four upward-pointing triangles]. The two letters [A and H, first and last of the alphabet], taken collectively and separately with these nine, constitute the elevenfold Paśyantī.

25   Thus Kāma and Kalā united [in the forms of the diagram] are the letters whose own form is the three biṇḍus; for She the Mother takes on the form of the triangle and the character of the three guṇas [Sattva, Being, Rajas, Radiant Energy, and Tamas, Dark Inertia].

26   Next [from the centre] Paśyantī manifests, from whose self develop the individual mātṛkās Vāmā and the others; and so She becomes ninefold, being called the Mother Madhyamā [who personifies the condition of union between the Supreme and Paśyantī].

27   Madhyamā has a double nature, being both subtle and gross in form; as subtle she is [eternally] static, the essence of the nine sounds [nāda]; as gross she is the nine letter-groups [of the alphabet] and is called 'sense-traces' [Bhūtalipi].

28   The first [subtle Madhyamā] is cause and the other [gross Madhyamā] is effect; since this is their relation the latter is the same as the former; the two are not different [in fundamental nature] for the unity of cause and effect is an axiom [of Indian logic].

29   The [inner] circuit [ćakra] of eight triangles comprising the S and P letter-groups [eight letters in all] is an expansion from the centre triangle, and these nine together with the central biṇḍu make a ten-group, illuminated by the light of [pure] consciousness [ćit].

30   The double-brilliance of these ten is radiated as two further [concentric] circuits each of ten triangles, the inner set manifesting the T and Ṭ letter-groups and the outer the C and K letter-groups.

31   The light of these four circuits is the fully developed [outer] circuit of ten

triangles; thence came into being the circuit of fourteen triangles in which are the fourteen vowels beginning from A.

32 By the triad of the Supreme, Paśyantī and Madhyamā in the form of the gross letters is projected Vaikharī, whose nature is the [entire set of the] fifty-one letters of the alphabet.

33 These eight groups of letters, from the K group on, are on the petals of the eight-petalled [inner] lotus; and the [outer] lotus of sixteen petals should always be contemplated as bearing on its petals the vowels [plus two aspirations].

34 The three encircling lines are transformations of the three lights which radiate from the three bindus [in which other śaktis reside whose names are variously given]; these circles are on the earthplane [bhūpura], and here the three mothers Paśyantī and the others come to rest.

35 Progressive development is either stepwise [when Tripurasundarī projects countless individual śaktis from Her rays], or continuous in all directions [in an unbroken radiance passing from teacher to teacher]; so it is described as of two kinds, [the first] an [obscuring cloud-like] halo of śaktis, [the second] a line of gurus; both are movements of the Mother's lotus feet.

36 When this Supreme Great Lady transforms Herself into the [Śrī] ćakra the members of her body [which is a mass of light] change into Her [projected and] enveloping śaktis [appearing and reappearing in their millions like brilliant bubbles].
[Now follows a description of personifications which correspond with the patterns of letter-arrangement given earlier].

37 She, the Goddess Tripurasundarī, resides in the subtle region [ćakra] which is essentially bindu, sitting in the lap of [Śiva] the Lord of Love, a phase of the moon set [as an ornament] on Her forehead.

38 In her four hands She holds the noose [emblem of the power of attachment which separates the petty self from the Supreme], the goad [emblem of the urge towards liberating knowledge], and the sugarcane bow and five flowery arrows [emblematic, in the same way as 'Cupid's bow', of the passion which drives a person to dedicate his senses to adoration of the devatā].

39 That [divine] couple [who are recognized as the originating form of Brahman] are set in the triangle formed by the three bindus; and by transformation She also takes on the form of three other couples: Lord Mitreśa and Lady Kameśvarī [Lord Uddīśa and Vajreśvarī, Saṣthīśa and Bhagamālinī].

40 In the circuit [ćakra] of eight triangles [which is called the destroyer of all diseases] are the śaktis, Vāsinī and the others, who shine like the setting sun. This ćakra is the eight-fold subtle body of the Goddess, and its inner Self is the Supreme Experience [which naturally cures all diseases].

41 Her [projected Powers] assume the forms of [the female devatās] Sarvajñā [all-knowledge] and the others and reside in the inner of the circuits of ten triangles, [white and] splendid as the autumn moon.

42 The yoginīs [residing] in the [outer] circuit [of ten triangles] are Sarvasiddha-pradhā [givers of all achievements] and the [nine others]. They are the repositories of the organs of knowledge and action [projected from] the Goddess, and are clad in white clothes and [silver] ornament.

43 The śaktis who belong in the circuit of fourteen triangles embody the unfolding movements of fourteen projected faculties of the Goddess [the four forms of mental activity, the five modes of knowledge and the five sense organs, as in the diagram]. They wear clothing [red] as the setting sun and are the yoginīs of total presentation; they should be contemplated as such.

44 In the eight petals the following eight: the Unrevealed, the Totality, the Selving and the five sense realms, assume female shape [as projections of the Goddess] and shine in the eight-petalled lotus; they are called the most hidden yoginīs.

45 The five bhūtas [earth, water, fire, air and aether], the ten senses [five perceptive faculties and five organs of action; see diagram on page 182] and mind are the sixteen last modifications of the Goddess; they dwell in the sixteen petals of the outer lotus as Kāmākārṣiṇī and the others.

[Now follows a brief description of the way the ćakras of the subtle body relate to what has gone before.]

46 All the [female devatās called] mudrās, including the Triple Goddess Herself, are the supreme knowledge, transcending everything. In the inner enclosure of the earth-plane [of the yantra] they shine like early sun.

47 These mudrās are transformations of the śaktis of the nine forms of the Lord, [each occupying] one of the Goddess's nine stations [in the body of the sādhaka] which are themselves transformed into the nine lotus ćakras [of the subtle body, given elsewhere as seven or twelve].

48 Her seven physical components [skin, blood, flesh, fat, bones, marrow and juices] and Her own form manifest themselves as the forms of the eight Mothers, Brahmī and the rest, and reside in the centre of the [square] earth-plane.

49 The [eight] powers, [which are also] Herself, take on the shapes of beautiful young women who can be obtained by other meditative practices; being subordinate they are in the last [lowest] part of the [square] earth-plane.

50 Supreme Lord Śiva [the Original Guru] is identical with the bindu and ex-periences total Bliss. He it is, the highest self, who by degrees separates out into the unfolding [of the Universe], assuming the form of the Lord of Love.

51 Guru Śiva, who resides in the Uḍḍiyāna pīṭha [the innermost triangle], passed on this profound insight to his own śakti, the Lady of Love, form of the unfolding world, at the [remote] beginning of the Golden Age [Kritayuga].

52 She, the Lady of the three corners [of the central triangle, personified as Kameś-varī, Vajreśvarī and Bhagamālinī], is called the Eldest, Middle and Youngest, and is the object of Supreme Śiva's enjoyment, has the name of Mitradeva [the founding-guru of Tantrik tradition of Teachers in our present Kālī age].

53 It was She herself who initiated and revealed the Insight to the Teachers who are seeds of the Three Ages and Lords of the three bījas, and by whom the three orders [of gurus] are maintained. This is the system of gurus.

54 Here ends the description by Puṇyānanda [the author] of the erotically playful movements of beautiful Kāmakalā, the woman who is eternally the object of the desire with which Supreme Śiva is filled.

55 Over the ocean of wandering, whose waters are raging thirst and wild with the waves of anxiety, I have crossed by the grace of the Boatman, the respected Lord, to whom—Namas! Reverence!

[In this brief, often cryptic but widely respected Tantra the whole mechanism of yantra, mantra, devatā and the meaning of sādhana are summarized. By describing the process of Generation from a single point it demonstrates how libido may be withdrawn from any interest in, or attachment to, the objects of the world—which are no more than projections through each person's channels of mind and body of an original Desire for the mutuality of love. By focusing meditation inward on to the images and sounds of the yantra, which transcends time, the projected world comes to be seen as a distant panorama of intrinsically worthless accidents, 'play'. The libido, focused into unparticularized cosmic sexuality, and progressively condensed within the circuits of the yantra, is shown to be that very intensest point from which Creation continually springs and to which individual enlightenment may return.]

# Notes on the Text

1 Agehānanda Bharati, *The Tantric Tradition*, 1965. See Bibliography.
2 Avalon (ed.). See Bibliography.
3 Bhattacharyya, B., ed., *Guhyasamāja Tantra,* Chapters 5 and 9. See Bibliography.
4 This will be found explained in more detail in the author's *Erotic Art of the East,* 1968. See Bibliography.
5 M. Eliade, *Yoga, Immortality and Freedom,* 1958, *passim.* See Bibliography.
6 F. D. K. Bosch, *The Golden Germ,* 1960. See Bibliography.
7 Bhattacharya Mahodaya, S. C. V., *Tantratattva.* See Bibliography.
8 Summarized by the author in *The Erotic Art of Primitive Man,* 1973. See Bibliography.
9 Agehānanda Bharati, *The Tantric Tradition*, 1965. See Bibliography.
10 *Vijñānottara Tantra.*
11 *Mantrasadbhāva.*
12 *Śrikāntha Saṃhita.*
13 W. B. Onians, *The Origins of European Thought,* 1951. See Bibliography.
14 P. S. Rawson, *The Erotic Art of Primitive Man,* 1973. See Bibliography.
15 It is contained especially in the *Bhagavadgītā,* which is an interpolation into the epic *Mahābārata,* in the *Bhagavata Purāna* and the *Brahmavaivarta Purāna,* all of which have been translated into English.
16 A. Avalon, tr., *Karpūrādistotram,* p. 45. See Bibliography.
17 A. Avalon, tr., *Mahānirvāna Tantra.* See Bibliography.
18 *Foundations of Tibetan Mysticism,* 1960.
19 See J. C. Huntington, 'The iconography and structure of the mountings of Tibetan paintings' in *Studies in Conservation* 15 (1970), pp. 190–205.
20 There are a few insignificant philosophical groups that do.
21 Fuller details of the Hindu and Buddhist systems will be found in Arthur Avalon's *The Serpent Power,* 1950, and Lama Anāgārika Govinda's *Foundations of Tibetan Mysticism,* 1960. See Bibliography.
22 See Charles Luk, *The Secrets of Chinese Meditation,* London 1964, Lu K'uan Yü, *Taoist Yoga,* London 1970 and Chang Chung Yuan, *Creativity and Taoism,* New York 1963.
23 Described in Fairfax L. Cartwright, *The Mystic Rose,* London, n.d. (1897?).
24 A. Avalon, tr., *Mahānirvāna Tantra.* See Bibliography.
25 A. Avalon, *Shakti and Shakta,* 1939, p. 653. See Bibliography.
26 Govinda, Lama Anāgārika, *Foundations of Tibetan Mysticism,* 1960, pp. 181 ff. See Bibliography.
27 In the *Śatćakranirūpana* the female devatā, for consistency in sound, is called Lākini.
28 Bhattacharyya, B., ed., *Niṣpannayogāvali.* See Bibliography.
29 A. Avalon, tr., *Kāmakalāvilāsa.* See Bibliography.
30 *Yogini Tantra.*
31 *Navaratneśvara.*
32 Quoted, with slight stylistic emendations, from the *Tantratattva* of Śrīyukta S. C. V. Bhattāchārya Mahodaya. See Bibliography.
33 *Pratyabhijñā sūtra.*
34 *Maitri Upaniṣad.*
35 *Maitri Upaniṣad.*
36 *Māndukya Upaniṣad.*
37 *Maitri Upaniṣad.*
38 *Prapañćasāra.*

# Glossary

Aghoris: a sect of ascetics who haunt cemeteries and cultivate customs which break social convention, widely regarded with horror.

aham: 'I', the self of both person and Cosmos.

Ājñā: the ćakra or lotus in the subtle body located between the eyebrows.

Akṣobhya: the Buddha of the five who, in the Vajrayāna Tantrik system, occupies the eastern direction, and is, in a sense, the 'first'.

Anāhata: the ćakra or lotus in the subtle body located near the heart.

Ānanda: Supreme bliss.

Ananta: the eternal or endless one, a name usually applied to the snake upon whom the god Viṣṇu rests.

Apāna: one of the chief 'energies' in the subtle body, filling the region of the anus.

Arjuṇa: a hero of the Mahābhārata epic whose charioteer Kṛṣṇa was.

āśram: a house of religious retreat and meditation, often run for a particular teacher.

Atharva Veda: the fourth of the ancient collections of sacred text called Vedas, which deals especially with medicine and magic.

Barṇini: the name of a female devatā.

Bhaga: a word meaning wealth or womb.

Bhagavadgita: a mystical poem, supposedly uttered by Kṛṣṇa, incorporated into the great epic Mahābhārata.

Bhagavān: a name meaning 'Lord', he who possesses wealth or fortune.

Bhagavatī: an honorific name applied to goddesses in general, sometimes as a name for the Great Goddess.

Bhairavī: a name given to the Goddess in her terrible form as wife of the terrible form of Śiva.

Bhakti: the act and attitude of totally self-denying adoration.

bhang: a form of Cannabis Indica.

bhoga: enjoyment, as a principle of creation.

Biṇḍu: the creative male dot, point or seed, equated with the male sperm.

Bodhicitta: 'enlightenment consciousness', a term used in Tantrik Buddhism, often identified with the male semen.

Bodhisattva: a being, in Buddhism, entitled to Nirvāna, but remaining in the world, out of total compassion, to aid all suffering creatures towards their own enlightenment.

Bon-po: the old, indigenous form of the Shamanic religion in Tibet before the arrival of Buddhism.

Brahmā: a name for the Hindu deity who functions as active creator in some groups of myth.

Brahman: the ultimate, absolute principle, recognized since very ancient times in Indian tradition.

Buddha: originally a historical teacher c. 500 BC, who founded Buddhism, later recognized as only one of many figures embodying the transcendent principle of Enlightenment, the Buddha-nature.

ćakra: one of a series of centres in the meditative subtle body, conceived as discs or lotuses.

Chen-yen (Shingon) sect: a Buddhist sect in China giving an important place to mantras and maṇḍalas, which also reached Japan.

Chinnamastā: 'She of the cut neck', an icon indicating the way the Goddess divides herself into other functions.

Cosmic Body: the Cosmos considered in human form.

Cosmic Egg: a mythical golden egg from which the universe was born.

cosmogram: a diagram representing the structure of the universe.

Dākinī: a female figure, in Tantrik Buddhism, personifying an initiation or stage of wisdom.

Deva: a divine figure, the root of the word ($\sqrt{}$ div) meaning 'shine'.

Devatā: a term applied to Tantrik divine principles (cf. Deva).

Devī: a name meaning 'The Goddess', applied to the Female Principles of Tantra.

dhvani: 'resonance', a technical term.

Durgā: one of the names by which the Great Goddess is known, referring to a legend according to which she embodies the combined energies of all the other deities.

Dūtī: a female intermediary, here used in a technical sense.

Four Holy Truths: the basis of the Buddhist teaching, uttered by the Buddha in his first sermon.

ganjam: a form of Cannabis Indica.

Garuḍa: a mythical bird, vehicle of the God Viṣṇu.

gChöd ritual: a rite performed by an individual Tibetan monk, in which he symbolically butchers his bodily identity and feeds it to the spirits.

Gestalten: unitary shapes percieved by the mind within the multiplicity of appearances.

Goloka: the 'cow-world', the celestial region of fulfilment for followers of Kṛiṣṇa.

Gopī: 'Cow-girl', the name given to each of the girls of Kṛiṣṇa's cattle-herding tribe, with whom he conducted a love-affair.

gTum-mo ritual: a meditative Tibetan ritual for generating intense psychic energy and physical heat.

guru: initiated teacher belonging to an established line of teachers.

Herūka: male personification of energy and power, in Tantrik Buddhism.

*Hexeity* (haeccitas): Duns Scotus' term for individual and unrepeatable patterns in reality, understood as diametrically opposed to the Aristotelian system of inclusive general categories (cf. *inscape*).

Holi festival: a kind of carnival, held at the spring harvest, when people spray each other with coloured water or powder to celebrate fertility.

Hua-Yen (Kegon) sect: Buddhist sect in China, transmitted also to Japan, known for its profound philosophy of the total interdependence and interpenetration of the forms of 'reality'.

Hūṁ: a mantra embodying spiritual power.

*I Ching*: an ancient Chinese book of Oracles, known in English as 'The Book of Changes'.

idam: Sanskrit for 'this', the immediately objective present, here translated as 'that', to convey its objective distinctness from the subject.

Indra: the ancient warrior-king of the Vedic Gods.

*Inscape:* term coined by the English poet (and Scotist) Gerard Manley Hopkins for the unique individual form he grasped and contemplated as the essence of real experience.

Jambudvīpa: the image of the structure of the Universe.

Jaina (Jainism): a religion founded about 500 BC by Mahāvīra, whose monks practise total abstention from injury to any living creature, and hence ultimately attain suicide and bliss.

japa: repetition of a mantra by sustained recitation, which produces a stream of energy.

Kālaćakra: 'Wheel of Time', a special Tantrik Buddhist system of maṇḍalas and meditations.

Kālī: the Terrible Goddess in her guise as Destroying Time.

Kalpa (aeon) tree: the tree of time whose branches are the different epochs of cosmic history.

Kāma: love or desire personified.

Kāmadhenu: the celestial cow whose milk 'grants all desires'.

Kāmasūtra: a famous text dealing with the techniques of love.

Karma: the deeds performed by each individual during his successive incarnations, which, according to their positive or negative value, lead him up or down the scale of being towards or away from final release and bliss.

Kaulas: members, either by birth or by initiation, of a special widespread Tantrik family called Kula.

Knowledge-Holders: a grade of Tantrik Buddhist divine principles.

Kṛiṣṇa: a god, regarded as an incarnation of the High God Viṣṇu, who is the object of passionate devotion by his followers. He has a blue complexion.

Kula: a particular widespread family of Tantrik initiates, to which people may belong either by birth or by initiation.

Kulakuṇḍalinī: the subtle form of snake-like inner energy as she is known to Kulas (q.v.).

Kuṇḍalinī: the snake-like feminine form of inner energy which sleeps in ordinary people, aroused by Tantrik yogīs for meditative achievement.

Lalitā: one of the names by which the Great Goddess is known; it has overtones of erotic joy.

Laya yoga: yoga which uses the principle

of absorbing lower grades of energy into higher, up the successive levels of the subtle body.

līla: 'play', signifying erotic pleasure, joy, and cosmic activity which is free from any definite aim.

liṅgaṁ: the male penis itself, or a symbol of the male sexual organ of penetration which may be worshipped as emblem of the masculine Deity.

Mahākāla: 'Great time', the form of the High God Śiva in which his nature as Time is revealed.

Mahārāga: the highest form of concentrated passionate energy, a state known inwardly by the individual in which the ultimate truth is experienced as a whole.

Mahāvidyā: a female form in which one of the subdivided energies of the Great Goddess appears and can be worshipped.

Maheśvara: 'the Great Lord', a name for Śiva as Lord of Creation.

maṇḍala: a circular form of diagram used for concentrating and focusing cosmic and psychic energy.

maṇi: 'jewel', a substitute term for 'vajra' (q.v.), which indicates the highest Tantrik Buddhist insight.

Makara monster: a fantastic water monster, often shown vomiting out the waters of creation, fertility and time.

mantra: a Sanskrit syllable or group of syllables, used to concentrate cosmic and psychic energies, when correctly uttered. Mantras may be lettered on ritual implements and works of art.

Māyā: the Great Goddess as she who 'measures out' (Sanskrit root $\sqrt{\text{mā}}$, 'measure') space and time, both in an important sense delusory.

Meru: the mythical mountain at the centre of the universe, from which flow all the waters of creation.

Merundaṇḍa: the spinal tube in the human subtle body, which is identified with Meru (q.v.).

mudra: gesture concentrating a meaning and energy.

Mūlādhāra: the lowest ćakra (q.v.) in the human subtle body.

Nāda: sound, and the cosmic principle of vibration.

Nādabiṇḍu: the originating Seed of the Universe conceived as the original first vibration.

nadī: channel in which energies flow through the human subtle body.

Nirvāna: the Buddhist state, experience by those who attain the Buddha's ultimate condition of release, when all Karma (q.v.) is exhausted.

Nityā: a synonym for Mahāvidyā (q.v.) implying her eternal quality.

nyāsa: a rite of touching parts of the body to potentiate them and identify them with similar parts of the Deity.

Oṁ: the root mantra (q.v.) of the world, and the most powerful of all mantras.

Padma: lotus.

parāvritti: 'turning back up' the energies of the subtle body which are normally wasted in daily perception and action.

Parvatī: the Goddess as wife of Śiva.

Patañjalī: a Sanskrit scholar and author c. 150 BC.

phur-bu: magician's dagger, an instrument of power.

Prakāśa: the primal spark of Creation.

Prakṛti: the female element in the creative process.

Prāna: inner energy of the subtle body.

pūjā: practical worship-cum-ritual.

pūjārī: one who does pūjā (q.v.).

Purāna: a class of Sanskrit encyclopaedic collections of myth and legend.

Purūṣa: the masculine element in the creative process.

Rādhā: the chief of the Gōpis (q.v.).

Rāga: 'passion'; also used of one of the emotive scales of Indian music.

Rāginī: one of the 'female' scales of Indian music.

Rajput: one of the chief population groups, mainly in Northwestern India, whose traditions were military. They provided the rulers of many states in Rajasthān and the Panjab.

Rāma: the hero of the ancient Sanskrit epic Rāmāyana, adopted as an incarnation of the High God Viṣṇu.

Rasa: 'juice', a term also used to refer to the 'tasting' of one of the major categories of emotional experience.

Rasalīla: a term used by followers of Kṛiṣṇa for blissful erotic play in celestial springtime.

Ratna: jewel.

Red Hat sect: one of the two principal divisions of the Buddhist tradition in Tibet, that which is the more 'left-wing' Tantrik, distinguished by their headgear.

Ṛig Veda: the oldest sacred hymns of the Brahmins, composed in an archaic form of the Sanskrit language, c. 1200 BC.

Rudra: an ancient form of terrible deity, 'the howler', later assimilated to Śiva.

Sadāśiva: 'Eternal Śiva'.

sādhaka: a person committed to spiritual effort who performs acts of ritual, worship and meditation.

sādhana: the acts and efforts of a sādhaka.

Sahasrāra: the thousand-petalled lotus, located in the crown of the head of the subtle body.

Śaiva: follower of the God Śiva.

Śakti: female noun meaning 'power', applied both to the Great Goddess as supreme power, and to the female counterparts of male Tantrik sādhakas (q.v.).

Saṁsāra: the Buddhist world of birth, death and misery, which is seen to be delusory when enlightenment is reached.

Sāṅkhya: one of the ancient systems of philosophy recognized by the Brahmins as orthodox.

Sarasvatī: the Brahmin Goddess of Divine Speech or Chant, usually shown holding a musical instrument.

sense-field (or sense-realm): a region of experience defined by one of the human senses, sight, hearing, touch, smell and taste.

Shaman(ism): a type of gifted ecstatic, known among many early peoples, who performs trance dances to make contact with the supernatural world.

Śiva: the most important High God of Hinduism.

skandha: one of the set of psychological categories according to which ortho-dox Buddhism analyses human experience.

stūpa: a symbolic structure developed in India from a mound near the summit of which the bodily relics of early Buddhist saints were enshrined for public reverence.

subtle body: the structure of channels and knots parallel to but not identical with the human body through which the latter is imbued with its sense of reality.

Sufi: the name applied to Islamic mystics who experience a direct relationship with God.

Suṣumṇā (see Merudaṇḍa): the channel in the spine of the subtle body (q.v.).

sūtra: a basic text, with the force of divine revelation.

Svayambhū: the Self-Originated One, a name applied to Śiva and his emblems.

tanka: a Tibetan type of iconic painting, mounted in a special way so as to provide a dwelling for a divine principle.

Tantra: a kind of text embodying the special Tantrik tradition of teaching, many of the Hindu examples being in the form of a dialogue between the utlimate Divine Couple, Śiva and Śakti.

Taoism: the customs and beliefs of Chinese followers of 'the Way' taught originally in the ancient texts Tao Te Ching and the works of Chuang Tzu. Lao Tzu is its legendary teacher.

Tārā: name of a Goddess of Wisdom in Buddhism, of one of the Mahāvidyā Goddesses in Hindu Tantra.

Upaniṣads: ancient summaries of the nuclear philosophy of Hinduism, regarded in India with profound reverence as sacred scriptures.

uśnīṣa: the protuberance on the crown of the head of a Buddha signifying his condition of Enlightenment.

Vaiṣṇava: a follower of the High Hindu God Viṣṇu.

Vajra: an emblem of power in Tantrik Buddhism.

Vajrasattva: one of the Supreme Buddha figures of Tibetan Tantrik Buddhism.

Vajrayāna: a term for Tantrik Buddhism.

Veda: the most ancient and sacred collections of hymns and legends preserved by the Brahmins, in archaic forms of the Sanskrit language.

Vedānta: the 'culmination' of the Veda, a name for the extreme monist philosophy taught especially by Śankarācārya, c. AD 800.

Vimarṣa: 'reasoning' or 'discursive reflection', a term applied to the female function 'mirroring' the Original Spark of Being.

Vīna: a stringed musical instrument.

Vīra: hero, well-developed sādhaka (q.v.).

Viṣṇu: one of the principal High Gods of Hinduism, recognized in a variety of incarnations including Kriṣṇa, Rāma, and the Buddha.

Void, the: the only admissable definition for the Buddhist experience of ultimate truth.

yoni: Sanskrit word for the female genitals; also used as a name for the Cosmic Womb.

Yajña: the ritual sacrifice around which ancient Brahmin religion centred.

yantra: a diagrammatic symbol for a field of energy.

Yoga: groups of physical and mental exercises, with a spiritual purpose.

Yoginī: a female partner in Tantrik sexual yoga.

# Bibliography

A full, annotated and scholarly bibliography will be found in Agehānanda Bharati, *The Tantric Tradition,* London, 1965.

The following works are readily available in English, or with substantial English introductions with information for the English reader.

## TEXTS

Aiyar, K. N., tr. *Thirty Minor Upaniṣads,* Madras, 1914. Very important, but condensed, basic material for different schools of meditation, in English.

Avalon, A., tr. *Hymns to the Goddess,* London, 1913. Translations of ecstatic and philosophical hymns to different aspects of the Goddess.

Avalon, A., tr. *Kāmakalāvilāsa,* Calcutta and London, 1922. A summary text, of which a translation is also given as an Appendix in the present volume.

Avalon, A., tr. *Karpūrādistotram,* Calcutta and London, 1922. One of the most important short Tantras, a hymn translated with a commentary that explains a great deal of basic principle.

Avalon, A., tr. *Mahānirvāna Tantra,* Madras, 1963 (4th ed.). A voluminous encyclopaedic Tantra, somewhat Brahminized, in English.

Avalon, A., *Tantrarāja Tantra* (ed.) London, 2 vols. n.d. One of the greatest long Tantras, in Sanskrit with a fairly full English summary.

Bhaba, B., tr. *Hathayogapradīpika,* 1889. There are other editions of this important work on Yoga postures and techniques, in English.

Bhattacharya Mahodaya, S. C. V. (tr. A. Avalon) *Tantratattva (Principles of Tantra),* London and Madras, 1916; Madras, 1955 (2nd ed.). A great book written by a learned and generous minded Indian Tantrika.

Bhattacharyya, B., ed. *Guhyasamāja Tantra,* Baroda, 1931. Text of one of the oldest Buddhist Tantras, with full English summary.

Bhattacharyya, B., ed *Niṣpannayogāvalī of Abhayākaragupta,* Baroda, 1949. A large collection of maṇḍalas, with English summary.

Bhattacharyya, B., ed. *Śaktisaṅgama Tantra*, Baroda, 4 vols. A major encyclopaedic text, with a very brief English summary.

Chang, C. C., *Tibetan Yoga*, New York, 1963 (cf. also, Evans-Wentz *Tibetan Yoga and Secret Doctrines,* London etc., 1958). English translation of texts on basic meditative techniques.

Dawa-Sandup, K., tr. *Shrīchakrasambhāra Tantra,* London and Calcutta, 1919. Incomplete translation of a long meditative ritual full of visualizations.

Evans-Wentz, W. Y., ed. *The Tibetan Book of the Great Liberation*, London etc., 1954. Biography, translated into English, of the Mahā Siddha Padmasambhava, full of descriptions of magic and Tantrik ritual.

Evans-Wentz, W. Y., ed. *The Tibetan Book of the Dead,* London etc., 1949. A description of after-death experiences which amounts to a survey of the whole Tibetan symbolic system.

Hume, R. H., tr. *The 13 Principal Upaniṣads*, London etc., 1934. An English version of these fundamental and unparalleled religious texts.

Snellgrove, D. L., tr. *The Hevajra Tantra* (bowdlerized), London, 1959. An English version of what may be the oldest Buddhist Tantra.

Vasu, S. C., tr. *Gherandasamhita, Shivasamhita.* Allahabad, 1914. Texts on Hatha yoga postures and methods.

Vijñānānanda, Swami (tr.), *Śrimad Devī Bhagavatam*, Allahabad 1921–3.

## BOOKS RELATING TO TANTRA

Archer, W. G., *The Loves of Krishna,* London, 1957. Discusses the history of the Kṛiṣṇa cult and its preoccupation with love.

Avalon, A., *The Serpent Power,* Madras, 1950 (4th ed.). Gives a translation of a text and a long English discussion of the nature of the subtle body with its ćakras.

Avalon, A., *Shakti and Shakta,* Madras, 1939 (3rd ed.). A series of essays on many aspects of Tantra: a basic book.

Bhattacharyya, B., *The Indian Buddhist Iconography,* London etc., 1924. Deals with the figures appearing in Buddhist Tantrik meditations.

Blofeld, J., *The Way of Power,* London, 1969. A brief explanation of Tantra seen through the eyes of an author whose main experience was in the Far East.

Bosch, F. D. K., *The Golden Germ,* The Hague, 1960. A study of the archetypal symbolisms underlying Eastern iconography.

Bose, D. N., *Tantras, their Philosophy and Occult Secrets,* Calcutta, 1956. A survey of Tantrik culture.

Bose, M. M., *The Post-Chaitanya Sahajiya Cult of Bengal,* Calcutta, 1930. A study of the extreme cult of erotic sentiment directed on Kṛiṣṇa.

Chakravarti, C., *The Tantras, Studies on their Religion and Literature,* Calcutta, 1963. A survey of the sources and literature.

Dasgupta, S. B., *An Introduction to Tantric Buddhism,* Calcutta, 1950. A study of philosophy, religion and iconography.

Dasgupta, S. B., *Obscure Religious Cults,* Calcutta, 1962 (2nd ed.). A survey of the various surviving cults in Bengal which retain strong vestiges of older Tantra, including the Nāthas and Bauls.

David-Neel, A., *With Mystics and Magicians in Tibet,* London, 1931, and *Initiation and Initiates in Tibet,* London, 1958. Two excellent books, written in a popular style, but giving first hand, accurate information.

Douglas, N., *Tantra Yoga,* New Delhi, 1971. Enthusiastic with interesting plates.

Eliade, M., *Yoga, Immortality and Freedom,* London, 1958. A thorough scholarly investigation of most aspects of yoga from the standpoint of comparative religion.

Gnoli, R., *The Aesthetic Experience according to Abhinavagupta,* Rome, 1956.

Gordon, A. K., *The Iconography of Tibetan Lamaism,* New York, 1939. The only survey of the subject so far.

Govinda, Lama Anāgārika, *Foundations of Tibetan Mysticism,* London, 1960. A masterly piece of scholarship, dealing with Tantrik Buddhist symbolism from the inside.

Guenther, H. V., *Yuganaddha, the Tantric View of Life,* Banaras, 1952. A good study, verbalizing philosophical problems.

Masson, J. L. and Patwardhan, M. V., *Śāntarasa,* Poona, 1969. A study of Indian aesthetic principles.

Mookerjee, A., *Tantra Art,* Paris etc., 1967, and *Tantra Asana,* Paris etc., 1971. The two source-books for the whole of Tantra art.

Mukjerjee, P., *The History of Medieval Vaishnavism in Orissa,* Calcutta, 1940. Includes a study of Tantrik elements in the Kriṣṇa cult.

Nebesky-Wojkowitz, R. de, *Oracles and Demons of Tibet,* London and The Hague, 1956. Gives an insight into the Tibetan world of spiritual beings in which Tibetan Tantra is rooted.

Onians, W. B., *The Origins of European Thought,* Cambridge, 1951. Gives a clear insight into the roots of symbolism and conceptualization.

Pott, P. H., *Yoga and Tantra,* The Hague, 1966. Essays on special aspects of Tantra, supplementing other work, and very clearly written.

Rawson, P. S., *Erotic Art of the East,* New York, 1968. Contains a study of sexual ideas and imagery in India, with a chapter on Tantra.

Rawson, P. S. (ed. etc.), *The Erotic Art of Primitive Man,* London, 1973.

Sierksma, F., *Tibet's Terrifying Deities,* The Hague, Paris, 1966. A wide-ranging but somewhat inconclusive exploration of the sexual implications of the subject.

Tucci, G., *Theory and Practice of the Maṇḍala,* London, 1961. Discusses how maṇḍalas are constructed and used.

# Location of Objects

Alampur Museum, Hyderabad State 40; Collection Jean Claude Ciancimino, London 4, 27, 50, 54, 56, 57, 113, 125, 129; Collection John Dugger and David Medalla, London 32, 41, 48, 58, 59, 61, 63, 65, 66, 116; Collection Eskenazi Ltd., London 106; Collection Sven Gahlin, London 5, 11, 29, 33, 55, 60, 78, 86, 90, 137, 151, 170; Collection Philip Goldman, London 76, 77, 89, 108, 117 (Photos Werner Forman); Gulbenkian Museum, Durham 24, 75, 153; Collection R. Alistair McAlpine, London 155; Collection Prafulla Mohanti, London 6; Collection Ajit Mookerjee, New Delhi 2, 8–10, 12, 13, 15, 30, 31, 35–37, 39, 42–44, 46–47, 49, 51–53, 64, 67–69, 71, 74, 79–82, 85, 88, 91, 93, 94, 98, 100–102, 104, 105, 110, 111, 118, 120–124, 126–128, 130–134, 136, 138–144, 146, 147, 149, 152, 157–169, 171–175; Oriental Institute, Baroda 17–23; Private collections 1, 109, 112, 176; Collection Mrs Donald O. Stewart, London 135, 145; Victoria and Albert Museum, London 7, 25, 26, 28, 45, 62, 70, 83, 84, 87, 95, 96, 99, 103, 107, 114, 115, 119, 150, 156.

# Index